Pelican Book A806

Style and Civilization | Edited by John Fleming and Hugh Honour

Gothic by George Henderson

George Henderson was born in Old Aberdeen in 1931 and educated at the Universities of Aberdeen and London. He did research for his doctorate at Trinity College, Cambridge, and further research on medieval pictorial art and imagery, first as Research Fellow at the Barber Institute of Fine Arts in Birmingham and then as Graham Robertson Research Fellow at Downing College, Cambridge. He was lecturer in the history of art at Manchester University from 1962 until 1965, when he was appointed to a lectureship in the Fine Art Department at Edinburgh University.

George Henderson has published articles in various learned periodicals and is married with two children.

George Henderson

Style and Civilization

Gothic

With 115 illustrations

Penguin Books

Penguin Books Ltd, Harmondsworth,
Middlesex, England
Penguin Books Inc., 3300 Clipper Mill Road,
Baltimore.Md, 21211, U.S.A.
Penguin Books Australia Ltd, Ringwood,
Victoria, Australia

First published 1967
Copyright © George Henderson, 1967

Designed by Gerald Cinamon
Made and printed in Great Britain by
Balding & Mansell, London and Wisbech
Set in Monotype Garamond

For Matthew

Contents

Editorial Foreword

The series to which this book belongs is devoted to both the history and the problems of style in European art. It is expository rather than critical. The aim is to discuss each important style in relation to contemporary shifts in emphasis and direction both in the other, non-visual arts and in thought and civilization as a whole. By examining artistic styles in this wider context it is hoped that closer definitions and a deeper understanding of their fundamental character and motivation will be reached.

The series is intended for the general reader but it is written at a level which should interest the specialist as well. Beyond this there has been no attempt at uniformity. Each author has had complete liberty in his mode of treatment and has been free to be as selective as he wished – for selection and compression are inevitable in a series such as this, whose scope extends beyond the history of art. Not all great artists or great works of art can be mentioned, far less discussed. Nor, more specifically, is it intended to provide anything in the nature of a historical survey, period by period, but rather a discussion of the artistic concepts dominant in each successive period. And, for this purpose, the detailed analysis of a few carefully chosen issues is more revealing than the bird's-eye view.

Preface

This book is about the art produced in Europe in the latter part of the Middle Ages, from the twelfth to the sixteenth centuries. The artistic output of more than four hundred years is not easy to describe in a few chapters. Gothic is not so much a species of European art as a genus, itself containing many species. Gothic art was continually on the move. Its multiple potentialities were only gradually realized as artists lived through changing times and responded to the shifting moods of society.

I have selected what I believe to be characteristic qualities in Gothic art, characteristic, that is, either in methods of visual display or in choice of subject matter. There are inevitably gaps in this account and doubtless many people's favourite works of art are omitted. But although I offer a personal interpretation of facts and objects, I hope that the chapters which follow give a fair impression of the vitality, profusion, and diversity of the Gothic style, and also of the strong ties which bound Gothic art to medieval civilization as a whole. In a final chapter I have picked out, again by personal selection because they strike me as typical and illuminating, some examples of post-medieval appreciation and criticism of medieval culture, in order to give the reader some inkling of the fascinating complexities of the posthumous history of the Gothic style.

For advice and help I wish to thank Dr Margaret Whinney, Professor John White, Professor George Zarnecki, and the editors of this series, Mr John Fleming and Mr Hugh Honour. I am grateful to Miss Pauline Newton for her assistance in preparing this text for publication. I have had special help with the plates from Dr Kerry Downes, Mr Hugh Tait, Miss Elizabeth Glass, Mr Donald King, Mrs Joan Allgrove, Professor Erwin Panofsky, Professor Louis Grodecki, and Dr Peter Kidson.

Acknowledgements are also due to the British Museum, the Victoria and Albert Museum, the National Gallery, London;

the Cambridge University Library; the Bodleian Library, Oxford; the John Rylands Library, Manchester; the Library of Glasgow University; the Library of Trinity College, Dublin; the Bibliothèque Nationale, the Louvre, the Musée des Arts Decoratifs, Paris; the Musée d'Unterlinden, Colmar; the Bibliothèque Municipale, the Musée de la Ville, Dijon; the Musée des Beaux Arts, Ghent; the Museum Boymans-van Beuningen, Rotterdam; the Prado, Madrid; the Wiener-Neustadt Museum, the Kunsthistorisches Museum, Vienna; the Staatliche Graphische Sammlung, the Bayerische Staatsgemäldesammlungen, Munich; the Museo Civico, Turin; the Biblioteca Governativa, Lucca; the Metropolitan Museum, New York; and to Alinari/Mansell Collection, Anderson/Mansell Collection, the Courtauld Institute, the Warburg Institute, London; Archives Photographiques, Photographie Giraudon, Pierre Devinoy, Paris; Remy, Dijon; A. C. L., Brussels; Bildarchiv Foto Marburg; L. Herbert-Felton; A. F. Kersting; Helga Schmidt-Glassner; and the late F. H. Crossley.

Gothic

I

The Gothic Artist

The Gothic style, displayed in vast and complex works of architecture, in monumental sculpture, richly illuminated manuscripts, panel painting and stained glass, lavish jewellery and plate, delicate ivories and handsome textiles, is impressive both visually and intellectually. Yet for some people the appeal of Gothic art may be muted a little by the notorious anonymity of Gothic artists. Among all the splendid variety of artistic monuments dating from the Gothic period, works actually bearing the signatures of artists are few and far between, while historical records relating to the careers of architects, painters and sculptors are at best scanty and fragmentary. In trying to understand and appreciate Gothic art we have to take into account this widespread reticence about the practitioners of Gothic art, for it undoubtedly reveals something about the nature of the Gothic achievement.

The case of the Gothic artist is, however, by no means hopeless. While anonymity does appear to be the general rule, it should not be exaggerated. A number of individuals stand out clearly enough, and they help us to catch a glimpse of their innumerable unknown colleagues. We certainly know enough about particular artists and about their connexion with specific works of art to reject the old popular theory that in the Middle Ages the professional artist simply did not exist.

The great cathedrals of the Gothic period used to be represented not as the result of deliberate planning by anyone in particular, but rather as the result of a sort of fantastically extended game of Consequences played by generations of simple, pious craftsmen. As the incarnation of collective endeavour 'the Gothic artist' was allowed to loom quite impressively on the medieval scene, but inevitably he had no personal qualities or attributes to engage our attention, no works that were his as opposed to someone else's, no dates of birth or death, not even a name!

The Gothic artist in some such generalized and symbolic sense is the subject of a curious engraving by that eccentric

genius William Blake [1]. In 1773, when Blake was fifteen and apprenticed to the engraver James Basire, he produced a print based on a drawing of a figure from Michelangelo's *Martyrdom of St Peter* in the Cappella Paolina. At some later stage in his career Blake reworked his plate and added the inscription:

This is One of the Gothic Artists who Built the Cathedrals in what we call the Dark Ages, Wandering about in sheep skins & goat skins, of whom the World was not worthy; such were the Christians in all Ages.

We are dealing here, of course, with Blake's private mythology and private pictorial vocabulary, so we have to make allowances. Nevertheless, his alliance of such a model with such a subject does reveal the extent to which the notion of the Gothic artist lacked, in the late eighteenth century, any natural visual equivalent. In 1774 or earlier Basire sent Blake to make drawings of the royal tombs at Westminster Abbey. Standing, sketchbook in hand, astride the great gilt-bronze effigies, he could scrutinize the ornaments, costume, and the idealized but still perfectly human physiognomy of some of the top people of the Gothic period. All around him was evidence of the style which artists of that period had employed. And Blake's own style was deeply influenced by these studious hours spent in the abbey. Yet all his on-the-spot, first-hand observations did not deter him from choosing a Michelangelesque image for his personal 'portrait of the artist when Gothic'. We see an uncouth mountain of a man, insufficiently clothed, shambling along a rocky sea-coast in the half dark.

The picture and inscription alike would have flabbergasted Hugues Libergier, the architect of the brilliantly beautiful church of Saint-Nicaise at Reims, designed in 1229, and destroyed during the French Revolution. Libergier was the genuine article, a real Gothic architect. He is represented on his grave-slab in Reims Cathedral warmly clad in a distinctly academical-looking gown – in keeping with his academical-sounding title, '*Maistre*' – and holding a staff and a model of his church [2]. Instruments belonging to his profession, the square and compasses, lie at his feet, and he is sheltered by an elegant aedicule and attended by angels. This stately official never wandered about in goat skins. Even less was he a rude mechanical equipped only with a hammer and a hymn. His personal achievement is plainly recorded both in the border inscription, '*qui comensa ceste eglise . . .*', and in the

William Blake's engraving
a 'Gothic Artist'

2. Tomb-slab of Hugues Libergier,
Reims Cathedral

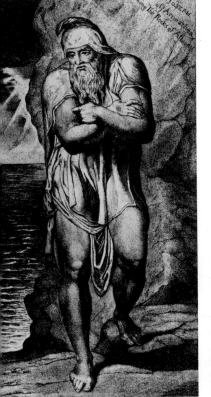

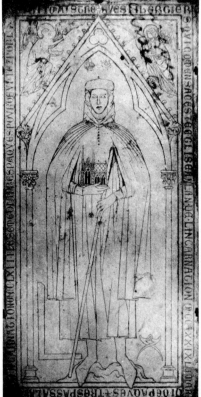

image of his church held in his hand. His name is there, and the date of his death, 1263.

In Reims Cathedral, down to the late eighteenth century, a labyrinth pattern was to be seen on the floor of the nave, containing representations of men famous in the history of the fabric, accompanied by their names and deeds. First came Jean d'Orbais, 'who began the chancel of the church'; next Jean le Loup, 'who was *maistre des ouvrages* of this church for the space of sixteen years and who began the portals'; next Gaucher de Reims 'who was *maistre des ouvrages* for the space of eight years and who worked on the voussoirs and portals', that is, who reached the top of the great western portals; and lastly Bernard de Soissons, who was in charge of the work for thirty-five years and who 'completed five vaults', probably of the nave, and 'worked on the O', that is, the rose window on the western façade. From a document signed by Bernard as Master of Notre-Dame in 1287, and from the fact that the foundation stone of the cathedral was laid in 1211, we can calculate the approximate dates of these Masters: Jean d'Orbais, 1211–31; Jean le Loup, 1231–47; Gaucher, 1247–55; Bernard, 1255–90.

The length of service of, and the principal parts of the church built by, various named architects were thus recorded for posterity in an elaborate memorial, laid out probably in about 1290, when a fifth master, not recorded in the labyrinth, took charge. The memory of Master Robert de Luzarches, his successor Master Thomas de Cormont, and Thomas's son Master Regnault, was celebrated in a similar inscribed labyrinth at Amiens Cathedral. Notre-Dame in Paris and the cathedral of Clermont contained simpler inscriptions preserving the names of thirteenth-century architects. At Strassburg, over one of the west doors, there was formerly an inscription stating that the giant façade [27] had been begun in 1277 by Master Erwin von Steinbach. There is perhaps brevity in all these inscriptions, but the inscriptions, and the fame and honour they imply, were there.

Of course this fame and this honour have definite limitations. We cannot pretend to know about Jean d'Orbais or Robert de Luzarches in the way we know about, say, Brunelleschi or Bramante. What we know, in fact, about Jean d'Orbais consists of his name, and as much as can be discerned from the actual plan and growth of Reims Cathedral. The

personalities of medieval artists are not substantiated and expanded, like those of Renaissance and post-Renaissance artists, by the recommendations of biographers. In the Middle Ages the art of biography, factual and interpretative, was applied solely to a special kind of hero, the Saint. In the age of Humanism, when in all branches of activity human personality had come to be regarded as important and interesting quite outside any scheme for the supernatural regeneration of mankind, the hagiographical method was freely applied to poets, architects, painters. So we find an official life of Michelangelo, where before we found an official life of St Francis.

The medieval attitude to the artist was less or more mature and healthy, according to our own lights. The artist was at any rate taken more for granted. He belonged to the normal and accepted order of things. Artistic creation, while recognized as involving admirable skill and learning, was not yet equated with the self-expression of an excelling mind. In an age when even the commanding rôle of a king was hedged about and restrained by traditional attitudes, an artist could not regard his art as his own peculiar prerogative. Just as a judge would try to clarify the law, apply it well and faithfully, and not impose his will upon it, so the medieval artist developed and expounded a fundamentally traditional form of art, and left us no hint of his having a personal axe to grind. For all that, faced by the inventiveness and nobility of Gothic forms and the scope, complexity, and striking-power of Gothic imagery, we cannot suppose that the medieval artist was any less capable, exacting, or professional, than his more self-conscious successors in later centuries.

From sober factual records of outstanding exponents of architecture in the thirteenth century let us turn to a revealing account of a fictional artist written by the twelfth-century poet Chrétien de Troyes. The artist, who is called John, plays a leading part in Chrétien's Romance *Cligés*. Basically John is the familiar folk-tale character, the faithful servant who guards and aids his young master by the exercise of supernatural powers. Chrétien has rationalized both aspects of this character, the faithful servant, the powerful magician. In the first place, John is a serf, standing at the bottom of the feudal hierarchy, bound in servitude to his master, who can give him away or sell him like a chattel. But, in return for help in a certain perilous undertaking, Cligés will set him and his heirs free.

The medieval serf's great aim in life was, of course, to jump up into the freeman class. Then, in the second place, John is an artist whose skill and ingenuity amount almost to sorcery. To advance Cligés' schemes, he constructs a marvellous tomb in which the emperor's wife, Cligés' mistress, feigning death, is preserved from harm. He builds a wonderful tower full of cunningly concealed apartments, splendidly decorated, where the lovers can live unsuspected and undisturbed. Cligés boasts thus about his serf's talent and fame:

> There is no land where he is not known by the works which he has made and carved and painted. There are no arts, however diverse, in which anyone can vie with him, for compared with him they are only novices and nurslings. It is by imitating his works that the artificers of Antioch and Rome have acquired what skill they have

The modern reader finds John's international reputation and his depressed social status too obviously discrepant. One surely could not command the world's art market when one was liable anytime to be sold oneself! Chrétien's characterization of John falls, clearly enough, into two parts. One part reflects observable facts or accepted social values in the poet's immediate environment, the other reflects a literary ideal. This literary ideal goes back ultimately to classical antiquity. The notion of the superlative artist is found, for example, in the famous chapters on the fine arts in Pliny's *Natural History*. Pliny says that the Greek painter Apelles

> excelled all who came before or after him. He contributed more to painting than all the others put together His style was quite outstanding, despite the fact that the greatest artists were living at the time.

Euphranor, too, 'far excelled all others'. As well as being a painter he produced sculpture in bronze and marble, statues and reliefs. 'Receptive and industrious, he showed equal talent in all kinds of work.' Chrétien is evidently following classical precedent in setting no limit to John's skill and reputation. But Pliny tells us that drawing, or painting, was so highly regarded throughout Greece that

> at all times the freeborn practised it, and by a permanent prohibition no slave might be instructed in it. For this reason neither in painting nor in statuary are there any celebrated works by artists who had been slaves.

So in the matter of John's servitude Chrétien breaks sharply with the traditions of the ancient world and speaks instead of a world he knows at first hand.

Sometime between 1082 and 1108, while the Abbot Gérard ruled the monastery of Saint-Aubin at Angers in north-western France, the abbot and monks made an agreement with one Fulk, a man well versed in the art of painting (*pictoris arte imbutus*). The terms of this agreement were recorded in the cartulary of the abbey. Fulk was to decorate the entire monastery with paintings, execute whatever was prescribed by the community, and make stained-glass windows. In return for these services he was to quit his serf's status for that of a freeman, and was to be allowed life-possession of a house and a vineyard. If he had a son who knew that art and could serve Saint-Aubin in the same way, then at Fulk's death the son would succeed him. I have included among the illustrations in this book a leaf from a Romanesque illuminated manuscript, as an example of the harsh and mannered style which held the field before the rise of Gothic art [14]. The manuscript is a *Life of St Aubin* made for the monastery at Angers round about the end of the eleventh century, when Fulk was artistic factotum there. Not impossibly Fulk painted it. At any rate, it represents the style in which he must have worked.

In Fulk we have a real-life equivalent of Chrétien's serf-artist. Within the rigid social system and general uncertainties of life of the early Middle Ages, Fulk's artistic ability was clearly an important asset. With it he could bargain his way up out of servitude, enfranchize his heir, gain security and a house, and make an honourable contribution to that pre-Gothic civilization whose focal-points were the monasteries.

In confining his imaginary artist to the lowest levels of society, Chrétien was thinking in Romanesque terms, as we see on the analogy of Fulk. By making John a famous master, supreme in all the branches of art, he was thinking in classical terms. But we might venture to say that he was also thinking Gothically, for a number of later medieval writers were to celebrate real artists of the Gothic period with similarly hyperbolic tributes.

We find a striking parallel for John in his rôle of peerless executant in the famous *Chronicles* of Jean Froissart, under the year 1390. Froissart tells us that Jean de Berri, one of four royal brothers of whose sumptuous patronage I shall have

more to say in a later chapter, retired for three weeks to his castle at Mehun-sur-Yèvre near Bourges and there spent the time discussing new works of art with the manager of his works in sculpture and painting, Master André Beauneveu. The duke, says Froissart,

was always full of schemes for sculpture and painting, and he was well advised. For this Master André . . . had no superior or equal in any country, nor has anyone else so many fine works remaining in France, or Hainault, where he was born, or the kingdom of England.

Then again, around 1400 a monk of St Albans Abbey, Thomas Walsingham, uses a very similar form of words in his eulogy of a distinguished predecessor, Dom Matthew Paris, who lived in the thirteenth century.

He had such skill [writes Walsingham] in the working (*sculpendo*) of gold and silver and other metal, and in painting pictures, that it is thought that there has been none to equal him since in the Latin world.

Remembering the words of Pliny on Apelles and Euphranor we can see that in these medieval 'best in the world' tributes we are dealing with conventional evaluations, the-thing-which-it-is-customary-to-say about an artist. But of course it is significant that the convention was in vogue at all. Mastery in the visual arts, personal accomplishment of that order, was evidently regarded as worth writing about in northern Europe in the Middle Ages, even if it was written about in clichés. Then again, such positive affirmations of skill and *identity* were hardly likely to be made about nobodies. Conventionally exaggerated as they are, they doubtless bear some relationship to what medieval men expected of an artist and to what the writers knew to be true in individual cases. And in fact when we turn from praise-formulae to the historical Matthew Paris and André Beauneveu we can see that Chrétien de Troyes, in emphasizing the sheer professionalism of John, accurately enough anticipated the kind of artist who made the churches, tombs, paintings, palaces, and all the other monuments of the Gothic age.

No one was able to match John in any art, however diverse, said Chrétien. It is noteworthy that the eulogies of Paris and Beauneveu credit them with mastery in both painting and sculpture. Other sources of evidence tend to confirm their versatility. Paris, who became a monk at St Albans in 1217 and

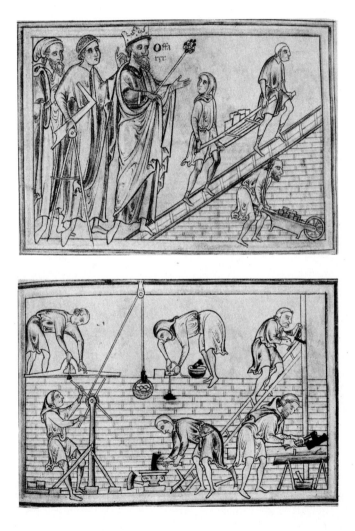

3, 4. The building of St Albans Church,
from Matthew Paris's *Life of St Alban*

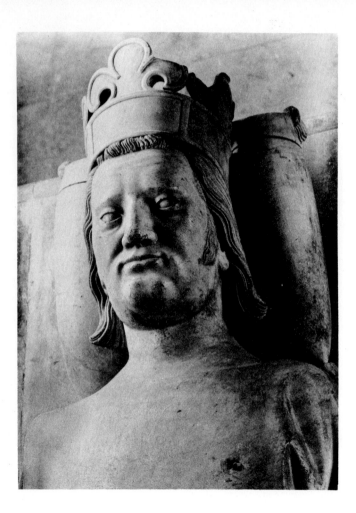

5. Effigy of King Philip VI of France, Saint-Denis

died in 1259, was an historian of prime importance. He was also an exceedingly prolific and lively illustrator of his own chronicles and of Saints' Lives. I reproduce two typical drawings by him, from his *Life of St Alban,* now in Dublin [3 and 4]. On the fly-leaf of this manuscript are some notes in Paris's hand:

G., send please to the lady Countess of Arundel, Isabel, that she is to send you the book about St Thomas the Martyr and St Edward which I translated and illustrated, and which the lady Countess of Cornwall may keep until Whitsuntide.

In the Countess of Winchester's book let there be a pair of images on each page, thus. . . [There follow verses, in pairs, to which the pictures will refer.]

These casual jottings reveal the sort of people to whom Paris's fluently inventive draughtsmanship was personally familiar. Obviously he was well-known in Court circles as an artist.

In Paris's day the precious metalwork produced at St Albans Abbey enjoyed a high reputation. The creation of the shrine of the famous martyr of Canterbury, St Thomas à Becket, was entrusted to a monk of St Albans, Walter of Colchester, who died in 1248. Walter also made magnificent metalwork ornaments for his own monastery. King Henry III was so much impressed by a beautiful lectern which he saw during a visit to St Albans that he commissioned a replica for the chapter house at Westminster Abbey. Though there is not contemporary evidence pointing to Matthew Paris as an important sculptor, it is quite likely that he would be acquainted with the techniques of carving and casting. He may himself have made the silver cup which is listed among his many gifts to St Albans.

There is no doubt at all about the range of André Beauneveu's talent. His career can be traced in royal, princely, and municipal accounts and other records throughout the second half of the fourteenth century. In 1364 he was in charge of work on four royal tombs ordered by King Charles V of France [5]. He produced important sculpture at Ypres, Malines, and Courtrai. In 1394 he received payment for painting in gold, azure, and other colours in the chamber of the Market Hall at Valenciennes. By 1386 he had entered the service of Jean de Berri, and an inventory of the duke's manuscripts drawn up in 1402 refers to a psalter 'very richly illuminated, in which there are

many picture-leaves [*ystoires*] at the beginning, by the hand of Master André Beauneveu' [6]. Beauneveu was thus sculptor *and* painter. In addition he was consulted about architectural projects at Courtrai and Valenciennes. The ideal of versatility was certainly realized in him.

The readiness to practise many arts concurrently is notably exhibited by Villard de Honnecourt, a contemporary of Matthew Paris, whose handbook, compiled for the instruction of apprentice cathedral builders, is one of the great treasures of the French National Library. When he sorted his notes and drawings into book form, Villard must have been a master-architect, head of a building-lodge. No doubt every medieval master-architect kept some such album of sketches, draft-schemes, architectural and other recipes. For example, Gerhard, the builder of Cologne Cathedral [7], must have kept by him notes and drawings made at Amiens and Paris, Saint-Denis and Beauvais, on the basis of which he worked out his own monumental design. But only Villard's book has survived.

Villard came from the region of Cambrai, just south of Beauneveu's home town of Valenciennes. He mentions in one of his notes a journey to Hungary, and he includes among his drawings a window seen by him at Lausanne. He visited Chartres. He saw Laon Cathedral and made drawings of one of the towers, because it seemed to him remarkable [26]. 'I have been in many countries, as you can tell from this book, but I have never seen another such tower', he writes, expressing the impact of Gothic art on a Gothic artist. He came to Reims during the régime of Jean le Loup, and drew various parts of the cathedral which were then standing, annotating his drawings with first-hand description and comment [8]. Naturally his drawings of architecture are not views, contemplative and romantic, but working-drawings, clean and energetic. He was thoroughly at home in the architectural idiom of his day, and unhesitatingly captures its essential breadth, still so purely balanced by vigorous detail. Besides his superb records of elevations and sections, he experiments with ground plans, and also illustrates mouldings, cleverly designed timber structures, and various pieces of practical machinery. All these things, we would say, appertain strictly to his character as architect. But his book also contains drawings of heroic draped figures, which are apparently exemplars for monumental stone statues [9]. His drawing of a magnificent lectern ornamented with figures, of richly embossed fruit and foliage, and

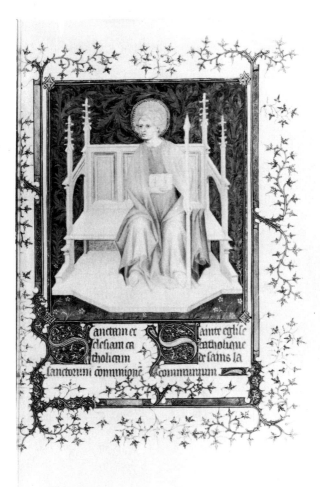

6. *St Thomas* from a psalter of Jean Duc de Berri

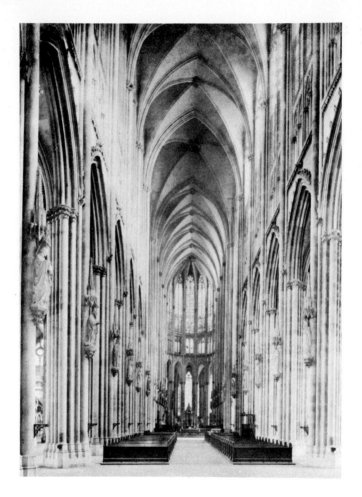

7. Interior of Cologne Cathedral

8. Drawing of elevation of Reims Cathedral by Villard de Honnecourt

Veeis bien a cest mometet le cueuat le nauure le oueuat deskauneuf voit auer note sur leu retiaucus et de sur le cotile deskauneuf se voit auer note de uant les eskarnes et un vas esteut si eime vos voez en le pourceurauit de uaue voez en le meof de uos places dauer auer auglees et buzzates et de uant arf buzzates et de uant le gut auer vos auer sommes et oueuat de sur leu remaunee ben iqui aler pur voit de fut et en lemaunelmet les uokerd por leue seni

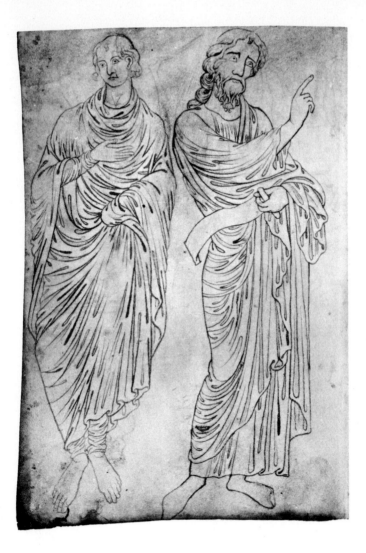

9. Drawing of an apostle and a prophet by Villard de Honnecourt

of fantastic animals, self-evidently await transformation into bronze or carved wood. Where schemes for sculpture give way to plans for paintings and miniatures is difficult to decide. His strenuous, hunched, sleeping Apostle and his man mounting a horse [39], his figure-groups, and his occasional sketches are at any rate all drawn with the authority of a great draughtsman.

Gothic artists such as Villard and Beauneveu, with their interests and gifts embracing architecture, painting, and sculpture, suggest something about the nature of Gothic art itself. Gothic is a style in which we are likely to meet with elaborate ambitious projects that aim at a kind of representation or expression beyond the scope of any single art. I have mentioned Jean de Berri's castle at Mehun-sur-Yèvre, where Beauneveu was established as artistic director. By 1393 it was so famous and resplendent that Philip the Bold, Duke of Burgundy, sent his own painter and his own sculptor to study 'the works in painting, figure sculpture, and carving' to be seen there. Froissart calls the castle of Mehun one of the most beautiful houses in the world, an opinion certainly borne out by an early fifteenth-century picture of it [10]. Sculpture and architecture are here inextricably mingled, not just because the designer made use of leafy pinnacles and gables and a lavish display of statuary but because the whole building has an overwhelmingly tactile quality, with its sudden changes of plane and texture and its massive bands of rippling crenellation. Colour, especially gilding, evidently played its part in the external glamour of the place, though the painter's real chance would come inside, and would extend to glass and tapestries. The perfect fulfilment of John's wonderful tower in the old Romance, this faery palace, summoned up by means of all the visual arts in unison, provides us with one norm of Gothic art. The other is provided by that more awesome and disciplined assemblage of masonry, carving, and colour – the cathedral of Chartres, erected in Villard de Honnecourt's time as the image not of a faery palace but of a celestial one [11].

The age of the Renaissance was to inherit from the Middle Ages the ideal of the omnicompetent artist, able to plan and devise all aspects of some great enterprise, ready to turn his hand to half-a-dozen tasks. When we read the famous letter in which Leonardo da Vinci offers his services to Duke Ludovico Sforza, his cold conceit and the dreadful, Machiavellian, level tone in which he speaks of his ingenious weapons of war may persuade us that we have really entered a new phase in the

The following text appears within the illustration:

nnmca .i.quadrage
ftuocauit mefunt.
cc cgo craudiam cu
capiam cum ct glo

nficabo cum longitudic
dicum adimpleco cum.
lu hirac mad psst
iuconio alaffimu in pzo

10. *The Temptation of Christ* from
Les Très Riches Heures of Jean Duc de Berri

history of mankind. But we are on familiar enough ground
when we find him offering to give satisfaction in architecture,
to carry out sculpture in marble, bronze, and clay, and to 'do
in painting whatever may be done, as well as any other'. In
his letter of self-introduction Leonardo casts himself, as it
were, in the rôle of the magical servant. When he says that he
will show his Lordship his secrets, offering them to his best

pleasure and approbation, he sounds exactly like John broaching the matter of his wonderful tower to the astonished Cligés. Then again Leonardo helps us to realize that no very violent revolution has taken place in the economics of art and the status of the artist as we move from the Middle Ages into the age of the Renaissance. Leonardo is in search of settled employment, ready to trade his skill for a pension, no less than the Romanesque artist Fulk. Saint-Aubin's gave Fulk a vineyard sometime around 1100, and Duke Ludovico gave Leonardo a vineyard in 1499! The artist in service, whether in the Renaissance or the Middle Ages, may strike us as an

11. South transept of Chartres Cathedral

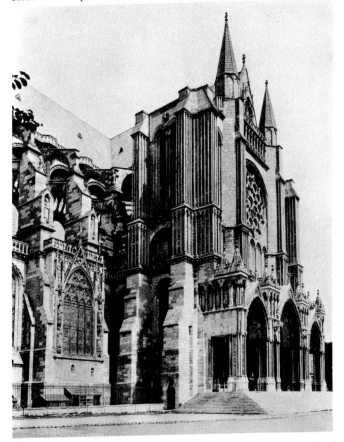

incongruous idea. It clashes with Romantic notions of the Artist as Rebel and of the essential liberty of artistic genius. Among the giants of the High Renaissance Michelangelo always comes off best nowadays because he is regarded as uncooperative, frustrated, and moody. The superb efficiency of Raphael is unfashionable.

It is certain that in the Gothic period the artist was in no sense freelance. Often we find him attached as servant to the person of his patron. Jean de Beaumetz, the painter whom the Duke of Burgundy sent to view the works at Mehun in 1393, was the Duke's '*valet de chambre*'. The same title was given to Pol de Limbourg, the artist who, along with his brothers Hennequin and Hermant, painted Jean de Berri's most famous manuscript, *Les Très Riches Heures* [10 and 77]. Certain Gothic artists emerge as fully-fledged civil servants, officers through whom art is done, just as there are officers through whom justice is done.

The English royal accounts called Close Rolls, for the year 1256, contain the following entry:

> Because the King has suffered much damage through causing his [building] works to be carried on by Sheriffs and other officials, the King provides that Master John the King's mason, and Master Alexander the King's carpenter shall cause those works to be done for the future by task or otherwise and shall see to them and dispose of them personally for the better commodity of the King. And because they cannot labour at this at their own expense, the King wishes their wages, while journeying in connexion with the said works, to be doubled.

This Master John, of Gloucester, was the second Master in charge of the construction of Westminster Abbey [36]. In 1253 he succeeded Master Henry of Reynes, as Jean le Loup succeeded Jean d'Orbais at Reims. Master Henry received a gown of office as Master of the King's masons in 1245. Matthew Paris's drawing from the *Life of St Alban* [3], which shows the eighth-century King Offa of Mercia visiting the new church at St Albans, helps us to visualize King Henry as he toured the building-site at Westminster with his executive officer Master Henry, the latter equipped with square and compass like Hugues Libergier on his tombstone.

The Romanesque serf-painter's agreement to serve Saint-Aubin all his days in exchange for certain benefits, represents the give and take of primitive feudal society. The transactions between Gothic artists and their employers were made in a

more complex and dynamic society, where wealth and power depended more and more on expanding trade, and where the old customary relationships were subjected to all sorts of strains. Yet the bond between artist and patron in the Gothic age is still fundamentally feudal. The artist expends his best skill in return for favour and support. His art may be interpreted as a labour-service, such as the medieval villein owed his lord. The work done is the patron's due. It appertains to him for whom it is done rather than to him who does it. Thus Jean de Beaumetz went to Mehun to see certain 'works in painting, figure sculpture and carving *which Monseigneur de Berri had had made*' Of course the patron was not indifferent to the quality of service offered to him. His artists have their place in his purse, his regard, perhaps in his inventory of treasures. The 1402 Berri inventory, in listing the Beauneveu Psalter, calls the illumination 'very rich' and records the illuminator's name. But the Psalter itself, now in the National Library in Paris, is not signed by Beauneveu. It is simply inscribed as belonging 'to Jean, son of the King of France, Duke of Berri'. The owner's ownership is not obtruded upon by the maker's name. Similarly a splendid early thirteenth-century psalter at Chantilly, illuminated in a style close to that of Villard de Honnecourt, is not signed by the artist, but is identified as belonging to the Queen of France, Ingeburg, by the presence in the preliminary calendar of various dates and entries of personal interest to her. It is entirely fitting that this manuscript is famous as the Ingeburg Psalter [12].

King Richard II of England, a contemporary of Jean de Berri, rivalled him in his magnificent and fastidious cultivation of the arts. One of the masterpieces of Gothic painting, the so-called Wilton Diptych now in the National Gallery, London, represents Richard, accompanied by his patron saints, kneeling before the Virgin, who stands on a flowery meadow holding the Christ child and attended by eleven eager angels wearing crowns of roses [13]. These exquisite panels are the work of a master of high technical skill and sensibility. Unfortunately no contemporary document, inventory, contract, or record of payment relating to the Diptych has survived. We do not know who painted it, for it is unsigned. This lack of signature seems inevitable, for the Diptych is all Richard's. A shield with his arms is painted on the reverse of the right panel and a white hart, his heraldic animal, is painted on the reverse of the left. The king wears

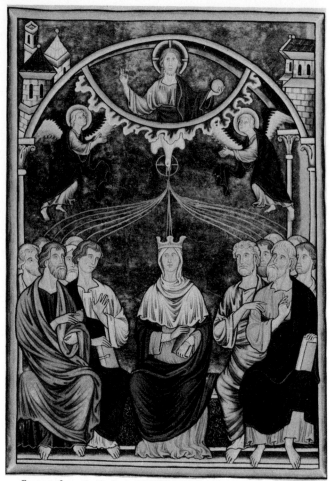

12. *Pentecost* from the Psalter of Queen Ingeburg

his emblems and devices, the collar of broom-cods and the badge of the white hart, and more harts and broom-cods are woven into his golden mantle. Each of the eleven angels in the right panel displays the king's badge of livery, exactly like the armed retainers whom Richard, on a famous occasion in 1397, stationed menacingly around his assembled Parliament. Thus even the angels are drawn into Richard's orbit, bound to his personal service. Having marked the entire Diptych with

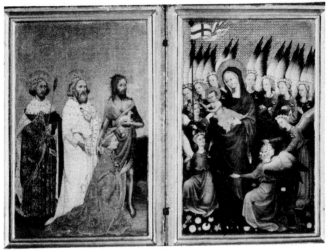

13. The Wilton Diptych

ostentatious marks of ownership, the master-painter has done his loyal duty, and declines to identify himself.

The beauty and the lively charm of the Wilton Diptych presumably reflect the patron's delicacy of mind. A patron's taste and temperament are bound to affect the works which he orders to be made. Sometimes his general outlook may control the whole visual character of a work, as for example when the modest and ascetic Henry VI lays down in his so-called Will of 1448 respecting his foundation of King's College, Cambridge:

> I wol that the edificacion of my same College procede in large fourme clene and substancial, settyng a parte superfluite of too gret curious werkes of entaille and besy moldyng.

A patron may further define a new project in advance by pointing to models upon which it is to be based. At Henry VI's orders various features in the design of Eton College Chapel, twin foundation with King's, were copied from earlier churches. Back in 1242 Henry III ordered that the chapel at Windsor Castle be decorated with scenes from the Old and New Testaments, on the pattern of the scenes painted in the Bishop's castle beside Winchester Cathedral. Henry III, like his contemporary Villard, had gone about collecting impressions, giving this or that his approval, with consequences for the future. Then also the patron's thought might take a speculative

turn. As we have seen, Froissart says that Jean de Berri was always full of schemes for sculpture and painting, in the execution of which he had the help of Beauneveu. From entries in the Close Rolls relating to works of art ordered by Henry III, it is clear that this great thirteenth-century patron had one principal advisor and agent, Edward son of Odo the Goldsmith, a man who had succeeded his father in the king's service much as the hypothetical son of Fulk was to do back in the more constricted cultural environment of Saint-Aubin's Abbey. Edward's rôle of aider and abetter is vividly brought out in one directive from King Henry:

We remember that you said that it would be much grander to make the two leopards, to be placed on either side of our new chair at Westminster, of bronze rather than of marble or carved. So we command you that they shall be made of metal...

There is, however, little doubt that in Henry's artistic projects the chief creative and driving force was the king himself. The records of his commissions often contain a note of urgency, almost of impatience, as if he could hardly bear to wait for a work, once conceived, to be actually executed. His bedroom and state chamber in the Palace of Westminster contained an incredibly lavish programme of murals; an armed knight, life-sized, guarding the king's bed; a large picture representing the coronation of St Edward the Confessor; a series of personified virtues – *Largesce*, *Deboneret*, and so on – each a crowned woman seven feet high, trampling their enemy vices underfoot; and, most spectacular of all, running the eighty-foot length of the room, band above band of 'all the warlike stories out of the Bible'. Two Franciscan friars who visited this chamber in 1332 were full of wonder at its 'royal magnificence'. These paintings, and the host of others in the royal palaces scattered across the country, were an expression of the king's own mind, his attitudes, interests, and ideals. Certain themes turn up again and again. There are occasional touches of irony in the choice of subjects, which are completely personal. The great images, suave, meticulous, and gilded, with which he surrounded himself at Westminster, were as much his creation as that of the men who handled the brushes and paints, for they celebrated Kingship, its responsibilities, its trials, and its sacred honours, and in his long reign Henry experienced every hazard as well as every consolation of his office.

The patron as brains and heart, director and enthusiast, of a great new work of art is nowhere more apparent than in the first major project to which the name Gothic can be attached, the abbey church of Saint-Denis [21]. As a boy Abbot Suger had stared at the ominous cracks in the walls of the dark old monastic church. As soon as he got the chance, he had the walls repaired and painted with the finest colours. But the old-fashioned workmanship of Fulk and his kind no longer satisfied Suger. His mind was on the move, revolving thoughts of the treasures and famous monuments of Byzantium, Jerusalem, and Rome, and thoughts too of a kind of building that had never been seen before, full of uninterrupted light and the beauty of length and breadth, mounting loftily and fitly in the service and praise of God. He called together workmen and artificers from far and wide. In his account of the construction of the church he never mentions any of these by name, and by country he only identifies the goldsmiths from Lorraine. But his was the personality which dominated the rapidly advancing work, not just because he had planned the financial side with military precision, not just because he lay awake brooding about other practical problems which he solved on getting up next morning, but because he was aware of an over-mastering *reason* for building and had a total conception of the principles to be expressed in the new church. His ideas about the purpose of art, practically exhibited in a brilliantly integrated artistic monument, eddied out from Saint-Denis across all Europe. No artist ever had more right to inscribe his own work than Suger had to place these words on the west front of the abbey:

For the splendour of the church which fostered and exalted him,
Suger has laboured for the splendour of the church . . .
The year was the one thousand, one hundred, and fortieth
Year of the word when the structure was consecrated.

*

As we saw earlier in this chapter, the monk of St Albans, Thomas Walsingham, writing around 1400, declared in a fine flush of local patriotism that the thirteenth-century artist Matthew Paris was thought to have had no equal since in the Latin world. Between the 1250s and 1400 'the Latin world' did in fact contain among others the great Florentine painter Giotto and the great Pisan sculptor Giovanni Pisano [40, 41, 43, and 75]. Their names are well known, easy to place in the

history of art. They stand at the beginning of that sequence of notable men and noble achievements which continues triumphantly right up to the High Renaissance. It is as precursors of the Renaissance that they are presented by the distinguished sixteenth-century critic and historian Giorgio Vasari, whose *Lives of the Artists* has been for centuries a standard text-book on the central events in the history of Western art.

In 1334, late in Giotto's lifetime, an anonymous Florentine scholar wrote:

> Giotto was, and is, the most eminent among the painters known to men, and he belongs to this same city of Florence; works of his testify for him, at Rome, Naples, Avignon, Florence, Padua, and in many parts of the world.

We have met such sentiments before, and the Florentine writer was probably no more and no less committed in his use of the conventional praise-formula than were Chrétien de Troyes, Thomas Walsingham, and Froissart. But in the Latin inscription placed below the narrative reliefs in Giovanni Pisano's huge carved pulpit in Pisa Cathedral, completed in 1310, we are confronted by a new phenomenon in the history of Western art – new, at any rate, since the passing of classical Greece and Rome.

The inscription describes Giovanni as

> endowed above all others with command of the pure art of sculpture, sculpting splendid things in stone, wood, and gold. He would not know how to carve ugly or base things even if he wished to. There are many sculptors, but the honours of praise belong to him

Suddenly the praise-formula has been transformed. For it is *self*-praise that we have here. Giovanni placed the inscription on his own pulpit. He has filled out the familiar cliché with personal conviction, and made it into a resounding challenge which echoes down the centuries.

Literally so, for when in the sixteenth century Vasari came to write his authoritative history of art he took the Pisa inscription, as well as the 1334 commendation of Giotto, as simple statements of fact. Vasari composed the *Lives* in the age of Michelangelo, when Europe, as far as the visual arts were concerned, was well on the way to becoming a cultural province of Italy. Vasari was naturally disinclined to question written evidence of Italian ascendancy in an earlier period.

Consequently in his biography of Giovanni Pisano and his father Nicola Pisano he hardened the pretensions of the Pisa pulpit inscription into art-historical dogma, affirming that Nicola and Giovanni 'were the foremost masters in Europe of their time, so that nothing of importance was undertaken without their having a share in it. . . '. It follows that where they had no share, nothing of importance was undertaken. Vasari's remarks might well make an Englishman at Westminster Abbey, or a Frenchman at Reims, or a German at Naumburg, feel culturally inferior!

Vasari's tastes, ideas, and preconceptions were characteristic of the Italian Renaissance. He exhibits the normal Renaissance enthusiasm for Greek and Roman art, and makes it clear that art as practised in Italy from the Early Christian period up to the thirteenth century repelled and bored him. The first biographies in his book are those of thirteenth-to-fourteenth-century artists who showed, however inadequately by later standards, a renewed appreciation of the formal values of antique art. This renewal Vasari regards as having come about either spontaneously or through divine intervention.

It was nothing short of a miracle, [he says] in so gross and unskilful an age, that Giotto should have worked to such purpose that design, of which the men of the time had little or no conception, was revived to a vigorous life by his means.

The disfavour and obscurity into which our great heritage of medieval art sank in the seventeenth and eighteenth centuries was due, at least in part, to these over-hasty and partisan conclusions.

Today we can see that while Giotto and Giovanni Pisano were truly pioneers of the Renaissance, their work also represents the special Italian variant of the contemporary northern Gothic style. We know now that Giovanni Pisano had travelled in France or had otherwise felt the stimulus of French and perhaps even of English and German, thirteenth- and fourteenth-century art. Giotto and Giovanni Pisano become all the more interesting and remarkable for having an intelligible cultural context. They shed light on the nature of Gothic art and Gothic artists precisely because they were so intimately involved with both. Giotto in particular provides us with a standard by which to evaluate the qualities inherent in early Gothic, and further to evaluate the lines which Gothic artists chose to follow in the later Middle Ages.

Looking back at the dark times, as he regarded them, before Giotto had appeared to illumine the artistic scene, Vasari remarked that he had examined many buildings, as well as many sculptures of those times,

but I have never found any memorial of the masters, and frequently not even the date when they were created, so that I cannot but marvel at the simplicity and indifference to fame exhibited by the men of that age.

We have seen that a quantity of useful information about medieval artists, many names, dates, inscriptions and comments, has in fact survived – and as scholars come to learn more about medieval working conditions and methods, it may be possible to interpret yet other documents which still remain obscure or ambiguous. But by and large the Gothic artist has hidden himself from us, behind his perfectly poised and ceremonious creations. In the matter of 'simplicity and indifference to fame', Abbot Suger has a typical and useful word to say. In his record of the stirring events of his administration of Saint-Denis, he declares that his resources were insufficient for the great work which he had undertaken, just as Solomon's were when he began to build the temple in Jerusalem. But now, as then, God was the Author and he supplied funds, men, and materials. '*Identitas auctoris et operis sufficientiam facit operantis*: The identity of the Author and the work provides a sufficiency for the worker.'

2

Unity, Peace, and Concord

In Book Five of his treatise *De consideratione*, completed in 1152, St Bernard of Clairvaux contrasts the unity of the Three Persons of God with other lesser kinds of unity. First in his list is the unity which he calls 'collective, as for example when many stones make one heap'. And second is the unity which he calls 'constitutive, as when many members make one body, or many parts constitute one whole'. During the first half of the twelfth century the principle of collective unity as the basis of artistic composition was replaced by the principle of constitutive unity, and as a result the Gothic style was created.

The artistic style which dominated north-west Europe around the year 1100 is represented by a picture in a manuscript of the *Life of St Aubin* written and illustrated in his monastery at Angers [14], and by the oldest parts of the priory church of La Charité-sur-Loire [15]. The picture from the Saint's *Life* shows a party of Norman marauders sailing out to sea after their miraculous rout by the saint. The artist achieves compositional unity by the mere accumulation of aggressively distinct parts, the seven wavy bands which make up the mound of water, the four curved timbers of the hull of the boat, the eleven oval shields, the eleven brutally square faces of the soldiers, their thirty-four vertical spear-shafts, their innumerable domed helmets. The artist's style is vehement, schematic, repetitive, and inhuman. His picture brings vividly to mind St Bernard's example of collective unity, separate stones placed in a heap. The designer of the choir of La Charité shows this same tendency to think in distinct units which he accumulates but does not integrate, the massive semi-dome and barrel vault above, the firm chunky columns below, crowned by tight arches. These columns and these arches belong to the same visual world as the Norman pirates' cramped menacing array of spears.

Into this visual world of stiff and congested forms there entered in the early years of the twelfth century the powerful influence of Byzantine works of art, imported either directly

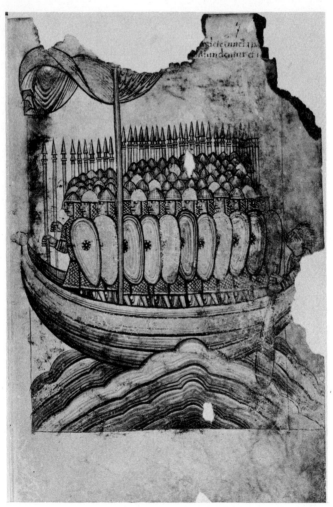

14. Norman pirates from a manuscript of the *Life of St Aubin*

from Constantinople, which in those years was thronged by
Western diplomats and pilgrims, or from the Byzantine cultu-
ral province of southern Italy. Byzantine art, hieratic, schema-
tized as it was, retained in its treatment of the draped figure
that sense of the human body as an organism which character-
izes classical sculpture. The introduction of Byzantine works
into the West had two effects. Byzantine models were copied,

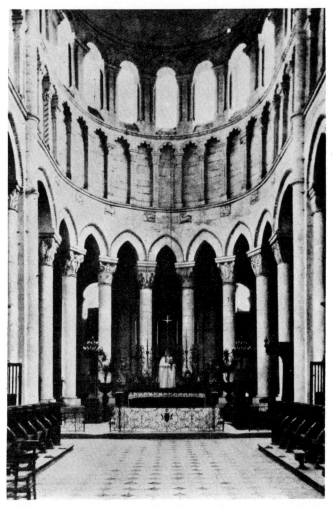

15. Interior of the priory church of La Charité-sur-Loire

and older Western artistic traditions, which themselves ulti-
mately reflected the principles of antique art, came again to
be admired and imitated.

An elaborate representation of Isaiah's prophecy about the
Tree of Jesse (*Isaiah,* xi) painted in the first quarter of the
twelfth century at the Abbey of Cîteaux is typical of the art
produced in the West under direct Byzantine influence [16].

It shows its dependence on a Byzantine model not only in the Greek title of the Virgin, Theotokos, inscribed beside the Virgin's head, but also in the calm humanity and naturalism of the figures, the realization of the bulk of the living body beneath the formalized draperies. In the great bronze font of St Barthélemy at Liège, cast by Rainer of Huy between 1107 and 1118, the immediate stimulus of Byzantine art is seen reanimating the classical traditions established long before in Carolingian Aachen and Reims [17].

6. *The Tree of Jesse* from a Cîteaux manuscript

7. Bronze font by Rainer of Huy, Liège

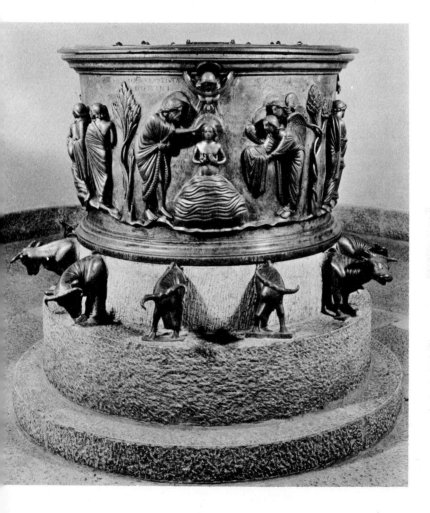

Rainer's monumental figures move with a noble gravity and are displayed in varied attitudes, sometimes even turning away to present their backs to the spectator, their draperies, richly pliant as in the old Reims manuscripts, drawn across the well-realized substance of the human body. The beautiful trees, carefully differentiated in shape and foliage, the realistic swing and lurch of the heavy bodies of the twelve oxen which carry the font on their backs, above all the casual normality of the human figures, remarkably anticipate the greatest achievements of Gothic sculpture. Rainer of Huy was a peculiarly gifted individual, but his, and his generation's, desire to represent the human figure as substantial and organic, not simply as a schematic aggregate of arms and legs, head and trunk, inert or capriciously twitching, marks the beginning of a general change in the aims of Western artists.

This general change was not brought about solely or even chiefly by external artistic stimulus and the revival of neglected Western traditions. It was the result of a great revolution which altered all aspects of life in western Europe in the eleventh and twelfth centuries. The new line of thought can be seen in a letter written to the Patriarch of Constantinople by Pope Leo IX in about 1054. The pope refers to the Apostle Paul's image of the Church as the body of Christ, with many members, but one body. 'The composition of that body and of its members may teach us the nature and the extent of the unity which the Church ought to have.' This letter announces the programme for the reconstruction of Christendom to which the papacy devoted its energies for the next hundred and fifty years. The inhabitants, lay and clerical, of western Europe were to be transformed from a mere crowd into a community. By the great contest over the lay-investiture of bishops, concluded in Germany, its sharpest battle-ground, in 1122, the papacy made itself master of the Western clergy, freeing them from secular domination and mere local loyalties. The papacy took upon itself the moral leadership of lay society, suppressing the habit of destructive petty warfare by an appeal to Christian brotherhood, and channelling the military energies of the West into the Holy War for the liberation of Jerusalem. By means of the Crusades, papal authority encroached upon the ancient territories and responsibilities of the proud and independent Greek Church, and the ideal of Christendom as a territorial and doctrinal unity was advanced yet further. By the second quarter of the twelfth century the

clergy and laymen of western Europe, the right and left sides of the body of the Church, as a twelfth-century writer calls them, were effectively united to their directive head, Christ's Vicar, the pope.

In the treatise to which I have already referred, St Bernard quotes with approval some words written by St Paul about the nature of Christ's church on earth. St Paul represents it as from Christ, the Head,

fitly framed and knit together through that which every joint supplieth, according to the working in due measure of each several part, making the increase of the body unto the building up of itself in love [*Ephesians,* iv, 16].

These words are astonishingly apt as a description of the products of a great new age of Christian scholarship, initiated by Anselm at Laon Cathedral in the late eleventh century and continued principally in various schools at Paris by contemporaries of St Bernard – the famous masters Abelard, Hugh of St Victor, Robert Pullus, and Peter Lombard. The purpose of this scholarship was the clear exposition of Christian doctrine to the future bishops and clergy of France, and indeed of the whole of western Europe, Paris being now the recognized intellectual capital of the West.

The methods of this scholarship were revolutionary. Previous generations had merely allowed patristic and later commentaries on scripture to pile up, like the hallowed but unsifted archives of some great institution. Now the work of evaluation began. The commentators' doctrinal interpretations of scriptural passages were systematically arranged on the ground-plan of the Creed, so that what pertained to God the Father came first, what pertained to the general resurrection and the Judgement came last, with all else in between. Thus an intelligible shape was given to the whole accumulated tradition of Christian learning. Within this framework the opinions of the commentators on specific problems were compared and contrasted. Where they appeared to conflict, the twelfth-century master would either try to show how they might be reconciled, or would support one authority against another, or might even, with unheard-of boldness, advance his own solution of a problem. In general framework and in detailed discussion these books of *Sentences*, as they are called, are organic and unified, like the new disciplined coherent ecclesiastical polity of which they are one of the first fruits.

They are the work of men who combined respect for past authority with confidence in their own intellectual powers, and who felt it their duty to expound the Christian faith in such a way that its inner coherence was clearly revealed.

The consciousness of being the masters of their environment exhibited by the creators of the new *Sentence* literature is found also in the writings of the leading representative of the old monastic culture of western Europe. In 1137 Peter the Venerable, Abbot of the great Burgundian monastery of Cluny from which all the ideas implemented by the reforming popes of the eleventh century had originally issued, wrote a treatise exposing the errors of a heretical sect in southern France called Petrobrusians after their leader Peter de Brys. This sect preached a 'spiritual' religion, opposed to the whole material edifice of Western Christendom which was coming into being. Two portions of Peter the Venerable's treatise, those in which he defends, first, the building of material sanctuaries, and, second, the sacrament of the altar, shed light on the future development of art in western Europe.

Peter the Venerable was convinced that he lived in a time of fulfilment. 'Now is the hour', foreseen by the prophets and by Christ himself, 'when God is everywhere worshipped in spirit and in truth.' But to worship God 'everywhere' and 'in spirit' did not mean that religion was to be without material organization. Abbot Peter's arguments for the embodiment of Christian worship in certain hallowed locations and rites are based on history, and he defends modern practice in the light of ancient precedents, first Jewish, then apostolic. The Jewish patriarchs had built altars to God at God's command. These altars had later been replaced by the Temple in Jerusalem, God's chosen dwelling-place and point of contact with men until the full revelation of God in his incarnate Son. The single Temple in Jerusalem had sufficed for the Jewish people, who were few in number, but the vast Christian community needed many churches, this large number being fully sanctioned by the Apostles' practice of founding churches as they proceeded on their mission throughout the world. Though the churches were many they were united in one faith, one sacrifice, and formed one Church.

The Church differed from the Jewish Temple in that the animal sacrifices prescribed by the law of Moses had been replaced by the sacrifice of the flesh and blood of Christ, the unique Paschal lamb. The repetition of this sacrifice by the

Church fulfilled Christ's command that his disciples should not only 'take, eat' but also 'do this', and in addition the prophecy of Malachi that a pure offering would be presented to God throughout all the world. The purity of the offering in no way involved the rejection of a material setting. If a mere ox might only be sacrificed within the Temple, 'is the Lamb of God to be sacrificed in a grove or field, market-place or steading or stall?' The Jewish Temple was built, ornamented, consecrated, and ritually purified 'with the greatest care, for servile sacrifices'. The preparation of a worthy sanctuary for the shedding of Christ's blood was therefore the duty and privilege of Christians.

Furthermore the nature of the holy sacrament itself demanded, and as it were guaranteed, the validity of its material setting, for in it, as in the crucial historical event of the Incarnation, God accommodated himself to Man's physical nature and needs, and communicated his spiritual gifts through the medium of the senses. The sacrament of the altar bound the present world indissolubly to the eternal spiritual world, but in a fashion which did not detract from the present world but added to it a peculiar lustre.

The opinions about the material sanctuary expressed by Peter the Venerable find close parallels in the writings of Abbot Suger of Saint-Denis. In the same year in which Peter wrote his treatise against the Petrobrusians, Suger began to rebuild the church of his monastery near Paris. The new sanctuary of Saint-Denis is generally admitted to represent the first great monument of the Gothic style.

In the '*caput*' or chevet of his church Suger erected a remarkable stained glass window [18]. Illustrating a passage in Chapter xi of the Book of the prophet Isaiah, this window helps us to understand the character of the new art created at Saint-Denis.

A shoot shall spring from the root of Jesse and a flower out of his root. The spirit of the Lord shall rest upon him, the spirit of wisdom and understanding, the spirit of counsel and might, the spirit of knowledge and righteousness, and the spirit of the fear of the Lord....

– the seven gifts of the Holy Spirit. This was the most vivid of all Old Testament prophecies as to the nature of the Saviour of mankind. It asserted the humanity of the Saviour, but related to him the potent attributes of God. It dealt in organic terms, the

growth of a plant, with the historical emergence of Christ's body, that flesh which he took from his mother, and through her from the root of humanity, Adam. The fact that Suger placed this window celebrating the manhood of Christ in the '*caput*' of his church shows him thinking of the organic constitution of the Church on earth, a body united by its physical nature to Christ, the Head.

The Saint-Denis Jesse Tree was by no means the earliest version of the theme. During the first decades of the twelfth century many artists had felt its fascination and had tried to find a pictorial formula to express it. I have illustrated [16] an early Cistercian version in which the Tree of Jesse is not a true tree with a single stem having its roots in Jesse, but a stylized plant form, not even rooted in the ground but composed of two foliated strands which move apart and come together to form compartments for enclosed figures. In the lower compartment Jesse stands, steadying himself by gripping the side stems. Above him are the Virgin and Child, enthroned in a leafy mandorla. A single dove perches at the top of the tree. This, and every one of the other tentative pictorial formulae evolved in the early twelfth century, were taken into account, reconciled, and reconstituted in a single coherent image at Saint-Denis.

The brief vertical sequence of foliated mandorlas containing figures found in the Cistercian picture is extended by a perfect reconciliation with an alternative early formula, a straight-stemmed tree growing from Jesse's loins. At Saint-Denis the enclosed figures sit, like the Virgin in the Cistercian picture, but like Jesse in the same picture they grip the branches with their hands, and are securely placed within clefts of the main trunk. A primitive formula carved in about 1130 on a church façade at Poitiers, where Jesse's Tree springs from behind his neck, has been given a brilliantly common-sense application to the great vertical scheme of Christ's ancestors. The seven doves, representing the gifts of the Holy Spirit, which in the Cistercian picture are reduced to only one, and which in other primitive versions comprise the sole occupants of the Tree, are rationally, and theologically accurately, disposed in a half-circle about the head of Christ, who is raised up and enthroned as the logical consummation of the whole historical process. The way in which the incoherent mass of experimental forms, thrown out almost haphazardly by earlier artists, is, at Saint-Denis, clarified and disciplined, offers a most striking analogy

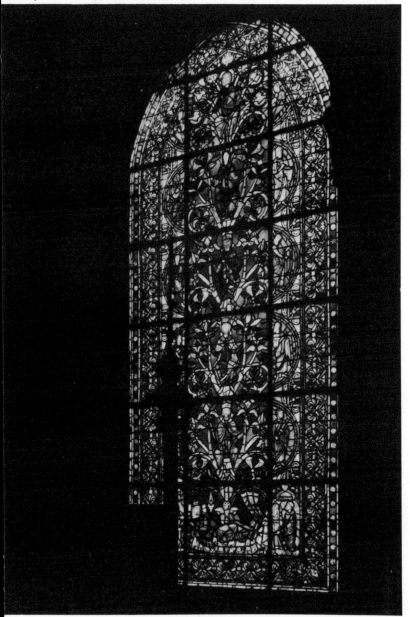

Tree of Jesse window, Saint-Denis

to the creative process of the authors of the new theology of Paris who, as I have said, reconciled, ordered, and expounded with an unprecedented precision and sense of direction the accumulated authority of the past. The Tree of Jesse at Saint-Denis is organic in just the way that the contemporary *Sentences* of Robert Pullus is organic. The individual formulae put forward by earlier artists each play their part, but interpenetrate to form a marvellous new synthesis, whose form and theological content are as clear as they can possibly be.

Peter the Venerable, Abbot of Cluny, ends his treatise against the Petrobrusians with an appeal not to the abbots but to the bishops of France to defend the faith. He acknowledges the bishops, that is, the leaders of the secular clergy, as the successors of the Apostles. Saint-Denis was a monastery, but it was in a position to reflect the most advanced ideas of the age, being itself regarded as an apostolic foundation, standing close to the city of Paris, and deeply influential in the affairs of the French kingdom. Suger lists the names of five French archbishops and thirteen bishops who took part in the consecration of the new choir of Saint-Denis in 1144. Henceforth the task of promoting the Gothic style passed into the hands of the bishops, one of whom, Geoffrey of Chartres, presided over the erection of the next great monument of Gothic art, the western portals of the cathedral of Notre-Dame at Chartres.

19. West portals, Chartres Cathedral

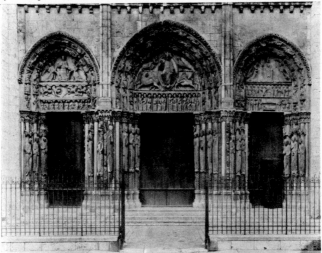

Each of these portals carries figure-sculpture on its sides and top, tall stone figures flanking the doorway and over the doorway a sculptured tympanum surrounded by elaborately carved archivolts. The portals of Chartres reveal the capacity for selective synthesis which marks the emergence of the Gothic style. The great tympana continue the tradition long established in the doorways of Burgundian monasteries such as Cluny, but the idea of archivolts decorated with successive human figures following the line of the arch was taken over from the Romanesque tradition of Poitou, where sculptured archivolts, but no tympana, were the rule. The fusion of the two isolated traditions is visually superb, the bands of archivolt figures hovering protectively about the now much enhanced tympana. In Burgundy and Aquitaine, figures had been carved on the sides of doors, but designed as areas of relief sculpture visually related to the frontally-viewed tympanum above. In western France columns, not figure sculpture, had flanked the doorways, and by these columns the architectural orders of the archivolts, but not their figure-sculpture, had been carried downwards from the crown of the arch to the earth. By a characteristic act of reconciliation, columns and figure-sculpture are merged on the sides of the Chartres doorways, the figures related visually not to the frontal plane of the tympanum but to the ordered ranks of figures on the richly plastic archivolts, so that at the sides as well as at the top of the portal the eye is led inwards by the same gentle rhythmic recession from the outer face of the church to the inner depths of the portal.

The sensitive reconciliation of earlier artistic traditions and the logical extension of art beyond precedent have the single aim of the 'constitutive' unity of each portal. One constituent of this unity, the glorious invention of the column figures flanking the doorway, has a superficial resemblance to the rigid vertical army of Normans in the *Life of St Aubin*. But now the ordered verticality of the figures is meaningful. It results from their dual function as representations of human beings and as architectural accents. They fail in neither function. Tall and slender like the columns whose vertical rhythm they underline, they nevertheless exhibit their sculptors' magisterial understanding of the organic unity of the human body. By their individuality and their strange quality of being alive they even exemplify that further unity cited by St Bernard, the 'natural' unity 'whereby soul and body are one man'.

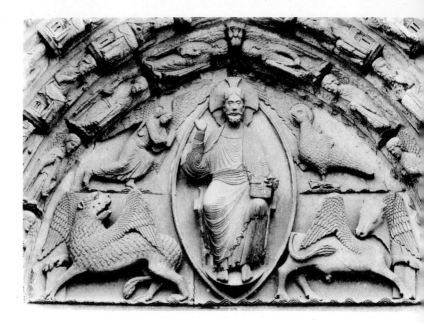

20. God with the four beasts of the Apocalypse, Chartres Cathedral

Just as each portal is presented to the eye as a visual unit, so the three portals are integrated to form one whole. The tympanum of the right portal celebrates the second Person of the Trinity, since it shows men and angels adoring God incarnate in Mary's flesh. The left tympanum shows Christ's Ascension, a subject which implies the coming of the Holy Ghost upon the Apostles. The central tympanum represents the vision of St John in Chapter iv of the *Book of Revelation*, and the figure on the throne is God the Father, though revealed to men's eyes in the likeness of the Son. Thus the three tympana relate to the Three Persons of the Trinity, though in terms of the second Person who had made God's nature manifest to men.

In the twelfth and thirteenth centuries physical overlapping or integration of two or three human bodies was accepted even in monastic scriptoria as a permissible way of expressing visually the supreme unity of the Trinity. It is tempting to regard the integrated group of three portals at Chartres as a grand-scale attempt to exhibit visibly the central mystery of Christian theology. Be that as it may, the artists who executed the western portals had technique, genius, humanity enough to restate, as it were, in stone the deepest theological conceptions of their day. Looking at the noble figure of God enthroned in the central tympanum [20], we see the visual counterpart of words written by St Bernard. The angels of the order called Thrones

are called Thrones because they sit on thrones, and they sit because God is seated in them. Do you ask what I mean by that sitting? The deepest tranquillity, the utmost calmness and serenity, the peace which passeth all understanding. Such is the Lord of Hosts, tranquilly judging all things, perfectly calm, serene, peaceful.

The Jesse Tree of Saint-Denis and the western portals of Chartres make it clear that their designers were pursuing the ideals of formal unity and constitutive unity common to all branches of creative endeavour at that time. These ideals found their grandest artistic expression in the architectural design of the Gothic sanctuaries of the Île de France. This part of France had contributed nothing original to the evolution of Romanesque architecture. In the twelfth century, with the sudden rise of the Paris area to intellectual pre-eminence in western Europe, its former artistic conventionality became an

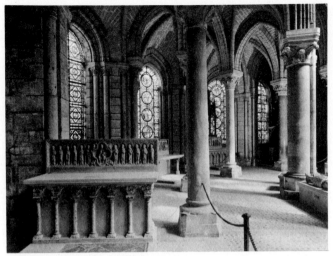

21. Interior of ambulatory of Saint-Denis

advantage. The abbey of Saint-Denis and the cathedral churches which followed it were unconfined by any strong local architectural tradition. They drew all that was best from a wide range of regional styles, in especial that of the political unit England–Normandy and that of Burgundy. At Durham before 1133 Anglo-Norman masons were able to raise over the body of the cathedral a high stone vault, tethered on diagonal ribs which allowed the curves of the vault to be planned in advance instead of being incalculable and geometrically irregular, as was the case with the earlier system of groin vaulting. The great transverse arches over the nave of Durham are broken or pointed, another technical advance, since pointed arches are nearer to the vertical than round arches and consequently more stable, and in addition are applicable to more varied spaces and larger distances than round arches. Thus in the period immediately preceding the building of Saint-Denis, the Anglo-Norman architects were the most competent and daring engineers in Europe. Romanesque architects in Burgundy, on the other hand, though conservative in their use of massive barrel vaults, had matured in the detailed treatment of elevations a fascinating and sophisticated language of forms, notably the sharply pointed arches employed in the principal arcades of such churches as Cluny, Paray-le-Monial, and La Charité.

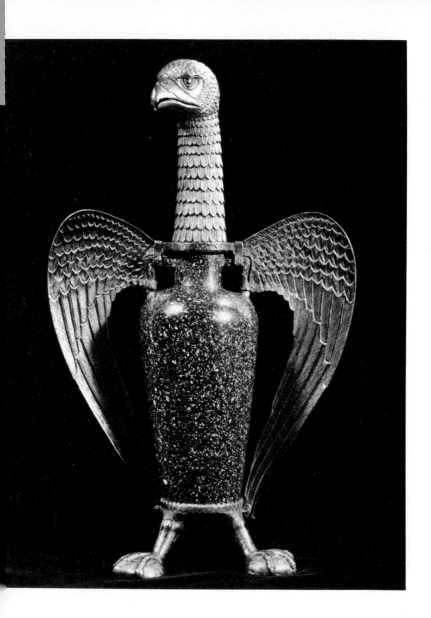

The eagle vase of Abbot Suger of Saint-Denis

These two potent devices, the rib vault and the pointed arch, still popularly equated with the Gothic style, were in fact known to Romanesque architects. Naturally the Gothic style in architecture had Romanesque precedents. But when, in the interior of Saint-Denis, we are aware of a new style, we are aware of it not so much in the forms themselves as in their integration and mutation, in the sudden revelation of their logical relations, which speak of the absolute mental clarity of their manipulator [21]. Gothic is a thoroughly novel mode of artistic expression. The incorporation of Romanesque tradition in the new Gothic idiom can be likened to the conversion, at Abbot Suger's orders, of one of the ancient treasures of Saint-Denis, a massive porphyry vase, into a taut and expansive image of an eagle with outstretched neck and wings, the symbol of St John the Evangelist who 'with acute intellect' and 'lucid speculation' is seen 'mounting above the clouds of earth and reaching the liquid light of heaven' [22].

To realize that constitutive unity is the central aim of the new style in architecture we have only to look at the ground-plan of a typical twelfth-century Gothic cathedral, Notre-Dame at Paris [23]. Romanesque planning is quite different.

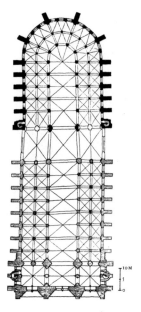

23. Ground-plan of
Cathedral of Notre-Dame, Paris

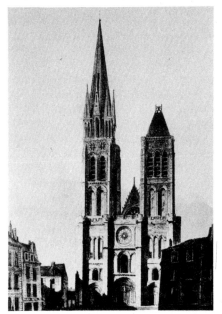

24. West front of
Saint-Denis
before restoration

In planning their churches, Romanesque architects were guided by an additive collective principle. Romanesque churches were the sum of separate portions, each stated with aggressive individuality. Abbot Suger recorded the completion and consecration of the new choir of Saint-Denis with an inscription containing the following words:

> Once the new part is joined to the part in front, the church shines with its middle part brightened. For bright is that which is brightly coupled with the bright. . .

These words are prophetic of the canonical ground plan of the churches of the Île de France. Notre-Dame in Paris, for example, consists of three simple uniform portions, the nave at the west, the transept, given no special emphasis, at the centre, and the choir at the east. These three portions are 'fitly framed and knit together through that which every joint supplieth . . . making the increase of the body unto the building-up of itself in love' – that is, in unity. It was not always easy for Gothic architects to plan in this way. The new churches which were designed had often, as for example in the

case of the cathedral of Chartres after 1194, to be mounted on the stubbornly irregular foundations of Romanesque buildings. The way in which these irregularities were smoothed out shows that the Gothic architects were consumed by a passion for order, consonance, and cohesion.

In the western façades of the churches of northern France we can trace the gradual emergence of a grand organic design. The most primitive Gothic façade, that of Saint-Denis, is Gothic in its iconographic programme and the visual inventiveness of its portals [24]. But the façade as a whole is substantially an imitation of an earlier Norman Romanesque façade, that of Saint-Étienne at Caen. As at Saint-Étienne the façade of Saint-Denis is square, topped by tall towers and divided into three portions by buttresses. At Saint-Étienne the three small unornamented doorways at the base of the façade are segregated by the buttresses, and at Saint-Denis the sculptured portals are similarly segregated even though they fill the breadth of their individual compartments.

The designer of the three western portals of Chartres was uncommitted to any large-scale architectural design. The portals were originally planned as the eastern termination of a low narthex or porch leading into the central vessel of the nave beyond. But after all the stones had been cut and the sculptures prepared the siting of the portals was altered. The three doors were brought forward, as it were, into the light, and used to tie together the two western towers which fronted the aisles of the nave. Although the peculiarly intimate liaison of the three portals at Chartres was a corollary of their being independent of the buttress-system of a major façade, their admirably integrated design took its place among the gradually accumulating authoritative statements of the new style, to which all future artists had to refer.

The first west front to carry the logic of the Chartres portals to its conclusion was that of Laon Cathedral, designed in about 1170 [25]. To integrate the whole façade as a single composition in the way that the Chartres portals were integrated meant the annihilation of the buttresses whose unbroken vertical accents had hitherto divided the façade into three distinct compartments. Since buttresses were structurally necessary, the designer of the west front of Laon allowed them to be swallowed up in the depth of the wall at the top of the façade, and at the bottom masked them by his great pedimented porches. Consequently the west front of Laon is of

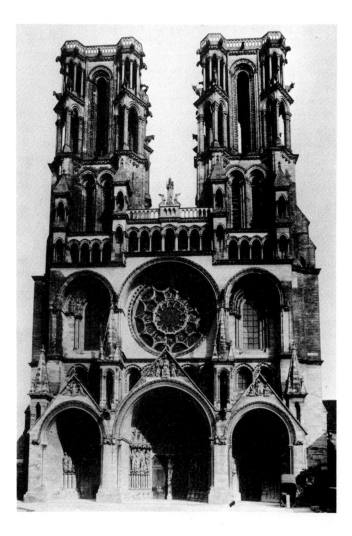

staggering plasticity. Its design is the visual counterpart of the resonant clamour of pealing bells.

Released from the cramping discipline of the buttresses the semicircular arch and the two flanking pointed arches which occupy the centre of the Saint-Denis façade are flung right across the whole Laon façade, sheltering under a giant over-hang the rose window which lights the middle nave and the pointed windows which light the aisles. An even more gigantic overhang shelters the three doorways, which were originally undivided from one another by the side walls of the central porch. The façade is seen as a unit because every part of it is stamped with the same dynamic rhythm and plasticity. A single motif, the arched opening, is repeated over the whole façade in many different sizes, drawing the eye into many different depths. The amazing towers seem to have been deliberately designed to provide the basic masses through which a rich variety of openings might be cut.

For a later generation of Gothic architects the Master of Laon's vigorous interplay of voids and solids, while deeply stimulating, seemed over-emphatic and unresolved. In his famous handbook, Villard de Honnecourt records his re-action to Laon in words of admiration, but also, and more significantly, in a drawing of a tower modelled on the bull-laden west towers of the cathedral but subtly different in emphasis and proportion [26]. The way in which Villard modifies the pinnacled aedicule at the base of the tower is characteristic of his rehandling of the entire monument. He alters the proportions of the aedicule from three equal parts – occupied by the colonnettes, the arch and spandrels, and the pinnacles – to two equal parts – into one of which pinnacle, arch, and spandrels are squashed, while the whole of the other is occupied by the colonnettes. The clean vertical accent of the elongated colonnette catches the eye in place of the vigorous plasticity of block and opening, solid and void. So the entire tower is lightened and made to soar, its rhetoric turned into a single confident affirmation. Villard's older contemporary, the designer of the south transept façade of Chartres, interprets Laon in exactly the same way, smoothening and streamlining his great original [11].

As the thirteenth century advanced, less and less of the stalwart amplitude of Laon survives in Gothic façades. In 1277 the west front of Strassburg Cathedral was begun ac-cording to a scheme by Master Erwin [27]. Strassburg has

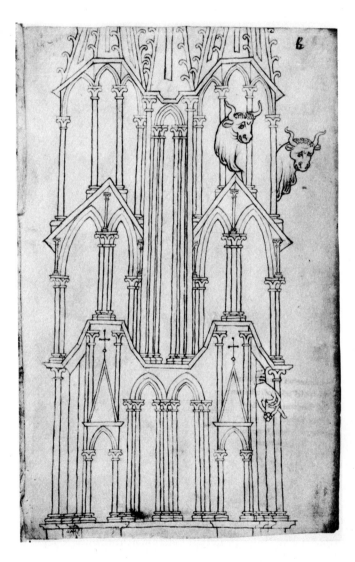

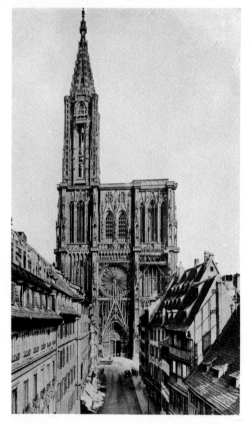

really two western façades. One is broad and simple in its design, reminiscent, at the level of the rose window, of the twelfth-century façade of Notre-Dame at Paris. But that façade is as it were surveyed through the transparent screen of another, set in front, and the façade in front consists of a multiplicity of delicate shafts and pinnacles, which give the whole elevation the appearance of an inverted waterfall. The verticality of Strassburg, especially as added to by later architects, is in danger of seeming shrill and monotonous, whereas the south transept façade of Chartres, of fifty years before, gives the ideal impression of controlled and directed energy and is more truly spiritually charged.

On the interior, as on the exterior, the ambition of Gothic architects to knit together the individual members into a single

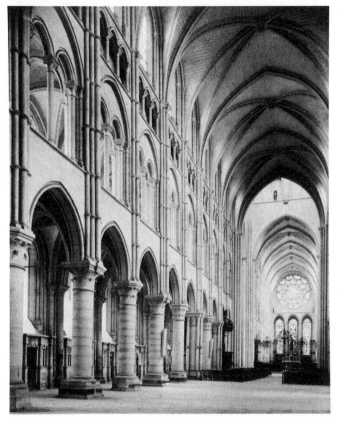

body was not achieved by one easy leap of the visual imagination. The relation of the successive Gothic interiors to one another is like the relation to one another of the books of *Sentences* of the early scholastic writers. Robert Pullus's *Sentences* seemed the last word in clarity and comprehensiveness in 1142, but within ten years Peter Lombard's great synthesis of theological knowledge had made Robert's work redundant.

The abbey of Saint-Denis, Sens Cathedral, and Noyon Cathedral, are the immediate antecedents of the interior of Laon Cathedral [28]. Laon excels its predecessors in the unified treatment of the nave elevation. The piers are of uniform design throughout, in place of the ultimately Norman alternation of major and minor piers which at Sens and Noyon

had broken the design up into pairs of bays. But with typical sensitivity to the authority of the past, an echo of this differentiated rhythm of bays was allowed to remain in the groups of alternatively three and five shafts running up the wall above the capital of the piers. The visual function of these groups of shafts was, first, to carry the ascending vertical of the column all the way up to the vault, so that the four storeys of the elevation are seen to form a unified composition, and secondly, to reiterate the rotundity of the column on the flat wall above, harmonizing these contradictory forms. At the base of each bay is the uninterrupted opening into the depth of the aisle. At the apex of each bay is the shallow frame of the clerestory window. The two storeys in between function visually – their practical function is to hold up the high wall and the stone vault above – as the means of achieving a gradual transition from extreme depth to extreme shallowness, from three to two dimensions. The second storey of the elevation, the tribune gallery, is as deep as the aisle beneath, but here flat wall-surface asserts itself against the void behind it, veiling the arched opening with a blank tympanum set above a pair of minor arches on a central colonnette. The third storey, the triforium corridor, marks the drawing-together of the outer and inner walls of the church, and in the clerestory, where a thin sheet of glass is engaged in its narrow stone frame, they meet and fuse. Throughout the elevation, visual compromises are worked out between the individual forms, so that 'what each part supplies' is directed towards the building up of a coherent whole.

At Chartres, after the great fire of 1194 had destroyed all that lay beyond the west façade, the designer of the new cathedral united the interior in a much more dynamic way, discarding the great tribune gallery of Laon and reducing the elevation to three storeys, main arcade, triforium, and clerestory [29]. This involved no loss of scale or height, rather the contrary. He made his columns taller and vastly expanded the clerestory windows. External flying buttresses took over the function of the tribune gallery in stabilizing the high vault, and the interior of the church is radically simplified and unified, purged of the tribune's segregated and redundant volume of space. From the bottom to the top of the elevation, the gradation from depth is more frank and rapid. The column now carries an attached shaft down its outer face, closely associating the column with the group of shafts which runs up

from it to the springing of the vault ribs. This continuous
vertical rhythm asserts the larger order to which the graduated
ranks of the elevation design belong.

The programme of the elevation of Chartres is essentially
retained by the designers of Reims and Amiens Cathedrals,
Jean d'Orbais and Robert de Luzarches, though the scale
grows even greater, and there is more visual liaison between
the form of the clerestory windows with their new bar
tracery and the triforium openings below. In the great archi-
tect Pierre de Montereau's construction of the Saint-Denis

29. Interior of Chartres Cathedral

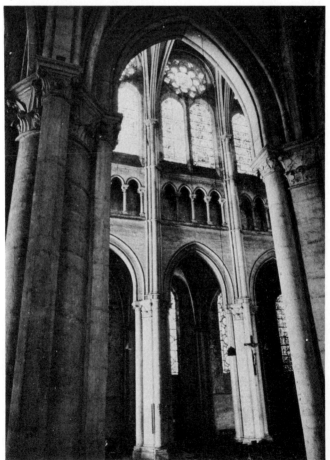

nave, begun in 1231 [30], the triforium itself is glazed, so
that the whole area above the arches of the main arcade and
between the shafts which rise uninterrupted from column
base to vault springs becomes a shimmering sheet of glass,
articulated by the slender vertical mullions, and impregnated
with sunlight. This principle of design was adopted in Spain
at León Cathedral, about 1255, and by Master Gerhard in his
mighty cathedral at Cologne, begun in 1248 [7].

For masonry to exist in a harmonious visual relation with
the vibrant figures of men and angels represented in the stained
glass, it had to appear to be weightless and shot through with
visible energy. Hence the concentration of the architectural
structure into slender streaming vertical bands, amidst
which the glowing figures are suspended. The unity which
Gothic interiors attain in the first half of the thirteenth century
goes far beyond that system of graduated planes which we
find in early interiors such as Laon. Columns, walls, and win-
dows are now instantaneously perceived as one whole. The
emphasis is not so much on 'the working in due measure of
each several part', although that is still present, but on 'the
increase of the body unto the building up of itself in love'.
The individual members share in the divine order of the
angels in heaven who, according to St Bernard, are 'insepara-
bly one in heart and mind, blessed with unbroken peace, God's
building, dedicated to divine praise and service'.

In his *Speculum de mysteriis ecclesiae* Hugh of St Victor says,

The church in which the people come together to praise God
signifies the Holy Catholic Church which is built in heaven of living
stones.

The material sanctuary is regarded as a type of the spiritual
sanctuary, the City of God, the Heavenly Jerusalem. This was
not a new idea. The abbey church of Monte Cassino, in Italy,
consecrated in 1075, and the church of Cluny, consecrated in
1095, seemed to contemporaries to reflect the City of God.
Monte Cassino was called 'another Zion', as glorious as
Solomon's Temple, and of Cluny it was said that, if it was
lawful to believe that an earthly habitation could please the
citizens of heaven, then the angels might well walk in it. God
had commanded Moses to erect and equip a material sanctuary
according to the pattern shown to him 'on the mount'. Since
the ornaments of the Mosaic sanctuary listed in the *Book of
Exodus*, and the treasures of the later Temple established at

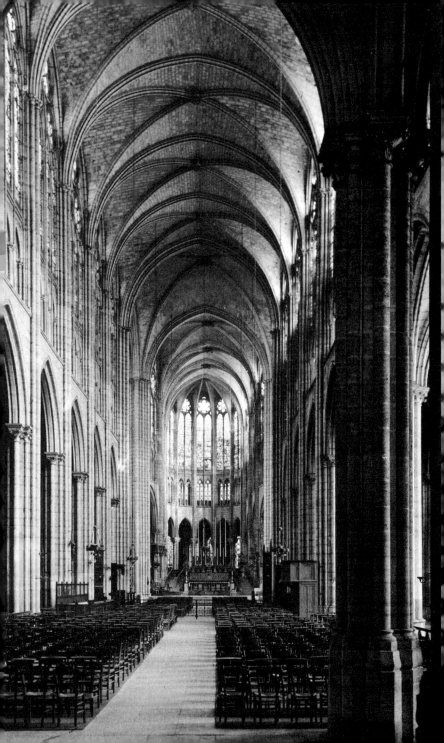

God's command by King Solomon, listed in the *Book of Chronicles*, were divinely ordained, they provided the obvious starting point for later evocations of the spiritual sanctuary. The Liège font of Rainer of Huy was directly modelled on the description of Solomon's brazen sea: 'round in compass . . . it stood upon twelve oxen . . . the sea was set upon them and all their hinder parts were inward' [2 *Chronicles*, iv, 2–4]. The great candlestick given to Cluny by William the Conqueror's granddaughter, the Empress Matilda, was an imitation of the seven-branched candlestick prescribed under the old Jewish law. Twelfth-century theologians had a wide range of traditional christological interpretations which they could apply to the ornaments of the Jewish Temple. For example, Peter of Poitiers, who taught theology in Paris from 1169 to 1193, says that Moses's golden candlestick 'is Christ in whom human nature shone with the divine light . . . made of gold because Christ took our human nature without sin'. But for the theologians to spy Christ through the dark allegories of the Old Testament was one thing. It was another thing to build the Christian sanctuary according to the second-hand precepts of the Temple. Peter the Venerable was, as we have seen, well aware that the splendour of the Christian sanctuary should far excel that of the Temple. No doubt Peter thought that the abbey church of Cluny, erected by his great-uncle St Hugh, fulfilled the requirements of the Christian sanctuary. Peter's contemporary St Bernard, on the other hand, wrote scathingly about the sumptuous Romanesque basilicas of the Cluniac Order with their massive bronze candlesticks as big as trees. When he said that the spectacle of Cluniac churches reminded him of the 'old rites of the Jews' he was passing an adverse judgement on the whole Cluniac interpretation of the monastic vocation and of the Christian life, but he also implied a judgement on Cluniac art. The stiff and grandiose Romanesque manner, with its gorgeous but palpably extraneous ornament, was simply no longer in touch with the spirit of the age. The Gothic style came into action as a visual counterpart of that intense awareness of twelfth-century men that the Christian Church, though historically allied to the Jewish Temple, was a 'new creation'. The old Jewish law had 'a shadow of the good things to come, and not the very image of the things' which Christ's birth and redemptive death had revealed. The pattern on which the Christian sanctuary should be modelled was to be

found in the New Testament, in the direct perception of the Heavenly Jerusalem granted to the Apostles.

The concordance of all the parts of the earthly hierarchy in a single body, referred to by St Paul, was understood by St Bernard and his contemporaries to reflect the organic unity of the angelic hierarchy, the original citizens of the Heavenly Jerusalem. Hence the need to represent the Christian sanctuary as an organic unity. In addition, a full description of the Heavenly Jerusalem in architectural terms was supplied by St John at the end of the *Book of Revelation*. The celestial city

had a wall great and high . . . on the east three gates, on the north three gates, on the south three gates, and on the west three gates . . . and the city lieth foursquare, and the length is as large as the breadth . . . and the building of the wall of it was of jasper, and the city was pure gold, like unto clear glass. And the foundations of the wall were garnished with all manner of precious stones. . . .

Given the liturgical requirements of the Christian church and the technical means at the architect's disposal, the cathedral of Chartres as it was evolved in the first three decades of the thirteenth century was an accurate reproduction of the ideal image. It was more than a representation. It moved into the status of an icon, for it shared the nature of the sacred reality which lay beyond it.

On the interior the walls of Chartres are made transparent, composed of vast sheets of glass which glow with the colours of precious stones [31]. On the exterior there are three portals at the west, three at the north, and three at the south. The development of this great system of entrances was gradual, and reflects the subtle interaction of two influences, that of the authority of artistic precedent and that of the authority of the ideal scriptural image. The west front of Chartres, which had escaped the fire of 1194, represented a comparatively primitive type of façade. As we have seen, the Master of Laon Cathedral had now revolutionized ideas about what a major façade should look like. The immediate intention of the designer of the new cathedral of Chartres seems to have been to have a single portal in the north and south transepts, or even perhaps no portal at all on the south, and to replace the old work at the west with an up-to-date façade. But by 1220 a different idea had emerged. The transepts were both constructed on the model of Laon and each given

three great portals, while the old work at the west was retained. This change of plan must stem from a recognition of the irreplaceable religious and artistic quality of the western portals, and from a desire to body forth the Celestial City, with its centralized ground-plan and its panoply of gates [11].

'And I John saw the holy city, new Jerusalem, coming down from God out of heaven, prepared as a bride adorned for her husband.' The chief relic of the Cathedral of Chartres was the tunic which the Virgin Mary was said to have worn at the birth of Christ. The possession of this relic concentrated the attention of the theologians of Chartres on the rôle of the Virgin in the process of salvation. God had dwelt in Mary, as he had formerly dwelt in the Temple. The body of Mary, through which the tangible bond between God and Man, the Church, was established, had been taken up incorruptible into heaven, as the very type of the heavenly sanctuary, the Mother of angels and men. The subject of the Assumption is represented in an English miniature of the third quarter of the twelfth century, where a company of angels lifts the shrouded figure of the Virgin up to heaven in a great sheet which, spread out between them and grasped along its edges by their outstretched hands, seems strangely to echo the shape of a rib vault, laid like a canopy over the walls of a Gothic cathedral [32 and 33]. Fulbert, Chancellor and later Bishop (1006–28) of Chartres, and the great scholars who after him maintained the standards of the Cathedral school, were foremost amongst those who interpreted the New Jerusalem, the Bride of Christ, as the Virgin. The cathedral of Chartres, enshrining the material vesture of the Virgin at the moment of the historical reconciliation of God and Man, was therefore also an image of the New Jerusalem as Bride, as Mary. On the central portal of the north transept, surrounded by a marvellous recapitulation of the theme of the Tree of Jesse, the tympanum displays the final union of God and Man. Mary who gave flesh to Christ is given by Christ the crown of eternal life [34]. The enthroned figures are conceived in a grave and humane style, in keeping with the profound humanism of the subject.

Standing before the portals of Chartres, we are, in St Paul's words, 'compassed about with so great a cloud of witnesses' – patriarchs, prophets, apostles, martyrs, confessors, and doctors of the Church – the citizens, with the angels, of the Celestial City [35]. The monumental stone figures which flank the entrances of the transept façades are weightier and

Windows in the north transept of Chartres Cathedral

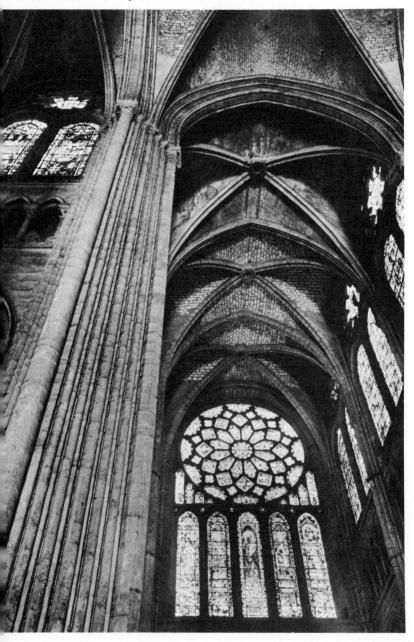

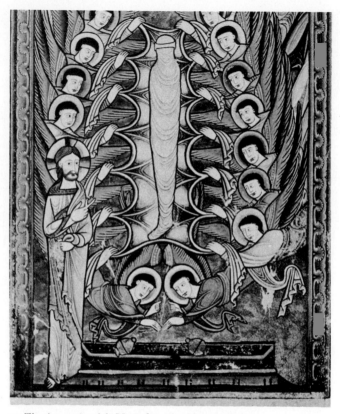

32. *The Assumption of the Virgin* from the Glasgow Psalter

more mobile than the earlier Chartres column figures. But then the architectural design of the transepts is more massive and three-dimensional than that of the old west front. All the elements in the huge composition still merge into a grand symbolic unity.

As we look at any of the monuments of the first hundred years of Gothic art we are inevitably struck with awe and admiration at the mechanical inventiveness and aesthetic sensibility of the men who executed them. Nevertheless, great artists as they were, the essential stimulus which promoted invention, sharpened sensibility, and liberated the new Gothic style from its vast and various Romanesque antecedents came from outside the visual arts. The artistic revolution of the

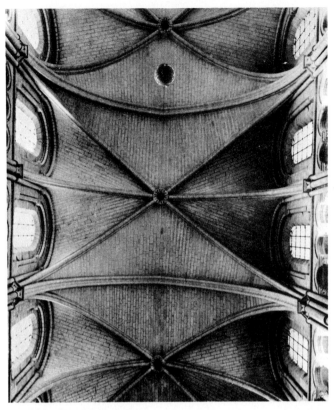

33. Vault of Laon Cathedral

twelfth century was a revolution at second-hand. In the intro-
duction to the Romance of *Lancelot*, the twelfth-century poet
Chrétien de Troyes says of his patroness the Countess Marie de
Champagne:

> Her commands have more to do with this work than any thought
> or labour which I may expend upon it The materials and their
> interpretation are transmitted to Chrétien by the Countess, and he is
> involved in the work only in the exercise of his care and artistry.

If we substitute Theology, the great mistress of the sciences,
for Marie de Champagne, Chrétien's words apply perfectly
to painters, sculptors, and architects during the first glorious
century of Gothic art.

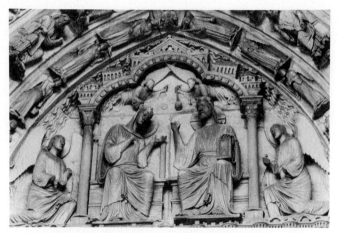

34. *The Coronation of the Virgin*, Chartres Cathedral

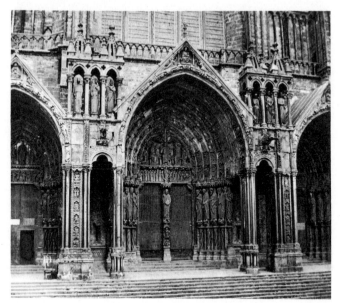

35a. Central portal of south transept, Chartres Cathedral

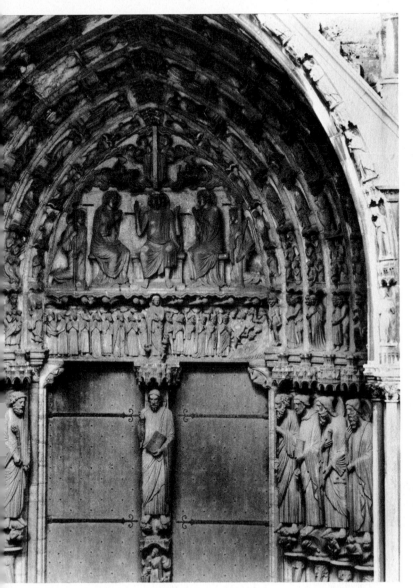

. Detail of 35a

3

Gothic for Art's Sake

A little over one hundred years after Abbot Suger had begun the rebuilding of Saint-Denis, another great monastic church, Westminster Abbey, was begun by an equally enthusiastic patron, King Henry III of England. The emergence of a layman as the prime mover in a major artistic undertaking is typical of the later history of Gothic. And the extent to which the upper ranks of secular society were now cultivating the elegancies of life is well illustrated by a passage from Jean de Joinville's biography of Louis IX, King of France, Henry III's brother-in-law. Writing of his master's personal care for the administration of justice, Joinville remarks:

> I saw him, on one occasion, in summer, when to do his people's business he came to the garden in Paris, dressed in a coat of camelot, a sleeveless surcoat of cotton, with a mantle of black silk about his shoulders, capless but with his hair well combed, and a coronal of white peacock feathers on his head. And he had carpets spread for us to sit round about him.

This is an eye-witness report, a record of historical fact, but it has all the charm and magic of Romance.

No doubt Henry III's motives for rebuilding the abbey-church which lay alongside his chief palace and seat of government were many and various. One motive was certainly religious devotion, in particular devotion to the royal saint who was enshrined at Westminster, Edward the Confessor, the last Anglo-Saxon king of the English. But Westminster Abbey was first and foremost the result of Henry's keen delight in architecture, painting, and sculpture. Throughout his life, despite the dangerously mounting expenses of government, he was unable to resist the urge to be continually recreating and refining his visual environment. From his high pew in the south transept of the abbey Henry could look out into the most elegant, most up-to-the-minute, most lavishly equipped and decorated building in his kingdom [36]. The gradual emergence of that glorious vista, between 1245 and 1269, must have

Interior
Westminster
bey

81

consoled him among the many pressing anxieties of his reign. Conventionally devout though he was, King Henry did not climb the staircase to the royal pew only in order to enjoy a vision of the Celestial City and the promise of an incorruptible crown. Westminster Abbey also provided him with the more limited but tangible consolations of art and connoisseurship.

The style which we call Gothic came into being in an intensely idealistic, religious, and scholarly atmosphere. If we want to know why early Gothic looks as it does, it is necessary to comprehend something of its intellectual background, and this I have attempted to describe in the previous chapter. But as Gothic developed, its tone was set more and more by the taste of secular patrons. Even the works commissioned by bishops and monks came to share this overall secular quality. So it becomes easier for us to approach Gothic in purely visual terms. By the middle of the thirteenth century the cry of the cathedral builders, 'O Lord, I have loved the beauty of thy house!' has become abbreviated to 'I have loved beauty'. What it was that Gothic artists and their employers then regarded as beautiful is our concern in this chapter.

As we have seen, the coordination and balance of the vast forces of a cathedral façade, its forward-thrusting solids and its gaping voids, involved the development of very large deeply splayed doorways articulated by strongly plastic figure-sculpture. The great positive values of the first phase of Gothic art, its theologically-inspired breadth of human feeling and passion for internal consonance and harmony, carried a particularly talented group of sculptors working at Reims in about 1225 beyond their immediate task of providing sculptural accents in keeping with the architectural accents of the Gothic façade. The statues flanking the Judgement and Sixtus portals on the north transept of Reims Cathedral, and certain other statues on the west front and high up on the exterior of the choir, are not so much to be compared to the slender attached shafts of Gothic architecture as to the self-sufficient, rotund, richly textured Corinthian columns of antiquity, for example the giant members which adorn the great Roman triumphal arch in Reims itself. In the right embrasure of the Judgement portal, three big broad-shouldered apostles, SS. Paul, James, and John, stand in poses at once relaxed and resolute, planting their feet firmly on flat disk-shaped bases originally borne up by short thick columns [37]. The saints and angels on either side of the Sixtus portal stand with their

Statues of apostles on the north transept, Reims Cathedral

38. Four saints by
Nanni di Banco,
Or San Michele, Florence

feet resting on a broad continuous platform. Such forceful stocky figures cannot pretend to be suspended weightlessly. They demand a stable and rational support. All these statues are overhung by enormous architectural canopies which emphasize their depth and their projection. The aggressive bulk of the statues has begun to condition the framework in which they are set. Grand and massive, wrapped in circulating draperies, individualized works of art of great power and beauty, the Reims figures seem ready to present themselves to the eye from every direction, as free-standing statues, each mounted on a plinth, like antique hero-portraits. To be displayed to full advantage in an architectural setting they require a specially designed show-case, a strongly framed, frontally presented semi-circular niche of the kind which Nanni di Banco used for his remarkably similar statues of the Quattro Coronati at Or San Michele in Renaissance Florence [38], or even the adjacent Donatello–Michelozzo tabernacle with its Corinthian pilasters and classical pediment and cool, clear details.

The implications of the plastic qualities of the latest figure-style were well understood by the artist who illuminated the Psalter of Queen Ingeburg of France late in the first quarter of the thirteenth century. The Apostles and the crowned Virgin in the scene of Pentecost [12] are the painted counterpart of the classical statues at Reims. The shoulder of the Apostle on the left is seen to project beyond the frame, and the looped and pliant drapery which streams about the massive forms draws the eye into depth, where, at the right, a slender colonette is set back behind the foot of a flying angel. Because they are painted, the Virgin and her companions have an importance in the history of art even beyond that of the splendid statues to which they are stylistically allied. They are, as it were, characters in search of a cathedral – no longer the Gothic cathedral, the visible symbol of suprasensory reality, but the 'cathedral' of picture-space, that illusionary three-dimensional world opening beyond the picture surface which was finally achieved by the perspective devices of the Italian Renaissance. The Master of the Ingeburg Psalter creates the illusion of three-dimensionality not by perspective but by the volume inherent in his majestic figures, and in so doing he anticipates the art of Giotto, of almost one hundred years later.

The Master of the Ingeburg Psalter was not the only early thirteenth-century artist to evoke on vellum the swelling

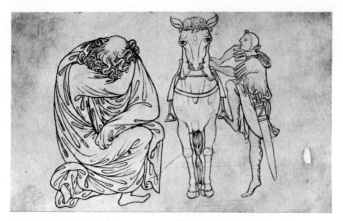

plasticity of the Reims statues. The fascinating handbook of his contemporary, the north French architect Villard de Honnecourt, is full of powerful drawings which are literally sculpturesque in that they relate to sculptures either seen or planned by the artist [9]. When we compare Villard's sketch of a sleeping Apostle with the figure of Joachim asleep from a fresco by Giotto in the Arena Chapel at Padua (1305–12) we seem to be contemplating two ideas of a single mind, the first dynamic draft and the final solution, more studied and certain [39 and 40]. Both Villard and Giotto have recognized the depth-creating potentialities of a sitting figure huddled in sleep. Both artists emphasize the strong rhythm of crossed arms and bent legs, tugging in and thrusting out the enveloping mantle. The Villard figure seems to wrestle with himself and his drapery spirals his body over-emphatically. The Giotto figure is calmer, more convincingly asleep, through the use of long straight folds of cloth which flow down and anchor the sleeper to the ground. There is no doubt that Giotto found his point of departure in the monumental space-demanding human figure exploited by the early thirteenth-century artists of north France for the first time since the decline of Roman civilization in the West. But the element of naturalism, of scientific observation of living forms, had grown in importance since the Sixtus portal of Reims. Vasari was right when he praised Giotto for

the excellence of his figures, for his arrangement, sense of proportion, truth to nature and his innate facility which he had greatly increased by study.

39. Drawing of figures by Villard de Honnecourt

40. *Joachim Asleep* from a fresco by Giotto, Arena Chapel, Padua

At the centre of the painting of *The Raising of Lazarus* in the Arena Chapel a young man stands momentarily rapt in amazement, his right hand lifted and accurately foreshortened and his left hand hovering lightly at his chin. Behind him another man holds up his hands, palms forward [41]. These figures are triumphs of intelligent observation of nature, most happy generalizations on the basis of direct transcriptions from the life. One can imagine the apprentices in Giotto's workshop posing for their master, as Raphael's apprentices did later. Like Raphael, Giotto was gifted with the power to see, to select, and to translate his observations into his magnificently controlled, coherent, and dramatic pictorial language. Giotto's powerful touches of naturalism are like those of his contemporary Dante, adding conviction and immediacy to his deeply serious description of an order of things outside the common experience of men.

Interest in natural appearances and the ability to record them are of course in evidence in Gothic art well before Giotto's time. In the western choir of Naumburg Cathedral stand a number of statues, some in pairs, some singly, which were carved about the middle of the thirteenth century and which represent the benefactors of the cathedral church, among them the Margrave Eckhardt of Meissen and his wife Uta [42]. As originally decked out with colour on faces and hands, clothes and jewellery, these figures must have had all the appearance of living beings. In view of their striking realism, the position of the statues, perched above floor-level and with no secure purchase for their feet, is to say the least anomalous. Eckhardt's strong broad face, completely individualized, alive, aware of his surroundings, can be paralleled at the Arena Chapel, in the head of Pilate in the *Mocking of Christ* [43]. But the forceful individualization of that head is unique in Giotto's *oeuvre* and is iconographically and dramatically purposeful. Pilate is the Roman official, the representative of an admired historical culture, the patrician, the conscious personality, the specific person amongst the idealized good and the conventional bad and the generalized mass of mankind. Where the great Florentine calculates his effects, the earlier German rushes unwarily ahead. Eckhardt and Uta may stick in the memory as an apt visual image for the bully Cornwall and his wife Regan in *King Lear*, but the immediate impression is one of commonplaceness, and the woman's gesture of drawing her high collar to her cheek reduces her to the level of a couturier's

The Raising of Lazarus by Giotto, Arena Chapel, Padua

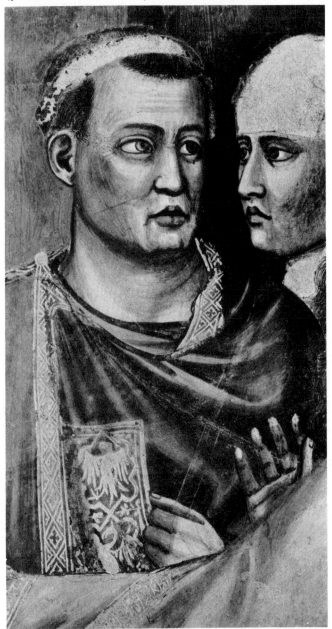

43. *Head of Pilate* from a fresco by Giotto, Arena Chapel, Padua

model. In another chapter I will show how this kind of total realism was imaginatively employed by Gothic artists working in a new tradition created by the rise of intensely introspective and emotional religious devotion. Later on, in the fourteenth and fifteenth centuries, immediacy – the sense of a passing moment – was to have a strong didactic purpose. But Naumburg's exaltation of the trivial and the contingent reflects rather the contemporary aristocratic taste in literature.

The courtly Romantic tradition recognized the function of such statues. In Thomas's *Tristran*, for example, the exiled hero employs masons, woodcarvers, and goldsmiths to build a secret chamber in which he places life-like statues of Queen Ysolt and her companion Brengvein, clothed and equipped as he last saw them.

'Addressing Brengvein he says: "My fair one, I complain to you of my mistress Ysolt's fickleness and of her treachery towards me." He tells the statue whatever he thinks. Then he withdraws a little and looks at Ysolt's hand. She is about to give him the golden ring. He sees her appearance and the expression on her face as her lover takes leave of her . . .'

Exactly this kind of medieval 'Madame Tussaud's' was what Bishop Dietrich of Naumburg demanded from his sculptors.

However we rate the Naumburg figures as sculpture, there is no doubt that they represent a considerable intellectual feat, the conquest of a portion of the physical world, inconceivable since the disappearance of the antique portrait bust. Nor was human likeness the only piece of nature which the Naumburg artists mastered. The western choir and the great rood screen which isolates it from the rest of the building are decorated with marvellous portraits of plants, vine and hawthorn, buttercup and cherry. In England, also, sculptors in the second half of the thirteenth century delighted in representing foliage, each plant as individualized and true to life as the men and women of Naumburg. The gifted artists who carved the capitals of the doorway of the chapter house at Southwell Minster in Nottinghamshire must surely have worked *al vif*, as Villard de Honnecourt would say, with freshly plucked bunches of leaves laid out before them [44]. The freshness remains in their stone leaves, which look as if a breeze might at any moment stir them. The effect is enchanting and the technical skill is prodigious. But neither in front of the statues of the patrons of Naumburg, nor in front of the vine and oak

44. Capitals from entrance to chapter house, Southwell Minster

leaves of Southwell, does one catch a hint of any evolving system of naturalistic representation, any attempt to build up individual verisimilitudes into a coherent picture of the external world. If anyone ever failed to see the wood for the trees it was the Masters of Southwell and Naumburg. Fragments only of nature were scrutinized and painstakingly recorded: nature as a whole still remained a formidable mystery.

Foliage as exquisitely naturalistic as that of Southwell is lavishly displayed throughout *The Douce Apocalypse*, a splendid English manuscript of the *Book of Revelation*, now preserved in the Bodleian Library, Oxford, and painted probably for King Henry III or his son, the Lord Edward, round about the time of Giotto's birth, the late 1260s. On page 66 of this manuscript we find an early parallel for Giotto's empirical attitude to the business of picture-making [45]. The angel who empties the fifth vial of wrath on to the chair of the Beast (*Revelation*, xvi, 10) is shown in an oddly contorted position. The upper part of his body is bowed forward, but is represented as slightly above the spectator's eye-level. His chin is concealed by his raised right arm, and his right wrist is viewed from behind. His curiously complex posture, so carefully recorded, strongly suggests that the figure was drawn with reference to a living model. The other figures, St John seated at the right and the crowd of stricken blasphemers at the

45. *The Angel with the Fifth Vial of Wrath* from *The Douce Apocalypse*

centre, are much less studied and individualized, but bear witness to the accurate visual memory and technical facility of the draughtsman. The chest, shoulders, and arms of all the figures give a good impression of volume, and the hands, though held in excessively affected positions, are well drawn. In addition to these Giottesque qualities, the thin draperies with their big pleats and folds are handled much in Giotto's way. Having noted these resemblances, the differences begin at once to accumulate. The total effect is lighthearted, even frivolous, quite without that classic gravity and restraint which Giotto shares with the earlier masters of Reims. The bulky thrusting figure of the angel, presented in a deliberately difficult pose, somehow lacks conviction, and has about it a literal and pedantic air which, combined with the dry methodical linear technique, is strangely reminiscent of drawings of the neo-classical period, for example by Flaxman. Then again, every person in the scene defines the space which he himself occupies, often with unnecessary emphasis, yet the inter-relation of the figures remains obscure. The impression of spatial incoherence is confirmed by the landscape, which con-torts itself to segregate the principal combatants. Wherever the individual figures are placed they end up on the surface of the page as elements in a shrewdly calculated two-dimensional

pattern. We now see that the genuine reason for the raised and twisted arm of the angel with the vial is to provide the rhythm of an obtuse-angle precisely reversing that of the raised arm of the blasphemer placed next to him. A daring naturalism is introduced merely to vary and extend the surface pattern.

This drift of all the elements in the design towards a suppositious coherence, that of surface pattern, is a general characteristic of northern Gothic art in its mature phase. The amazing realism of the Naumburg figures and the Southwell foliage of course comprises a vital element in the mature Gothic style, but perhaps more typical of the style as a whole are the prophets who line the central portal of Strassburg Cathedral and the foliage which decorates the so-called Percy Tomb in Beverley Minster, Yorkshire [46 and 47]. The early fourteenth-century sculptor of the Strassburg prophets has rejected the separate personalities of Naumburg in favour of the group. His tall slender figures all look alike and make a collective impression. Their richly undulating draperies, fantastically rolling beards and clearly drawn features are all stamped by a bold and fluid rhythm. The foliage of the Percy Tomb, of the 1340s, similarly retreats from naturalism into stylization. Coiling, bulging, and writhing, the leaves and stems create a rolling pattern up the edge of gables, around arches, and

46. Statues of prophets, Strassburg Cathedral

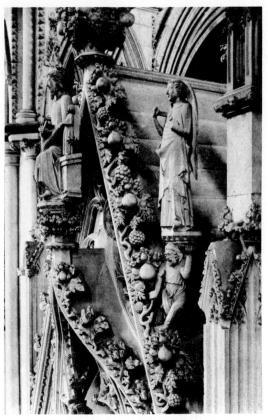

47. Part of the canopy of the Percy Tomb, Beverley Minster

within spandrels, underlining by their almost baroque exuber-
ance the rhythm of the architecture, the buoyant ogees, the
flamelike tracery, the deeply gouged mouldings. Here we see
the effects of an impulse towards conformity, throughout all
parts of a design. The same rhythms dominate every element,
be it representational or abstract, a draped figure or the
curvature of an arch.

*

'Jerusalem is built as a city that is at unity in itself', says the
Psalmist. The earnest pursuit by early Gothic artists of formal
consonance and integration, their smoothing out of distinc-
tions between the several parts of a structure or a pictorial

composition, were in accord with the teachings of the Church on earth concerning the nature of the Church Triumphant. The Gothic cathedral, both in detailed treatment and general appearance, was a subtle compromise between materials and ideas, between the world known through the senses and the spiritual world known by faith and devout contemplation. Abbot Suger acknowledged this quality of compromise. Standing in the choir of Saint-Denis he feels that he is 'in some strange region of the universe which neither exists entirely in the slime of the earth nor entirely in the purity of heaven'.

It was perhaps impossible for artists to work on these intellectual heights for very long. A hundred years of practice, from 1140 to 1240, equipped them with certain very definite mental and idiomatic habits. The peculiar integration of forms which originally symbolized the unity of desire of the citizens of God's invisible Temple became in the course of time no more than a necessary characteristic of any efficient exercise in the visual arts. To handle the Gothic style required pliability and a light touch, but not that vision of a new heaven and a new earth which the early Masters shared with their dedicated patrons. One of the misericords placed beneath the seats in the fourteenth-century choir stalls in Worcester Cathedral illustrates a famous folk-tale, found all over the world and known as 'The Clever Peasant Girl'. A king challenges a clever girl to come to Court under certain apparently impossible conditions, for example neither naked nor clothed, neither on horse nor on foot, bearing a gift that is no gift. The girl successfully performs the riddling task by clothing herself in a fishing net, by

48. Carved misericord, Worcester Cathedral

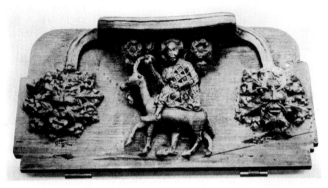

riding on a goat and keeping one foot on the ground, and by
bringing with her some live creature such as a hare which will
escape at the moment of presentation [48]. The heroine of this
popular fantasy, who resolves a series of irreconcilable con-
ditions by ingenious equivocation, provides us with an apt
symbol for the Gothic style as it was fairly launched upon the
European scene as an international visual language.

49. *The Vis*
Reims Cath

Formal compromise, cunning gradation from one element
in a composition to another, the creation of what we may term
a visual *continuum*, remains the essence of the Gothic style: it is
pursued with verve and skill. Indeed Gothic artists now
achieve some of their happiest and most striking effects. But
their work no longer reflects any broad and generous intellec-
tual theory. It has become an elaborate game.

The two most famous products of the Reims classical school,
the Virgin and St Elizabeth on the south side of the central
western portal, are set, like the later figures which surround
them, on shallow pedestals terminating in a row of open
arches, and are flanked by slim attached shafts [49]. They are
like fish out of water, visually too big and too heavy for their
setting and their supports. The designer who ordered these
figures to be placed in such a conspicuous position evidently
valued them as works of art, but at the same time shrank from
the formal and intellectual demands which they made. At
Reims the equilibrium of Gothic art, threatened by such
figures, was restored in the second quarter of the thirteenth
century by the exaltation of a simple architectural motif, a
flat sharply pointed gable, as the dominating visual accent of
the whole façade. Not only do the straight converging lines
of this gable jab upwards on every portion of the façade but its
shape also controls the design of the sculptured portals [50].
The deep independent canopies of the Sixtus and Judgement
portals are discarded, and a regular band of flat gables zig-zags
across the façade above the level of the delicate foliage frieze
in which, typically, the distinction between the capitals of the
attached shafts and the wall is blurred. Around the solid base
of the façade a fictive curtain is suspended. Its drapery falls in a
series of sharp V-shaped pleats – the line of the gables in
reverse. Between the curtain and the gables stands a new race
of Gothic figures, tall and elegant, with sharp foxy faces and
thin draperies which crack into great angular folds, the first
suave products of a strictly visual sensibility. It was on the
basis of these figures that the later Naumburg and Strassburg

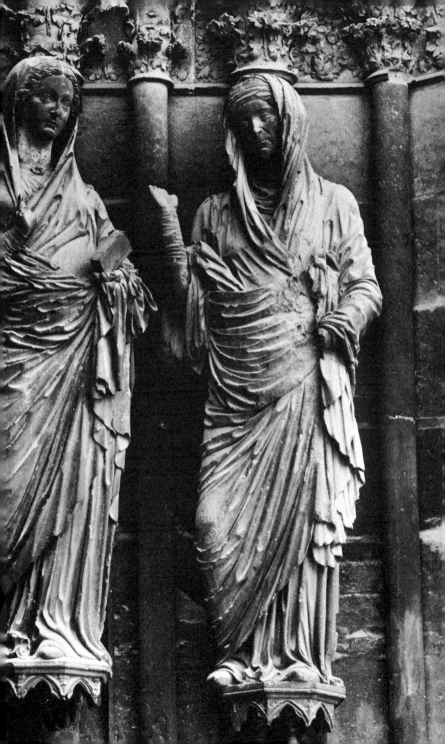

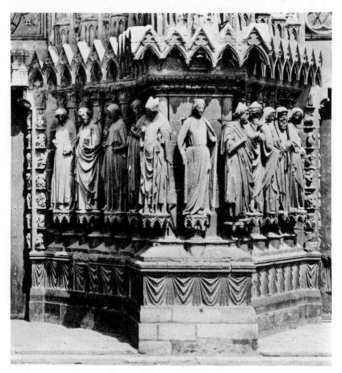

50. Statues on the west front of Reims Cathedral

sculptors carried out the experiments which we have already discussed.

The problems which faced the Gothic artist in his quest for visual conformity are represented in the late thirteenth-century frieze of Genesis scenes on the west front of Auxerre Cathedral [51]. The wall is split up first by a series of miniature buttresses supporting pinnacles and sharply pointed gables, and secondly by richly moulded trefoils and larger lobed compartments. The trefoils armed with extra points or barbs which unite the right and left spandrels of each pair of gables have a rosette at the centre of the two upper lobes, like eyes under the low curved brows of an animal, while the lower lobe is gripped within the jabbing angle at the base of the gables. This row of trefoils is strangely reminiscent of one of the most popular decorative devices of the Romanesque architects of England and western France, the rows of glowering bird masks called 'beak-heads'

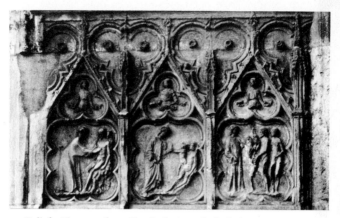

51. Relief with scenes from *Genesis*, Auxerre Cathedral

hooked over the archivolts of doorways, for example at St Peter's-in-the-East in Oxford [52].

The Gothic designer contrives exactly the same eye-catching reiteration of curves and angles as his Romanesque predecessor, but by more sophisticated means, the interaction of geometrical forms beautifully and buoyantly delineated. He is by inheritance committed to a much more varied and rational vocabulary of forms than the Romanesque artist. The products of his compass and ruler have to be balanced against architectural and lively natural forms. The rolling plastic mouldings of his geometrical compartments can be visually equated with the slim pliant limbs of Adam and Eve, and the heavy folds of God's robe. The rigid architecture yields a

52. Romanesque 'beak-heads', St Peter's-in-the-East, Oxford

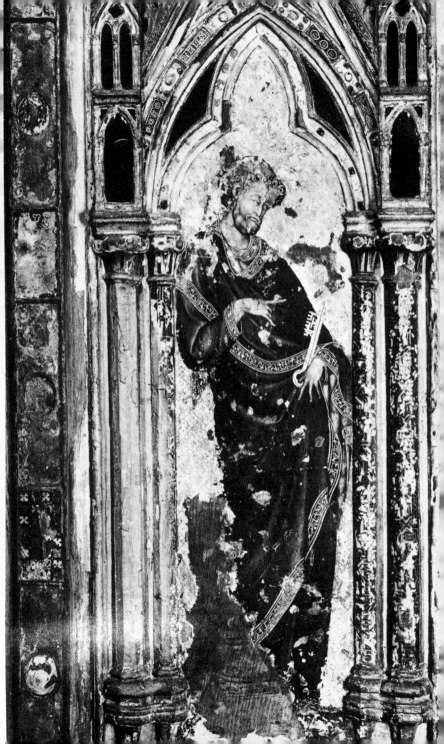

little to the naturalism of the figure compositions by throwing out leaves from the outer edge of the gable. The complex relief sculpture in the lower compartments dwindles to a single half-length figure in the trefoil within the gable, and finally to a single point of relief in the form of the rosettes of the upper trefoil, an attempt to soothe the transitions of the design. But all these visual links are insufficient to integrate the three forceful propositions, architecture, geometrical lobed compartments and figure sculpture. Each individually fights for our attention, and when we try to focus on any one of them, the others become mere irritating distractions.

In the famous 'Retable' which stands in the south aisle of the choir of Westminster Abbey (a much mutilated panel which is, like *The Douce Apocalypse*, a product of the Court School late in the reign of Henry III), the stylistic and formal vocabulary is very close to that of the Auxerre frieze. The difficulties of integration are partially avoided by keeping the figure compositions contained in the purely geometrical compartments, eight-pointed stars, right away from the compartments framed by columns, pinnacles, and gables. In the architecturally framed compartments a most subtle integration of forms is achieved [53]. The figures are large enough to make themselves felt against the architecture. The long slender columns are decorated with tiny geometrical forms picked out in gold, and similar flickering goldwork is applied to the broad hem of St Peter's robe. The curve of the Apostle's right elbow, and the gleaming folds of his cloak rising to the strong upward accent of the keys, quietly complete the quatrefoil begun by the cusped arch over St Peter's head. Most daring of all is the visual liaison between the Apostle's head and the nearby capitals. St Peter's round bearded chin, his curiously sunken cheek, and the sudden bulge of his brow with its swelling outcrop of curls exactly repeats the outline of the capitals, concave and crowned by a tight coil of leaves. A head and a capital are here equated, not because of any high humanistic theory of proportion such as caused Renaissance artists to measure off a Corinthian capital against the human head, but because the artist is aiming at a visual amalgam of the stock-in-trade of Gothic art.

I pointed out that the barbed quatrefoils at the top of the Auxerre frieze almost appear to have human or at any rate animal features and expression. In the Steeple Aston Cope, a

work of the great English school of embroidery whose pro-
ducts were called *opus anglicanum* in continental inventories and
which reached its height of productivity and technical skill in
the early fourteenth century, quatrefoils formed of vine leaves
and two grape clusters have a lugubrious human face peering
out foolishly from their centre [54]. The antique motif of the
leaf-face, revived by Gothic artists almost as the epitome of
formal equivocation, acts as a knot between a great series of
barbed quatrefoils which spread across the entire area of the
embroidery and frame figure-scenes illustrating the Passions
of Christ and of his saints. These barbed quatrefoils are no
longer the clean cut compartments of Auxerre. They are con-
structed of irregular branches of oak and ivy. The leaves which
began to undulate on the gables and crocketted pinnacles at
Auxerre, as a visual compromise with the figure-scenes, have
here swamped the dangerous firmness and autonomy of the
geometrical lobed compartments. In the Butler-Bowden Cope,
a triumph of the mature Gothic principle of the visual *con-
tinuum*, architectural forms also succumb to the softer accents
of plant-life [55]. The squat flat figures with their quick
gestures and rolling draperies are perfectly at home among
their fanciful arbours of oak leaves and acorns, gleaming with
gold thread against the bright-red velvet background. A
sparkling tangle of lines animates every portion of the design.
In view of the Butler-Bowden Cope, such eighteenth-century
rococo-Gothic experiments as those of Richard Bentley appear
by no means a travesty of the Gothic idiom [56]. St Bernard
and his meditations on the place of man in the order of creation
seem very far away.

Yet if we admired the foliage-swathed figures in the Jesse
Tree of Saint-Denis why should we not equally admire the
Butler-Bowden Cope? The fact that nearly two hundred years
have elapsed between the two works in itself argues some loss
of drive, but more important is the manifest failure of *tone*.
The peculiar alignment of leafy stems and figures in Suger's
great window represents a dramatic break-through of imagi-
native insight, at one and the same time resolving a jumble of
formal problems, illustrating a complex literary theme, and
illuminating a profound theological truth. The fourteenth-
century embroidery on the other hand has no purpose but to
give pleasure. It is purely decorative – Gothic for art's sake.

The easy linear rhythms, the light-hearted alternation of
breadth and detail, the sheer prettiness of the Butler-Bowden

Christ carrying the Cross from the Steeple Aston Cope

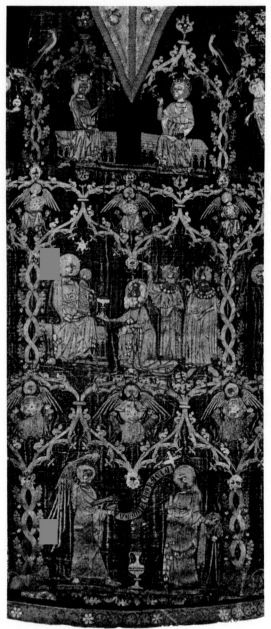

55. Central portion of
the Butler-Bowden Cope

56. Richard Bentley's frontispiece to Gray's *Elegy*

Cope are typical of the so-called minor arts in all media in the later Middle Ages. If we follow with our eye the inclined area which closes over the heads of the seated angels in the spandrels of the Cope, then move up the twisting lines of the columns to the next heart-shaped spandrels and on up the next twisting column, we have before us the essential outline of a thousand late-Gothic cups and flagons. The cup of Matthew Corvinus at Wiener-Neustadt [57] and the great silver ewer at Goslar, both of the second half of the fifteenth century, are as it were fragments of the visual *continuum*, small patches of that ebullient linear energy shared by every late-Gothic artifact be

57. The Corvinus Goblet

it a cup or a castle, an embroidered vestment or a church façade.

It may be thought unfair to present the mature Gothic style in terms of comparatively trifling objects intended solely for display, but we have descended logically enough from the west front of Reims to the Corvinus cup, and in fact the aesthetic ideal of the visual *continuum* blurs any distinction between major and minor arts. They all speak the same language. In their mass-produced household chests the *artisti ornamenti* of early fifteenth-century Florence employed the barbed quatrefoils and frames of plaited branches familiar to us from the Steeple Aston and Butler-Bowden Copes [58]. But the fluent decorative formulae of *opus anglicanum* are seen also in one of the major undertakings of Italian Gothic sculpture, the immense biblical friezes on the west front of Orvieto Cathedral, where they vie openly with Italy's solid tradition of sarcophagus-inspired figure reliefs [59].

Architecture remained a major art in the scale and costliness of its productions, but here too we find an almost pathological dread of the definite statement, an endless pursuit of ambiguity. During the classic phase of Gothic architecture, in the first half of the thirteenth century, the various elements in a building were integrated logically and lucidly. The visual effect of the interior of Reims or of the nave of Amiens is rich and magnificent indeed, but not lacking an over-all sense of noble austerity. From around the middle of the thirteenth century onwards, many self-conscious innovations and tricks of style were introduced, all tending towards more lavish ornamentation but also towards a disquieting formal equivocation.

58. Coffer painted with scenes from Boccaccio's *Decameron*

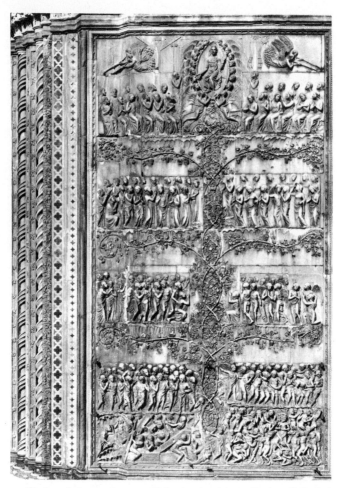

59. *The Last Judgement*, Lorenzo Maitani and assistants, Orvieto Cathedral

In the last stages of the construction of Amiens, for example, from 1258 onwards, triangular gables were placed over the choir triforium windows, on the interior. A triangular gable implies a ridged roof behind it. It is, furthermore, a useful device, on the outside of a building, for masking transitions in the shape or planes of buttresses and turrets. On the flat interior wall it is highly irrational. Inside the choir of Séez Cathedral, begun about 1270, triangular gables are displayed even more ostentatiously, over the arches of the main

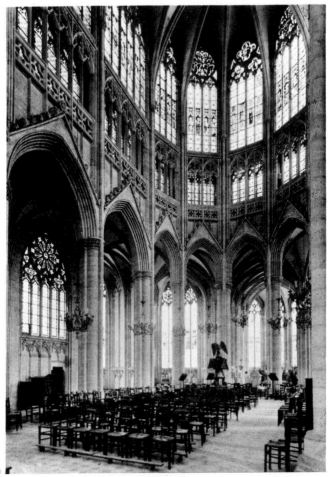

60. Interior of the choir of Séez Cathedral

arcade [60]. The arcade is in fact treated like the openings of a gigantic porch, leading into the aisles. The architectural iconography of an exterior has been transferred to an interior. A similarly mannered displacement of motifs occurs in Cologne Cathedral, whose foundation stone was laid in 1248. At Chartres, the outermost piers of the north transept porches carry figure sculpture, as part of the great assembly of 'witnesses' surrounding the gates of the New Jerusalem. Inside the choir of Cologne, the giant columns of the arcade are each

treated like the flanking piers of a porch, for they too are decorated with sculptured figures, standing on corbels and sheltered – from the inclemency of the interior – by pinnacled canopies [7]. This tendency to blur the distinction between the inside and the outside of a building reaches its dazzling climax in the octagonal western tower and spire of Freiburg Minster, completed in about 1340 [61]. Here one cannot talk of an interior or an exterior. Interior and exterior have merged. One goes inside and yet remains outside, for the whole consists of open-work tracery and stone filigree, a Gothic Folly in which the language of windows is extravagantly applied to the walls and the roofing of a building.

In 1344, four years after the completion of the Freiburg spire, the Emperor Charles iv began the construction of Prague Cathedral [62]. In the building history of this great church the emperor played the same role as King Henry iii at Westminster Abbey. The cathedral reflects his own highly cultivated taste. Certain elements in the internal decoration seem to represent his personal response to the ideals of beauty

61. Interior of spire of Freiburg Minster

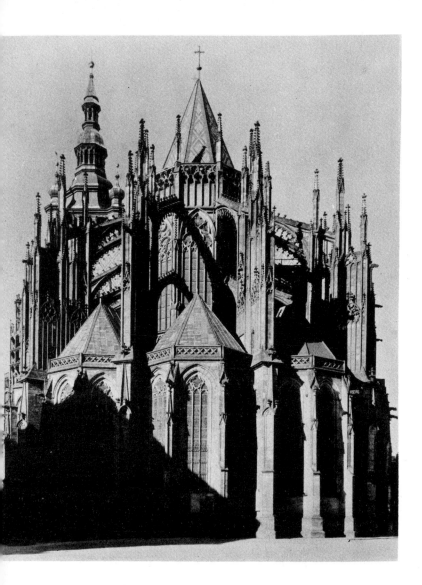

Choir of Prague Cathedral

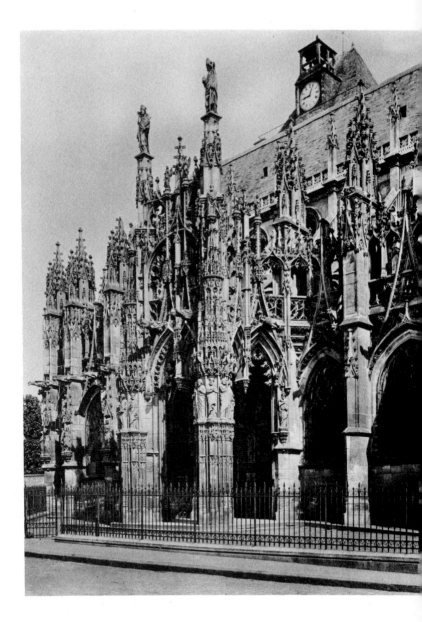

as defined by secular Romantic literature, just as had happened at Naumburg under Bishop Dietrich one hundred years earlier.

At Prague the emperor's Master Masons, first Matthias of Arras and then Peter Parler, contrived many striking examples of sophisticated ambiguity in their treatment of architectural forms. The buttresses of the eastern chapel and the choir have hardly begun their ascent before they are provided with mighty pinnacles. Pinnacles should crown and terminate the buttresses, but here they are irrationally displayed as an element in the buttresses' lower surface. The flying buttresses which tower above the roofs of the eastern chapels no longer present strong plain flanks as at Bourges, Le Mans, or Saint-Denis, but are elegantly ornamented with tracery, fantastic blind windows echoing the forms of the real windows beyond. Inside the south porch, and in the sacristy, Parler designed vaulting ribs which strike outwards from the cells behind and curve across space like the arches of flying buttresses, standing free like window tracery awaiting the glazier.

The ambivalence of late-Gothic architecture is immediately obvious in the silhouette of buildings. Long since conditioned not to commit themselves to any formal accent unless they can balance it by its opposite, Gothic architects even attempted a fantastic and ingenious compromise between the two poles of being and non-being. A Gothic building cannot simply stop, it has to fade away. Hence the familiar flurry of curves and spikes, by which the physical presence is gradually withdrawn and the dense material mass is dissolved into the empty air [63].

The west front of the church of Notre-Dame at Alençon, of the late fifteenth century, is masked by a porch, the central portion of which is in alignment with the west wall of the church while the two side portions are set askew. Standing in front of the porch the spectator has the impression that he is looking at a centralized, hexagonal building [64]. In fifteenth-century Italy the most advanced architectural theorists of the Renaissance advocated the construction of churches on a centralized ground-plan, circular, square, hexagonal, and so on, because buildings of such a form were inevitably harmonious and austere, rationally integrated in all their parts and instantly perceptible as a whole, symbols of the sublime and immutable order of creation. In the church architecture of the Italian Renaissance we find the same high seriousness and intellectual, or rather philosophical, inspirations which characterized the

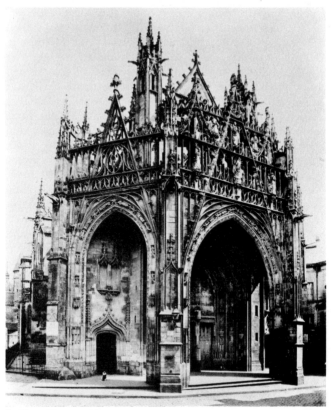

64. Notre-Dame at Alençon

first dynamic phase of Gothic. But all this is a far cry from
Notre-Dame at Alençon which is no more than a typically
frivolous piece of late-Gothic equivocation. For the diagonal
flanks of the porch in no way reveal the true form of the
church; on the contrary, they screen the front of a normal
medieval rectangular nave stretching away back towards tran-
septs and choir [65]. If the radical clash between the expecta-
tions aroused by the porch and the actual dimensions and
shape of the church seems to violate the principle of the visual
continuum, we have to remember that the *continuum* was sus-
tained by undermining the independent validity of each
particular member. Standing away from the church at the
north west we see a solid plain wall surface in the aisle coun-
tered by the flagrant gap of the entrance porch. We see the

window-frame circumscribing and controlling the interior pattern of mullions and tracery, countered by the application of tracery to the wall surface of the porch above and beyond the entrance arch. The porch negates the conventional, structurally necessary design of the side elevation.

But we may also assume that the designer of Notre-Dame at Alençon conceived his porch as a distinct pictorial unit, on which he could display the latest decorative ideas. These ideas were borrowed from the pictorial arts. The spatial devices of Italian artists – for example, the octagonal tower whose diagonally placed walls create the illusion of depth in Ambrogio Lorenzetti's *The Presentation of Christ* – were absorbed by northern artists as useful additions to their store of surface patterns [66]. A cube placed corner-on presents a more interesting and complex shape than a cube placed frontally. Northern Gothic artists invoked the third dimension only to supplement the resources of two-dimensional pattern.

65. Notre-Dame at Alençon, from the north

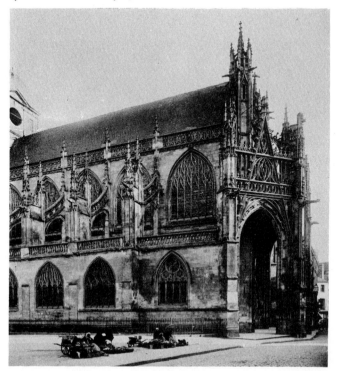

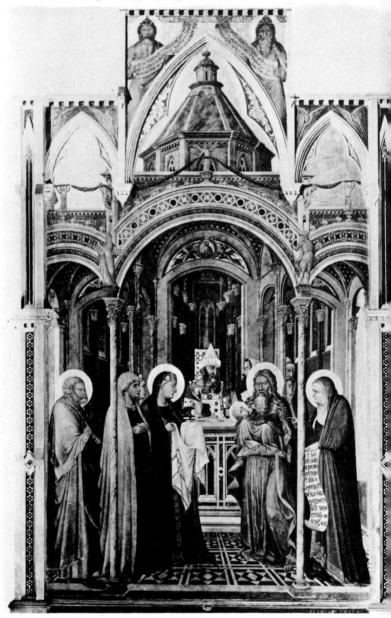

66. *The Presentation of Christ* by Ambrogio Lorenzetti

We have already met with this kind of thinking in the thirteenth-century *Douce Apocalypse*. The stem of the fifteenth-century Goslar ewer rolls away into depth so that a delightful variation of contour can strike the eye. Similarly the early sixteenth-century designer of the vaults of the chapels in the Frauenkirche at Ingolstadt suspends a series of slender ribs below the great tangle of true ribs built into the vault on the principle that two surface patterns are better than one [67].

So the diagonal placing of the side portions of the porch at Alençon gives rise to a peculiarly fascinating juxtaposition of shapes. The superb visual patterns of the gables and the elaborate window tracery of St Catherine's Church at Oppenheim, of the first half of the fourteenth century, are all presented frontally [68]. At Alençon much the same vocabulary of forms is artificially extended by utilizing the laws of visual perspective. The gables tilt away from one another so that their profiles are offered to the eye at different angles. The firm horizontals of Oppenheim are now struck across divergent planes so that in place of a line we have a pattern. The ostentatious dimensionality of Alençon is rigged with its ultimate

67. Vault in the Frauenkirche, Ingolstadt

68. St Catherine's Church, Oppenheim

69. Figure of a man from the Pepysian Sketchbook

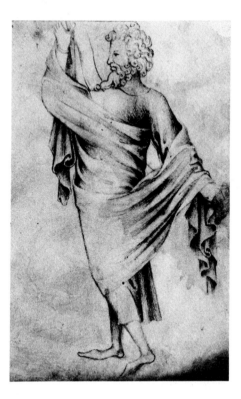

decorative effect in mind, just as the striding, gesticulating, back-turned figure drawn in the Pepysian Sketchbook, of about 1400, is valued by its designer principally as a mount for the two broad divergent streams of pleated drapery [69].

The return of Italian Renaissance architects to basic geometrical forms in their ground-plans was associated with a strong, simple, and strictly disciplined use of classical motifs in their elevations, the round arch, the column or the pilaster, so that the severe integrity of the wall mass is enhanced by its articulating members. On the west front of Notre-Dame at Alençon, wall surface exists only as a tenuous web, and mass is negated. The substance of the building is deliberately disguised and might indeed be the work of goldsmiths rather than masons. The formal vocabulary of the Alençon architect is largely abstract. His contemporary, the designer of the gallery of Ladislas II in Prague Cathedral, shows what patterns can

70. Gallery of Ladislas II, Prague Cathedral

71. Ornamental wood carving incorporating deer's antlers

be woven out of raw natural forms [70]. Here the mock rustic architecture of the Butler-Bowden Cope has its realization in real, if disagreeable, architecture. The gallery is articulated by sweeping ribs, represented as roughly trimmed branches from which sprout a pliant tracery of twigs. The Prague Gallery is only one step away from those popular late-Gothic pendant ornaments and lamps which utilize in their sophisticatedly ragged silhouettes the branching antlers of deer [71].

Earlier in this chapter I contrasted Giotto's purposeful and systematic approach to the representation of the visible world with the brilliant but haphazard efforts of northern artists such as the Masters of Naumburg and Southwell. In their work, striking realism in detail is not tied to any rationally organized system of representation. The Prague Gallery, in which cleverly imitated branches of trees play their part in a fantastic ornamental vault, is no more than a maturing of the decorative language annunciated at Southwell. The visual *continuum*, that highly artificial bond of pattern and rhythm, alone supplies a context in which individual motifs and items of the Gothic repertoire might be related to one another. The *continuum* was indeed voracious. All pictorial themes, both sacred and profane, and all forms natural or contrived, were made subject to it. This indiscriminate reduction of everything to ornament can be seen in the unsightly and loaded pages of late-Gothic manuscripts, where the selective acts of the seven days of Creation seem to be undone and chaos renewed. I illustrate two typical illuminations, one from an English four-teenth-century psalter and one from a French fifteenth-century book of hours [72 and 73]. In both, the highest theme of

72. Illuminated page from the Ormesby Psalter

Illuminated page from *Les Heures de Marguerite d'Orléans*

Christian art, the Persons of the Trinity, is locked within a careless largesse of forms. On a leathery barbed marginal band the English artist represents fat beetles and moths, buds of flowers and of ivy and wriggling plant stems, dimensionally intertangled stars and loops remarkably close in spirit to the Ingolstadt vault pattern, exquisitely delineated beasts and birds, coarse dragons and posturing human beings. The French artist lodges a hunting party and a whole forest on his page. A stream, bordered by bullrushes and flowers as large as the neighbouring forest trees, winds up the page, loosely reiterating the tight curves of the initial 'S' of '*Sancta Trinitas*'. These illuminations are executed with marvellous assurance, and they bear witness to the vitality and visual appetite of their designers. But fundamentally they represent the struggle of artists, unequipped with any intellectual foundation for their art, to give coherence to the world of visual phenomena.

Incidentally, the illuminated page from the English fourteenth-century psalter – the Ormesby Psalter – illustrated above, provides another striking example of that failure of tone which was mentioned earlier. In the pages of Queen Ingeburg's Psalter [12], religious faith and pictorial art nobly sustain one another. A hundred years later, the lush ornamentation of the Ormesby Psalter offered what was evidently a welcome distraction from the religious function of the manuscript. The cheerful idle pastimes of secular society were those with which the visual arts were now most happily associated. Carved over the length and breadth of the sumptuous fourteenth-century gittern now in the British Museum [74], we can see precisely the same heaped imagery as is painted in the

74. The Elizabeth–Leicester Gittern

Psalter – beasts in wild pursuit of one another, figures of huntsmen and foresters, squat grotesques, branches laden with foliage and nuts, and a fat dragon with outspread wings.

Throughout the Middle Ages, cultural exchanges between northern Europe and Italy were constant, and moved in both directions. Individual artists passed to and fro, and works of art were exported and imported. I have already pointed to a possible example of northern influence, in the great foliated scrolls which enclose the biblical narratives on the façade of Orvieto. Similarly, the strong swinging compositional lines in Giovanni Pisano's richly pictorial *The Adoration of the Magi* panel from the Pisa Cathedral pulpit of 1310 seem to hint at the influence of the medallion lay-out of gospel scenes in some northern psalter [75 and 76]. Certainly the motif of the rear and front viewed horse had long been part of the repertoire of northern artists [39]. Then, again, Italian art, with its concern for the accurate representation of figures in space, for figures rationally related to their setting, began little by little to infect northern painters. Timid or indiscriminate in their own approach to the world of natural appearances, they were now able to observe nature as it were at second-hand. But their work lacks the quality of directness and of real penetrating intellectual inquiry: an air of artifice appears instead, inevitable perhaps in an art built upon conscious aestheticism.

The supreme examples of the Italianization of northern Gothic painting are found among the miniatures in *Les Très Riches Heures* painted by Pol de Limbourg and his brothers for Jean de Berri before 1416. In the miniature of *The Presentation of Christ* the architectural setting is lifted in its entirety from Taddeo Gaddi's fresco of *The Presentation of the Virgin* at Sta Croce in Florence [77 and 78]. But the copy is subtly different from the original. We sense that the Italian wished to display the rules which govern the physical world, whereas the Fleming wished to display the rules which, as a sophisticated observer of international taste, he acknowledged to govern the world of art.

This is not the whole story of Pol de Limbourg. He was a great artist, whose mind and style gradually grew away – in the famous Calendar pictures in *Les Très Riches Heures* – from the brittle refinement of which he was the leading exponent. But it is as the leading exponent of international courtly Gothic that he concerns us here. In his version of *The Fall of Man*, Italian quotations abound [79]. The uncomfortably contorted

75. *The Adoration of the Magi* by Giovanni Pisano

76. Scenes from the story of the Magi from the Oscott Psalter

77. *The Presentation of Christ* from *Les Très Riches Heures* of Jean Duc de Berri.

The Presentation of the Virgin by Taddeo Gaddi, Sta Croce, Florence

Adam, to whom Eve is presenting the forbidden fruit, is borrowed from some Italian source, perhaps from Brunelleschi's Competition Relief of 1401, where Isaac is similarly posed, or from Giotto's *St Francis Receiving the Stigmata* in Sta Croce. The massive and solemn figure of God is recognizably Giottesque. The gateway through which Adam and Eve are driven into the harsh outer world is viewed obliquely, and penetrates deep into illusionary space, as also does the spectacular centrally-planned structure which encloses the fountain in the middle of Paradise. The firm skilfully modelled figures and the substantial architecture are, however, out of scale and out of character with their setting. The landscape does not behave rationally in relation to the buildings or the figures set down in it, but mounts straight up the page until it is abruptly ended by the curved wall which circumscribes this toy world of Paradise. The probing dimensional curve of the fountain-cover is repeated and yet fundamentally countered by the pure surface geometry of the garden. Touches of advanced realism, suggestions of weight and texture consistent with the style established by Giotto at the Arena Chapel one hundred years earlier, are here applied as dazzling ornaments to a design which is basically no more than a historiated initial like those found, for example, on pages painted by a Romanesque artist, the so-called Master of the Leaping Figures, in the great Winchester Bible, 250 years before [80]. Pol de Limbourg

80. Initial from the Winchester Bible

dei totaidic ·

Infidiasf cogitat lingua fua, quafi nouacula

133

is trying to have the best of both worlds. But we may feel that the two can never really blend.

Looking at Pol de Limbourg's gate of Paradise, with its long panels of delicate tracery and its flurry of beaded pinnacles, some words of the poet Spenser come to mind:

> And eke the gate was wrought of substance light,
> Rather for pleasure than for battery or fight.

This is the gate which admits unwary travellers to the deceptive 'Bowre of Blisse', described towards the close of Book II of *The Faerie Queen*:

> Thence passing forth, they shortly do arrive,
> Whereas the Bowre of Blisse was situate;
> A place pickt out by choice of best alive,
> That natures worke by art can imitate:
> In which what ever in this worldly state
> Is sweet, and pleasing unto living sense,
> Or that may dayntiest fantasie aggrate,
> Was poured forth with plentifull dispence,
> And made there to abound with lavish affluence.

Ingenious artifice vying with Nature herself has so often seemed the ideal of art, and the delicious epitome of excess. Thus Spenser's Bowre has its trailing ivy, which is in truth enamelled gold, and its vine laden with grapes which are gold also, burnished bright. Thus, too, the author of the celebrated *Travels of Sir John Mandeville* (*c*. 1360) regaled his readers with a description of the palace of the Great Chan, situated in the glamorously remote Orient, where the dining-chamber had a ceiling covered with a golden vine bearing many clusters of grapes 'all of precious stones and they are all so properly made that it appears a real vine bearing natural grapes'. The 'Bowre of Blisse' mentality, as we may term it, is characteristic of the patrons and artificers of Gothic for three out of the four centuries in which the style prevailed, but we are never more aware of it than when reading the records of the almost incredible collections of French royal plate – for example the inventory of well over three thousand items that belonged to Louis I, Duke of Anjou (died 1385), an elder brother of Jean de Berri.

One of the great gold vessels used to hold the duke's wine at table was designed as a garden surrounded by a battlemented wall, with trees growing about a fountain in which

81. Tapestry representing Charles of Orléans and his wife

people were bathing. On a gold basin, Louis d'Anjou himself and members of his household dallied in a flowery meadow – a type of subject equally popular in the tapestries of the period [81]. A golden goblet had rabbits playing on the grass at the base, while deer nosed their way between shrubs and trees on its bowl. A golden salt cellar took the form of a tree, with a brook running around its base. In illustration of a famous incident in the Romance of *Tristram and Yseult*, King Mark was represented in the branches of the tree, spying on the lovers and betraying his presence by the enamelled re-flection of his face in the enamelled brook.

82. Ivory casket carved with figures of Tristram and Yseult

83. The
Burghley

The imagery of the Romances is now most familiar from the beautiful jewel-boxes and mirror-cases carved in ivory by Parisian craftsmen of the fourteenth century [82]. But the heroes and heroines of Romance also acted out their strange histories in gold and silver. The most spectacular and fantastic of all the pieces of plate set out on aristocratic tables in the late Middle Ages was the *nef*, a great vessel in the shape of a boat. One of these splendid objects, the Burghley Nef, made in Paris in 1482–3, has silver figures of Tristram and Yseult seated playing chess before a mast of silver, under rigging of silver wire [83].

These princely toys, designed for pleasure and display, had for the most part a short life-span, all too soon pawned or broken up and melted to pay their improvident owner's debts. Lorenzo Ghiberti in his *Commentaries*, written shortly before 1455, preserves for posterity the memory of one Gusmin, 'a most skilful sculptor, of great talent', who ended his days as a hermit, after seeing all his creations destroyed to meet the Duke of Anjou's financial needs.

A distinguished survivor from the great lost treasure of the French royal households is the marvellous gold and enamelled cup in the British Museum, probably made in Paris for King Charles v, eldest brother of Jean de Berri, sometime before his death in 1381 [84]. In an inventory of his successor Charles vi's possessions, the cup is described as

a *hanap* of gold, all its cover well and richly enamelled on the out-side with the Life of Madame Saint Agnes; and the cresting of the foot is garnished with twenty-six pearls, and the crown round the

cover with thirty-six pearls; and the finial of the said cover garnished with four sapphires, three rubies, and fifteen pearls. And it weighs nine marks three ounces of gold ...

Although stripped of much of its jewelled ornament, it is still unsurpassably rich in colour, and splendidly represents the glittering extravagance and superb craftsmanship enjoyed by some of the most sumptuous art patrons of all time.

The handsome gold tabernacle in the treasury of Altötting in Bavaria, though designed not as a showpiece for a royal table but for a chapel altar, is doubtless typical also of hundreds of vanished masterpieces of secular plate [85]. It was given to Charles VI by his wife as a New Year's gift in 1404. The king kneels on a platform and adores the Virgin and Child. Next to him a noble attendant supports his crowned helm. Below the platform, the king's white horse is waiting, its bridle held by a second attendant. The Virgin and Child with their angel companions sit in a characteristic enchanted garden. Behind the Virgin rises a trellis of gold rods, bearing cascades of enamelled blossoms and jewelled fruit.

Long before the life-time of Gusmin and his fellow goldsmiths, the courtly poetic imagination had already created the likeness of their luxurious artifacts. In *Cligés*, Chrétien de Troyes' most flagrantly fantastic Romance, the capture of a certain town is to be rewarded with a cup of great price, weighing fifteen marks of gold.

The cup will be very fine and rich, and is to be esteemed more for the workmanship than for the material of which it is made. The cup and the workmanship are fine, but to tell the truth, the precious stones on the outside are worth more than the workmanship or the gold

Cligés indeed does not merely anticipate specific Gothic *objets d'art*. The tone of the entire Romance accords with the nature of the artistic works which we have studied in this chapter. The story moves freely from Greece to England, from France to Germany, but all these places are the same and society is truly international. The narrative is sometimes cursory and swift moving, sometimes extraordinarily dense and static as the hero or heroine enter upon their complex self-analyses. The plot is laggard and diffuse to a degree, but generally traces the fortunes in love of two pairs of lovers, first Alexander and Soredamors, then, in the next generation, Cligés and Fenice. The latter are exquisite doll-like creatures who

may well strike the modern reader as calculating, cruel, and immoral. Yet Chrétien is at pains to depict his leading characters as spectacularly beautiful and gallant. Soredamors works a strand of her gleaming hair into the fine stitching of an embroidered shirt. The threads of real gold tarnish, but the strand of hair grows ever brighter. Cligés wins every bout in a jousting contest lasting several days, and on each day he presents himself clad in gorgeous armour of a different colour.

85. The *Goldenes Rössel*

86. Armour for a horseman and a horse

As we admire the spiky splendour of late Gothic armour, it is easy to visualize Cligés' proud entry into the lists [86]. Throughout the Romance, the deliberate ostentation which passes for virtue in the hero, the transitions from breadth to detail, and back again, in the treatment of the narrative, the gossipy inconsequence of the literary style, the strange combination of licence and stiff decorum in the actions and psychology of the protagonists, the delight in artifice, the self-indulgence, brittle naïvety, and the lack of heart and moral centre which vitiates the whole story, exactly agree with the visual arts as they developed under aristocratic lay patronage in the late Middle Ages – beautiful, mannered, precious, and shatteringly superficial in their aims and methods.

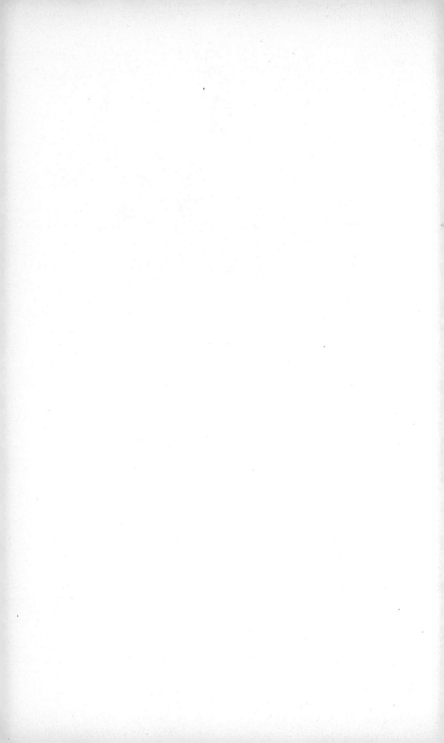

4

Art and Mysticism

> All Solomon's sea of brasse and world of stone
> Is not so deare to Thee as one good grone.

So George Herbert, writing in the tough aphoristic style of the seventeenth-century metaphysical poets, demolishes the pretensions of the cathedral-builders of the twelfth and thirteenth centuries. They had poured wealth and religious zeal into massive materializations of the Heavenly Jerusalem,

lest if we were standing mute in His praise [as Abbot Suger puts it], we might therefore incur a diminution of His benefactions and hear that terrible voice, 'There are not found that returned to give glory to God.'

But, declares Herbert, all the elaborate mechanism of institutional worship gives less glory to God than the heartfelt contrition of the individual sinner. At first sight this looks like a typically Protestant sentiment, but it was in fact shared by many of the most creative exponents of medieval Catholicism and had a deep influence on the development of Gothic art.

Long before the Reformation, a fierce consciousness of the individual's responsibility towards his Maker and Saviour had grown up alongside the great political, legal, and sacramental organs of Western Christendom. This sense of personal responsibility expressed itself in an intensely subjective use of conventional Catholic imagery. For example the traditional image of the Bride of Christ, firmly anchored by St Bernard of Clairvaux to the whole community of Christians, was cheerfully arrogated to herself by Margery Kempe, whose *Book* is a mine of information about the odd twists of late-medieval piety.

And then the Father took her by the hand in her soul before the Son and the Holy Ghost and the Mother of Jesus and all the twelve Apostles ... saying to her soul, I take thee, Margery, for my wedded wife, for fairer, for fouler, for richer, for poorer ...

Thomas à Kempis makes sensational use of similarly disproportionate imagery.

The righteous Solomon, King of Israel, edified a rich temple to the praising and worshipping of thy name by the space of vii year and for viii days hallowed the feast of the dedication of the same.... How dare I then, cursed and right poor among other creatures, receive thee into my house, I who scarce can know that I have well passed and employed one hour of time?

Thomas feels certain scruples, but he is nonetheless bent on substituting himself for the monumental masonry of a cathedral. These quotations from fourteenth- and fifteenth-century mystical writers make it clear that, in the later Middle Ages, religion has turned personal and introspective. The passage from Thomas à Kempis helps, incidentally, to explain the vacuity of so much late Gothic Church architecture. It had ceased to represent anything vital.

This change in the general religious outlook of medieval Europe begins at least in part with the curious speculations of an Italian hermit called Joachim of Fiore who lived in the second half of the twelfth century. Joachim had brooded over the strange prophecies and exotic visions of the Apocalypse of St John the Divine, and in his Commentary on the Apocalypse he foretold that in the year 1260 a new age would dawn in the history of the world, the thousand years' reign of the Saints, when, after appalling sufferings at the hands of Antichrist, a select portion of mankind would experience a kind of perpetual Pentecost, enjoying direct spiritual communion with God. Joachim's book caused wide excitement, and even the hard-headed lawyers of the papal curia began to be on the lookout for the signs and omens which would herald the new dispensation.

It is against the background of Joachim's speculations that we can best understand the extraordinary social and religious experiment of St Francis and his early followers. The Franciscans' strict avoidance of money and women, their shabby clothes patched with rags, their manual labour, their association with lepers, above all their earnest pursuit of martyrdom for the Faith which drove St Francis into the Moslem strongholds of the Levant, were all designed to mark out the Franciscans as 'the redeemed of God among men, the first fruits unto God and the Lamb' who according to St John would inherit the earth in the age of the Saints. Their way of life was not only, as is commonly thought, a return to Gospel traditions of Apostolic poverty. It was also an advance into the Wonderland of the Apocalypse.

The crucial year 1260 passed without incident, other than the shocking exertions of the Flagellants summoning all men to repentance, and it became apparent to all but the incorrigible few that Joachim lacked the gift of prophecy and that no New Age was to come. The official view of the church was expressed by St Thomas Aquinas in his *Summa theologica*. There could be no new revelation of the truth, since the Holy Spirit had communicated to the Apostles all that was necessary for human salvation. And in the fifteenth century Thomas à Kempis wrote sadly 'I must be content with the true faith.... '

Yet the spiritual excitement caused by the Apocalyptic speculations of Joachim, especially its noblest manifestation in the life and example of St Francis, did in fact herald a new epoch in the history of medieval religion. The idea of the outpouring of the Holy Spirit, which had been expected in 1260, continued to haunt the religious consciousness of Europe. In her *Book* Margery Kempe claims that she often heard 'a manner of sound as it had been a pair of bellows blowing in her ear'. This she interpreted as the Holy Spirit breaking in on her soul. The great mystic John Ruysbroeck would rush off into the forest of Soignes near Brussels to write feverishly, under the apparent compulsion of the Holy Spirit, breaking off stunned and unable to add one word when inspiration ceased.

In Chapter i of the Apocalypse we read:

I was in the Spirit on the Lord's day, and heard behind me a great voice, as of a trumpet, saying, I am Alpha and Omega, the first and the last: and, What thou seest, write in a book

Although speculations about the meaning of the Apocalypse might prove a broken reed, the religious experience recorded by St John, ecstasy, inspiration, and finally vision, set a standard for late-medieval piety. The Flemish Ruysbroeck under the trees, and a fourteenth-century English solitary who retired to Farne Island, consciously emulated the author of the Apocalypse. It is not merely St John's likeness but theirs also that we can see in Altdorfer's painting of St John on the Island of Patmos, gazing spellbound at the great spectacle of the woman clothed with the sun [87].

What were the consequences for art of this new religious outlook? Even back in the twelfth century we occasionally find an explicit link-up between a work of art and the idea of inward vision. In his book *De principis instructione*, published

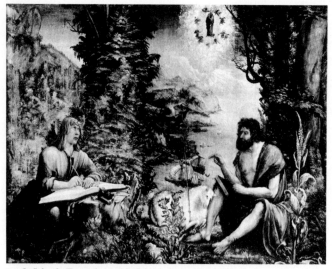

87. *St John the Evangelist and St John the Baptist* by Altdorfer

about 1216, the Welsh cleric and patriot Gerald of Wales tells
a story about a certain wall painting which, he says, was exe-
cuted in the king's chamber in the castle at Winchester on the
orders of Henry II, the great Plantagenet ruler of England and
half France. Henry's anxiety over the unfilial behaviour of his
sons had crystallized in his mind in the form of a picture of a
royal eagle pecked and harried by four eaglets.

> Thus first of all [says Gerald], his mind foreboding evil, he in-
> wardly depicted to himself coming afflictions caused by his children,
> and then bringing his mental picture out into the light, he had it
> painted by an artist.

Here the inward vision which pre-conditions the work of art is
the patron's, not the artist's. The artist is merely a tool, an
extra hand. Unfortunately Gerald's description of the painting
makes it perfectly plain that neither the artist nor the patron
had moved into a world of genuinely subjective imagery. The
wall painting at Winchester has not survived, but it must have
looked exactly like the illustrations of the Pelican or the bird
Epopus, pecked and bitten by its offspring, found over and
over again in the illuminated manuscripts of the great medieval
collection of animal-lore known as the *Bestiary* [88]. Either
King Henry's visual imagination was constricted by pictures

he already knew, or his artist settled for the conventional image which most closely approximated to his patron's 'vision'.

More interesting as early examples of the impact of personal visual imagination on art are the illustrations in the prophetic books of St Hildegarde of Bingen, a twelfth-century seeress about whom St Bernard had some doubts [89]. As an imaginative writer Hildegarde was a sort of talentless Dante, and as a recorder of religious experience she represents not so much mysticism as mystification. She tried to invest her opinions on theology, morals, and politics with the validity of divinely inspired revelations, and each chapter in her books begins with the words 'I saw'. Always, after she has run the full course of her obscure pictorial allegory, there is a heavenly voice near at hand to say what it all means. The best analogy for the illustrations in Hildegarde's books is offered by the engravings in seventeenth-century works on alchemy, in which the metals and other ingredients of scientific experiments are personified,

88. Drawings of birds from the Cambridge *Bestiary*

89. A *Vision* of St Hildegarde of Bingen

and their action on one another represented in grossly anthropomorphic ways, sometimes to very odd effect. Hildegarde's visions have an unmistakable air of intellectual contrivance about them, and of course the imaginativeness of the illustrations is entirely second-hand. Nevertheless, these illustrations are of historical interest. They mark the beginning of the close bond between Gothic religious imagery and the exciting mental life of the mystics.

At the bottom of each picture Hildegarde is represented seated pen in hand. Her presence identifies the illustration with the original vision, making the picture a portrait of a state of mind. Similarly, in the extensive series of elaborately illustrated Apocalypse manuscripts produced in England in the second half of the thirteenth century, St John is often represented peering through the narrow door into heaven, as if the accompanying vision was dependent on his being there to see it [90]. And the same motif of the seer presiding over his vision

90. *St John Looking into Heaven*, from an English Apocalypse manuscript

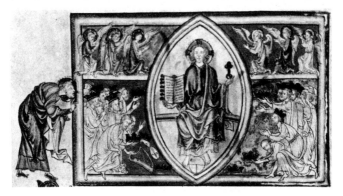

was to be taken up at the very close of the Middle Ages by the great German painter Albrecht Dürer.

Dürer was familiar with the late-medieval block books of the Apocalypse, themselves descended from the thirteenth-century English manuscripts, and in 1498 he published a splendid sequence of Apocalypse illustrations which rounds off the whole Gothic tradition. In his Trinity altar-piece of 1511, Dürer represents himself like St John on Patmos, standing alone on a wide landscape while the vision of the crowded court of heaven blazes overhead [91], and in the panel of the

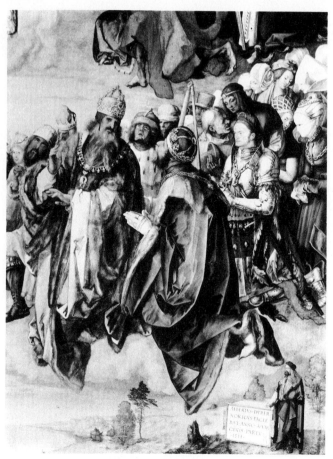

91. Detail from Dürer's *Adoration of the Trinity*

Martyrdom of the Ten Thousand Christians he wanders as in a dream through the midst of the savage spectacle. During the night between Whit Wednesday and Whit Thursday 1525, Dürer woke in terror from a frightful dream in which he saw enormous spouts of water descend from the sky on to an immense plain. As a passage from the Prophet Joel read in church during the season of Pentecost says:

I will pour out my Spirit upon all flesh . . . and your young men shall see visions and your old men dream dreams And I will shew wonders in the heaven above, and signs on the earth beneath.

92. Dürer's *Dream Vision*

Dürer made a water-colour drawing of his dream vision, on which he wrote, 'I painted it above here as I saw it. God turn all things to the best.' [92]. Here at the end of the Middle Ages no line can be drawn between the pictorial imagination of the artist and the inspired vision of the mystic.

How soon did the personal imaginativeness of the artist, in the sense of his own inward fancy or fantasy, become a factor in Gothic pictorial art? A standard for the lengths to which such personal imaginativeness can go is provided for a great many people, I suppose, by the fifteenth-century Flemish painter Hieronimus Bosch. Bosch has been hailed as a precursor of the Surrealists. Visual imagery certainly seems to have poured up out of his subconscious as words poured out of the subconscious of his fellow countryman Ruysbroeck. But much, of course, of what came out had previously gone in. Just as the pictorial imagination of William Blake, the late eighteenth-century mystical painter-poet, was nourished on a wide range of visual material, supplied by earlier artists, and on ideas acquired from his reading of esoteric religious literature, so we can trace motifs in Bosch's pictures back to earlier works of art, or, significantly, to the writings of the medieval mystics. For example, the great cavalcade which encircles the pool in the background of the Prado *Earthly Paradise* is an elaboration of the procession of the attendants of the Magi,

bearing monkeys and leopards behind them on their saddles, in Gentile da Fabriano's *Adoration of the Magi* painted for Sta Trinita in Florence in 1423. In Bosch's own *Adoration of the Magi* in the Prado a sinister looking man in fantastic costume lurks with some scowling companions at the entrance of the stable [93]. This weird figure subtly conveys an impression

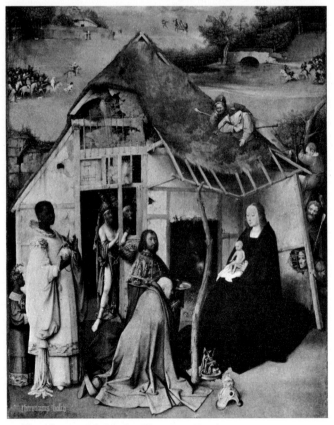

93. *The Adoration of the Magi* by Hieronimus Bosch

of anxious embarrassment mingled with open hate. He would seem to illustrate a passage in the fifth book of *The Flowing Light of the Godhead* by the thirteenth-century German mystic Mechthild of Magdeburg:

When the strange star shone, Satan came to Bethlehem, following swiftly after the three Kings, and looked angrily on the Child,

for highest honour was done Him with rich gifts. Satan was in great perplexity . . .

But Bosch's relationship to the mystics was not confined to this kind of literary inspiration or literal borrowing. Many of his pictures suggest that the psychology of the late-Gothic artist was exactly the same as that of the mystics. This is true especially of two very extraordinary works, the first, in the Prado, a view of the world from outer space, his most cosmic design, and the second his most stiflingly claustrophobic, the *Carrying of the Cross* at Ghent. These pictures can be compared with two highly characteristic passages in the writings of Thomas à Kempis and Dame Julian of Norwich.

In the *Imitation of Christ*, Thomas à Kempis prays for illumination of mind and says to God:

Send out thy light and thy truth that they may shine upon the earth, for I am idle earth and void till thou illumine me . . . wash my soul with that heavenly dew, minister waters of devotion to water the face of the earth, to bring forth good fruit and of the best.

Bosch was likewise attracted to the description in *Genesis* (Chapter ii) of the creation of the world, when a mist went up from the earth and watered the whole face of the ground [94]. He visualizes the huge globe hanging in space, its scale reducing God to a tiny figure enthroned in one corner of the heavens. Above the rim of gleaming waters the first stirrings of vegetable life are to be seen, already coiled and pointed in perverse shapes.

Bosch is equally evoked by the convincing account of a nightmare contained in *Revelations of Divine Love*, the book written by the fourteenth-century mystic Dame Julian. Julian says:

I began to sleep. And in the sleep, at the beginning, me thought the Fiend set him on my throat, putting forth a visage full near my face, like a young man's and it was long and wondrous lean: I never saw none such. The colour was red like the tilestone when it is new burnt, with black spots therein like black freckles. His hair was red as rust, clipped in front, with full locks hanging on the temples. He grinned at me with a malicious semblance, shewing white teeth: and so much me thought it the more horrible. Body nor hands had he none shapely

This description anticipates the peculiar horror of the Ghent *Carrying of the Cross*. Bosch's panel contains nothing but faces,

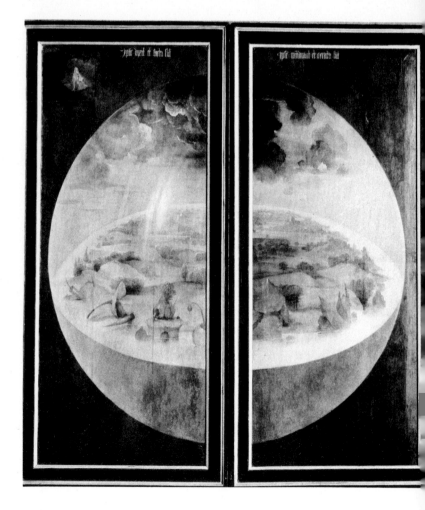

94. *The Creation of the World* by Hieronimus Bosch

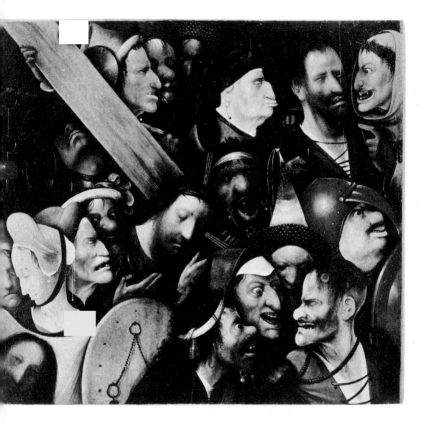

The Carrying of the Cross by Hieronimus Bosch

which press up against one another in the lurid half-light, the passive pale face of Christ with eyes shut against the throng, the stricken faces of the thieves, and the flushed lunatic faces of the executioners, with bulging eyes and swollen lips contorted with malice [95].

Both these pictures by Bosch have an authentic strangeness, as if they recorded sights seen in a dream. The literary parallels which I have quoted in connexion with them are distinguished examples of the highly introspective thought processes of the mystics. Thomas à Kempis applied the huge image of the emerging world to his own inner consciousness, while for Julian a nightmare was a significant religious experience. We may assume that for Bosch too the process of artistic creation was deeply subjective.

The earliest Gothic artist in whom we sense the genuine touch of original imaginativeness is the nameless illuminator of a fragmentary psalter manuscript dating to about 1260 and now in the library of St John's College, Cambridge. Among his many strange and powerful illustrations of the Old and New Testaments, one is outstanding [96]. It represents significantly enough a vision, the appearance of three men or three angels to Abraham, recorded in *Genesis*, Chapter xviii. In the Middle Ages these three men or three angels were sometimes interpreted as the three Persons of the Trinity, and it is God in Trinity whom we see here. Abraham is on his knees beside a marble throne, on which an awesomely tall, obviously supernatural Being is seated. Its vast mantle, broken in great triangular folds, cascades about its long feet with their curiously separated toes. Its tiny hands are flung up in a rigid hieratic gesture. Above the shoulders fantasy breaks loose. Three identical heads, with short curling hair surrounding the brow, and faces fixed as if in a trance, grow upon three serpentine necks, the side ones curving slightly outwards.

It is easy enough to trace the various pictorial precedents by which this particular version of the vision of Abraham was conditioned, the English and the French biblical manuscripts from which the artist selected a motif here, a motif there. But he goes beyond his models, or rather, at some point in the creative process, his models coalesced in his mind, under the pressure of an original imagination, and this strange and numinous image was thrown up. The artist who devised this image of the Trinity was in advance of his time. At the close of

96. *Abraham Adoring the Trinity*, from an English psalter

97. *The Last Judgement* from *Les Heures de Rohan*

the Middle Ages it had become quite commonplace to represent the Trinity as a three-headed man, but back in 1260 it was unknown. The physical monstrosity and the awesome proportions of the apparition are means to an end. The artist was evidently trying to convey the impact of a supernatural vision – that vision of God which caused St John the Divine to write: '. . . and when I saw Him, I fell at His feet as dead.'

In the manuscript which the great French artist known as the Maître de Rohan illumined for Yolande d'Anjou in the first quarter of the fifteenth century, we find another equally striking representation of God, in which the Persons of the Trinity are intermingled in rather a different way [97]. God is seated on a rainbow, while below him the dead rise from their graves. In the common run of medieval pictures of the Last Judgement it is Christ the Mediator who sits on the rainbow. Many attributes of Christ are visible here – the thin naked body, the bleeding wounds, the crown of thorns. But the face, the reverend white beard, the white hair, are those of God the Father. This image reveals an extraordinary and original penetration of the deepest wells of pathos. One is reminded of the words of a compassionate spectator in Shakespeare's *King Lear*:

> A sight most pitiful in the meanest wretch,
> Past speaking of in a king . . .

The Maître de Rohan's Judgement picture is of great interest for the light it sheds on the relation of late-Gothic pictorial imagery to the religion of the mystics. At Chartres the great figure of God in the central tympanum of the west front represents the Father in the likeness of the Son in accordance with the dominical saying: 'he that hath seen me hath seen the Father.' But to represent the Father with the special attributes of the Son, as the Maître de Rohan does here, is almost shocking, and recalls the ancient Sabellian heresy which regarded the Father and the Son as mere aspects of one divine Person. This picture must have disturbed any fifteenth-century man who saw it.

In the mind of the artist two quite distinct images – the Son as Man of Sorrows, the Father as an old white-haired king – have become conflated by an unprecedented leap of the visual imagination. The Latin meditations of the English fourteenth-century solitary of Farne Island contain a verbal parallel for this unusual mingling of attributes. Significantly enough, the

whole tenor of the solitary's writings is his fear of Judgement Day. He addresses God by the composite title '*Domine Sabaoth, amabilis Jhesu*', running the terrible war-God of the Old Testament into the gentle Saviour of the New.

In its immediate effect of oddness, the astonishing incongruity of the imagery, the picture by the Maître de Rohan is in keeping with the visionary experiences of the mystics. Often when a vision or 'showing' comes suddenly upon the mystic he is unable to comprehend it. In the *Legenda Gregorii* we read that St Francis saw a vision of a seraph standing over him, with its hands and feet nailed to a cross. 'When the blessed servant of God saw this, he was filled with the very greatest astonishment, but what the vision portended he could not guess.' And a vision of Julian of Norwich, in which she saw the Father enthroned in majesty and the Son as a ragged labourer, was so obscure to her that she took twenty years to wrest the full significance from it.

The miniature painting of the Last Judgement by the Maître de Rohan has introduced us to one of the most familiar themes of later Gothic art – the suffering Saviour full of wounds and pain. This theme is so important that it is worth detailed consideration. The idea that Christ, though ascended into heaven, still suffers, can be traced back to the twelfth century. St Bernard believed that the Church on earth was destined to endure temptations, heresies, schisms, and persecutions, since in his earthly life Christ had suffered, and the historical precedent established by the Head was to be followed figuratively by the Body, the Church. St Bernard applied this mode of thinking to the specific situation of an insurrection of the Roman populace against Christ's Vicar, Pope Eugenius III. In a letter to the Romans, St Bernard wrote,

What affects the head cannot but affect the body . . . when the head is suffering, does not the tongue cry out for all the members that the head is in pain, and do not all the members confess by means of the tongue that the head is theirs and the pain too?

This grotesque anthropomorphic image is given a further highly significant twist by St Bernard in his comments on the failure, personally embarrassing to him, of the Second Crusade. The Christians in the capital of Christendom, Jerusalem, were in distress. In sympathy for the sufferings of the geographical head, the spiritual Head also suffered. Christ's passion, says St Bernard, is renewed.

This idea was taken up by Gerald of Wales as part of his personal campaign to blacken the character of King Henry II. In 1185 the affairs of the Latin Kingdom of Jerusalem were desperate and the Patriarch of Jerusalem came to England to beg Henry to intervene. Gerald's anger at Henry's refusal found its outlet in two 'visions' which he records in his book. He claims himself to have seen the heavens open, and Christ seated on a throne. The Apocalyptic basis of this 'vision' is obvious. Then the place was filled with armed men, who flung Christ off his throne and pierced his side with a lance. Gerald attributes the second vision to a monk, who witnessed a duel between King Henry and Christ. The King 'struck the Lord on the brow, so that the blood was seen to flow from His face'. This is the earliest reference which I know to the theme of Christ the Jouster, 'in arms peynted all bloody', familiar in Langland's poem of *Piers Plowman*.

These references to the risen Christ tortured anew, physically affected by specific happenings in the world, introduced something new into the conception of God, an area of vulnerability not hinted at, for example, in St Bernard's image of the tranquil Judge sitting and sustaining the perpetual order of the Heavenly Jerusalem, nor in the serene and majestic iconography of early Gothic art. The Church Militant as St Bernard defined it, torn with dissensions and full of flaws, seems to be extending its bounds, encroaching on the territories of the Church Triumphant. For St Bernard and Gerald of Wales, such ideas were little more than rhetorical devices, adding piquancy to a political argument. But in later centuries these ideas became the very basis of the mystics' view of Christ. Just as they tended to overemphasize the misery of Christ's life on earth – 'All Christ's life was a cross and a martyrdom', says Thomas à Kempis – so they visualized him as continually suffering in heaven. He is not, as for St Bernard, the victim of specific historical betrayals only, but the perpetual scapegoat for all men's sins, great and little alike. Mechthild of Magdeburg pictures Christ standing before the Father as intercessor for sinful Man and still suffering the pains of his passion. 'For so long as sin endures on the earth, so long will the wounds of Christ remain open and bleeding.' When Christ appeared in this condition to the ten-year-old St Bridget of Sweden and she asked him, 'Lord, who has done this to thee?', he replied, 'Whoever despises me and spurns my love does this to me.'

Not to despise, not to spurn, but instead to be continually sensible of the pains which God had taken on Man's behalf, was the great aim of the medieval mystics. For them the supreme model of sensibility, after the Virgin Mary to whom Simeon had said, 'a sword shall pierce through thy own soul also', was St Francis of Assisi. In *The Book of the Three Companions* we read: 'So wounded and melted was his heart by the memory of the Lord's passion that always while he lived he bore the marks of Christ's wounds in his heart.' Not only there. It was believed that during the last two years of his life St Francis had borne actual marks in his hands and feet resembling the nails which fixed Christ to the cross. St Francis's reception of visible stigmata was regarded by the late thirteenth-century writer Jacobus de Voragine as a tribute to the 'vehemence of his imagination'. Other mystics exercised their sympathetic imagination in identifying themselves not with Christ but with his companions at Calvary. Ubertino da Casale, writing his autobiography in 1305, tells how he devoted each day of the week to meditations on the events in Christ's life, sometimes conceiving himself transformed into St John or the Virgin or the dying thief. And Julian of Norwich says, 'Methought I would have been that time with Mary Magdalene. . . .'

'Therefore,' Julian continues, 'I desired a bodily sight wherein I might have more knowledge of the bodily pains of our Saviour.' A 'showing', an actual sight of Christ's sufferings, would make compassion more intense. Such a 'showing' was given to Margery Kempe during her visit to the Holy Land.

It was granted to this creature to behold so verily his precious tender body all rent and torn with scourges, fuller of wounds than ever was a dove house full of holes, hanging on the cross with the crown of thorns on his head, his beautiful hands, his tender feet nailed to the hard tree . . . then she fell down and cried with a loud voice, wonderfully turning and wresting her body on every side, spreading her arms abroad as if she would have died.

But home again at Norwich, Margery behaved in exactly the same way, crying out and weeping 'as if she would have died'. This time she was driven into hysterical exhibitionism not by a vision but by 'a fair image of Our Lady, called a Pity' (Pietà), that is a statue of the Virgin with the dead Christ on her knees [98]. So here again Gothic art and the inward experiences of the mystics meet.

The *Pietà-Roettgen*

The terrible Christ on the cross at Cologne, a flayed corpse stretched out on a scaffold of rough wood, the muscles knotted and bulging, the veins striating the limbs, the rib-cage bursting through the skin, the stomach fallen in, and the blood rolling from hands and feet and brow and side, is a 'showing' for Everyman, the mystics' flash of insight captured, frozen, inducing 'pure pity and compassion' in the hearts of all spectators [99]. If Saint-Denis and Chartres were the Gothic equivalent or rather extension of 'Solomon's world of stone', we have now arrived at the perfect visual counterpart of 'one good grone'.

The crucified Christ at Cologne is strikingly paralleled by a condemned soul in the early fourteenth-century Last Judgement relief on the façade of Orvieto Cathedral, a product of the workshop supervised by the Sienese Lorenzo Maitani [100]. The German figure is suspended by the great nails piercing its hands: the Italian hangs by one arm from the devouring maw of a dragon. Both figures are brilliantly composed and modelled to show the human body under violent stress, and both are marked by an unstinting realism. The fervently emotional Gothic type of crucifix had already appeared in Italy in the work of Giovanni Pisano. The Orvieto sculptor was doubtless familiar with it himself from imported ivories and textiles, whose influence is marked elsewhere on the façade. But he had filled out the thin anguished Gothic type by reference to some antique model. The Orvieto figure's air of melodrama, the way in which the bony frame and the muscles are over-accentuated to produce a richly rolling surface, even the carving of the hair in separate snake-like locks, are strongly evocative of heroic and heavily naturalistic Hellenistic sculptures like the *Dead Gaul* in the Museo Archeologico in Venice.

Italy's vast visual inheritance from classical times had never ceased to influence Italian art but, only a few years before the Orvieto façade was designed, the first conscious, almost academic, effort had been made by the great sculptor Nicola, working in Pisa and Siena, to recreate, for their own sake, the formal values, the gravity and naturalism, of antique sculpture. This attempt to reanimate the art of an admired civilization, backed up by a growing conviction that modern genius might match that of the ancients, gave rise to a radical thoroughgoing professionalism among Italian sculptors.

A second inscription, placed in 1310 by Nicola's son Giovanni around the base of his pulpit in Pisa Cathedral, presents sculpture as a hard and exacting branch of science having its own cognoscenti.

Giovanni has encircled the rivers and parts of the world trying to learn much and to prepare everything with heavy labour. Now he exclaims, 'I have not been sufficiently on my guard. The more I have achieved, the more hostile injuries I have sustained. But I bear the pain with indifference and a calm mind.' So that I [the pulpit or the inscription] may take away from him this envy and mitigate his sorrow, and call forth due honour, add to my verses the moisture [of your tears].

These words could come straight from the justificatory preface to a mystic's spiritual autobiography. But it is Art which Giovanni has suffered for, and pursued so single-mindedly, not Lady Poverty or the personal vision of God. The work of art is there to secure the spectator's respect for the artist's unique skill and learning and to gain his sympathy, even his tears, for the person of the artist.

The Cologne crucifix was also intended to hold the spectator in awe, to move him to tears. But its harsh and uncompromising realism was not intended primarily to display the artist's knowledge of art and nature. It was intended to reflect knowledge of the kind Julian of Norwich prayed for, knowledge melting into compassion, knowledge of the bodily pains of the Saviour. Late Gothic realism represents an attempt to give the work of art the immediacy of the actual event. The way in which the religious imagination of the mystics went out after the vivid circumstantial details is revealed in the 'showing' which was actually granted to Julian. When she lay ill, her chaplain brought in a small portable crucifix and held it near her eyes. She looked at it fixedly, and after a time her imagination invested it with the kind of detail which could really wring her heart. She saw actual blood begin to trickle down the brow from the crown of thorns and drip 'like to the drops of water that fall off the eaves after a great shower of rain'. The body turned red and then black as the flesh shrivelled up on the bones. The ideal work of religious pictorial art would have such telling details built into its structure.

And all His disciples and all His true lovers suffered pains more than their own bodily dying. For I am sure by mine own feeling that the least of them loved Him so far above himself that it passeth

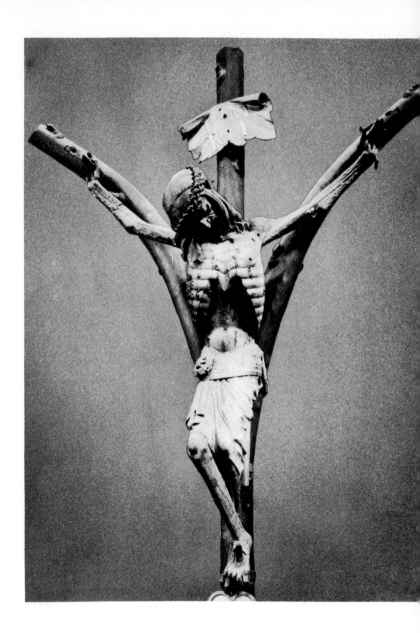

99. Crucifix in St Maria im Kapitol, Cologne

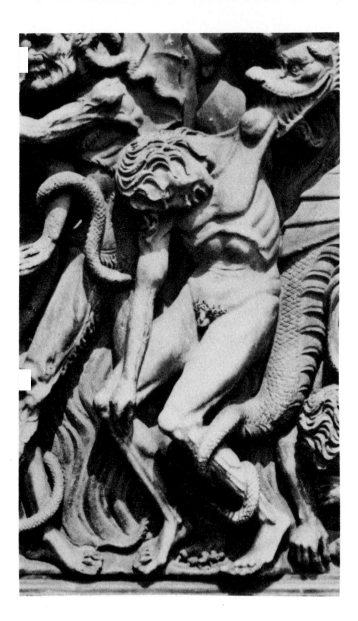

100. *Soul in Torment* by Lorenzo Maitani, Orvieto Cathedral

all that I can say. Here I saw a great one-ing betwixt Christ and us, to my understanding, for when He was in pain, we were in pain

Here Julian of Norwich outlines the theory of the relation between God and Man which characterizes late-medieval piety and late-medieval art, a unity, a bond, not intellectually known but felt in the heart. As we have seen, the Gothic style came into being when artists began to express formally the inter-connexion of all the members of Christ's Church in the supreme unity of the New Jerusalem. This intellectual notion of the interconnexion of heaven and earth, the careful evalua-tion and control of the data provided by the senses so that visible things should bear the stamp of the perpetual order of heaven, resulted in the essentially classic art of the cathedral-building age. In the late Middle Ages a new bond emerged, that of imaginative and emotional sympathy with the suffering Saviour, and inevitably Gothic art changed not only in content but in form. The great formalized all-inclusive compositions of the early Gothic cathedral façades were replaced by records of specific moments in sacred history, in the form of dramatic-ally isolated self-sufficient works of art. Religious art of the early-Gothic period is like the decoration of a great and stately chamber. The best analogy for religious art in the late-Gothic period, on the other hand, is the poster, spasmodic, sharp, appealing instantly to the eye and to the emotions. Late-Gothic artists illustrate a different notion of the one-ness of God and man from that of their predecessors. To them, men were brothers, and sons of God, in their capacity for compas-sion and contrition. These are deep feelings. Hence the subli-mation into art of the deepest, most subjective, mental imagery of artists and writers, and their search for a sensational and compelling visual language.

This passionate, highly individualistic piety was at one and the same time kept under control and stimulated by the established power of the Catholic church. The centre of popular devotion was of course the sacrament of the altar. The unvarying replies of humble recusants recorded in the inquisi-tions under Queen Elizabeth leave no doubt as to what aspect of the Catholic religion mattered most to the common people at the end of the Middle Ages:

Elizabeth Wilkinson, wife of William Wilkinson, Milner, sayeth she cometh not to the church because there is neither priest, altar, nor sacrifice. Margaret Taylor, wife of William Taylor, tailor, sayeth

she cometh not to the church because there is not a priest as there ought to be; and also that there is not the sacrament of the altar . . .

For faithful Catholics the Host was God and yet hid him. Thomas à Kempis says: 'I have thee very present, though thou art hidden under a strange likeness.' So, on his knees before the Sacrament, the late-medieval worshipper summons the aid of his imagination, to take him beyond the appearance. Hence a picture like the *Pietà de Nouans* by Jean Fouquet, where the donor kneels among the throng of disciples before the sacrificed body of Christ [101]. The composition is dominated by the raking lines of the arms and legs of Christ as he slides into a horizontal position on the knees of the Virgin. All the other figures are foreshortened and represented kneeling. The spectator too is forced to his knees in conformity with the painted figures. Both in its deliberately gauche realism, and in its formal devices to involve the spectator physically in the spatial image created before his eyes, Fouquet's altar-piece anticipates the Vatican *Deposition* of Caravaggio, a notable example of the striking power of Baroque religious imagery. Even when traditional piety gave way in Europe to the worship of Man as a social or political animal, the compulsive realism and power of communication inherent in the great emotive image of the dead Christ survived. We see the realism in Rembrandt's *Anatomy Lesson of Dr Tulp*, and the power of communication in the polemical paintings of dead heroes of the Revolution by Louis David. The bleeding corpse, suddenly

101. The *Pietà de Nouans* by Jean Fouquet

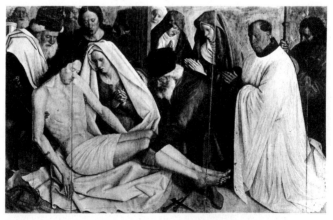

confronting the eyes, even finds its place, by an historical irony, as one of the stage effects of the Gothick novel.

The mystics whipped up their sensibility towards Christ not only by imaginative reconstructions of the minute-to-minute progress of the Passion, but also by a sentimental scrutiny of the detailed circumstances of the Nativity. The selection of Christ's infancy as a theme for meditation was natural enough. It was in the stable at Bethlehem that the paradox of Christ's fusion of God's omnipotence and Man's weakness could be sensed most acutely, equalled only by the paradox of the death of Life on the cross. In the seventeenth century John Donne responded memorably to the fascination of the Nativity story when he exclaimed, 'The Word, not able to speak a word!'

The desire for more information than the bare Gospel narrative provides, which was the *raison d'être* of so much of the rambling literature contained in the New Testament Apocrypha, caused mystical writers to elaborate and supplement, to make the story of Christ's birth more immediate and more moving. The mentality of the historical novelist is in evidence even back in the thirteenth century. One of the best-known Nativity descriptions occurs in *The Mirror of St Edmund*, a series of meditations written in Latin before 1240, and translated into English in the mid-fourteenth century.

> The time was midwinter, when it was most cold, the hour was at midnight, the hardest hour that is. The place was mid-ward of the street in a house withouten walls . . .

Later in the thirteenth century, Mechthild of Magdeburg elaborates the story of the Nativity still further:

> Mary took Joseph's rough saddle cloth Which the ass had worn under its saddle, And put to that the upper part of her shift, Under which she had carried our Lord In these clothes She wrapped the sublime saviour, and laid him in the crib. There he wept as a new-born child, For when they cannot speak children cry in need . . .

Mechthild imagines herself interviewing the Virgin. 'I asked Mary where Joseph was. She said, He has gone into the town, to buy small fish and common bread and water to drink.'

All this talk of rags and penury did not at all suit Margery Kempe, that solid member of the fifteenth-century merchant class who paid her way from Norwich across Europe to Jerusalem and back again. Pushing herself forward as usual she appoints herself maid-in-waiting to the Virgin, and sees to it personally that everything is fit and proper.

And then went the creature forth with Our Lady to Bethlehem, and purchased her shelter every night with great reverence, and Our Lady was received with glad cheer. Also she begged for Our Lady fair white cloths and kerchiefs to swathe her son in, when he was born, and when Jesus was born she provided bedding for Our Lady to lie in with her blessed son.

In spite of all her neatness and efficiency Margery weeps continually as she tends the Virgin and Child, remembering the dreadful death he was to die. This darker aspect of the implications of Christ's birth is poignantly conveyed by one of the last and greatest Gothic images of the Virgin and Child, the panel of the Isenheim Altar by Grünewald [102], which shows

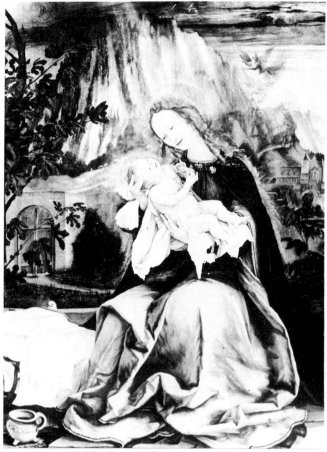

102. *Virgin and Child* by Grünewald

the happy smiling mother holding her newly bathed baby. The towel in which she wraps him is the rent and tattered loin-cloth which the gigantic figure of Christ crucified wears on the outer panel of the altar-piece. Even discounting these moments of hind-sight which release the full floods of Margery's compassion, her day-dream of the Nativity reflects a genuinely religious feeling, the desire to keep uppermost in her consciousness the important fact that Christ entered the world for the love of Man.

In the town museum at Dijon there is a beautiful picture of the Nativity painted in the early fifteenth century by the Maître de Flémalle [103]. When we compare this picture with, say, the courtly spectacle of the Adoration of the Magi created

103. *The Nativity* by the Maître de Flémalle

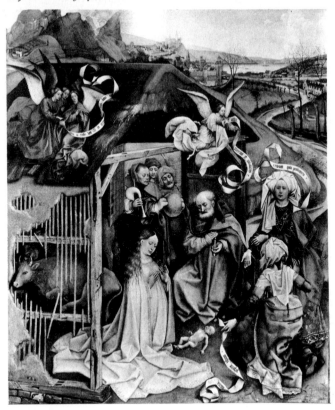

by Pol de Limbourg, the clumsy sincerity and almost raw realism of the Dijon panel become fully apparent [104]. The glamour and the elegance of the courtly style, its exquisite fancifulness, above all its surface pattern which equates flags with clouds, lithe animals with gorgeously dressed men, has been replaced by the light of common day. The Dijon panel can, of course, be interpreted as an assertion of *bourgeois* values against those of the Court. The Maître de Flémalle and his successors worked for middle-class patrons, practical self-reliant businessmen occupied in building up the financial and political power of the trading cities of the Netherlands. The patrons' realistic attitude to men and affairs is paralleled by a new accuracy and rationalism on the part of artists, a steady

104. *The Adoration of the Magi* from
Les Très Riches Heures of Jean Duc de Berri

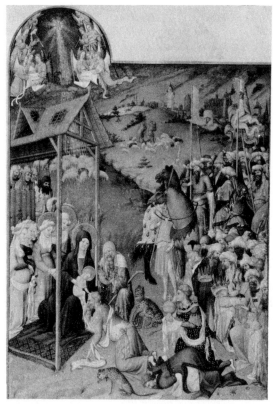

growth in their control over their visual environment. Inevitably, Gothic gives way to a full-bodied and strongly secular style which we recognize as belonging to the period of the northern Renaissance and the Reformation.

But this is not the whole story. We have seen the queer mixture of religious passion and prosaic detail in the writings of the eminently *bourgeoise* Margery Kempe. The kind of pietistic literature on the theme of the Nativity which I quoted above, the eye for detail, the consideration of circumstances, the desire to *know*, is perfectly evoked by the Maître de Flémalle's panel. The thatched hut with its shattered walls, the real road winding away into the distance between bare trees, the awkward lumbering figures of Joseph, Mary, and the midwives, forcing their way into pictorial space, the sober, almost despondent expressions on their faces, are a direct record of the re-animation of Gothic art by strong religious conviction. This art tries to represent the truths of the Christian religion in their most tangible and accessible form. Late-medieval drama, with its elaborate stage equipment, its colloquial speech, its bold anachronisms, worked towards exactly the same ends. Back in 1144 the rituals attending the consecration of Saint-Denis had appeared to the King of France and his nobles as 'a chorus celestial rather than terrestrial, a ceremony divine rather than human'. The dramatic spectacles of the late Middle Ages, and, closely linked with them, the artistic monuments which so often have the appearance of 'stills' from a film, urgent yet frozen, deliberately portrayed God as he had revealed himself in history, subject to the conditions of terrestrial existence.

Centuries later, when the heroic achievements of Renaissance and Baroque artists had blocked men's minds to the beauty and purposefulness of the old northern tradition, Sir Joshua Reynolds, the great English academician, offered the following definition of the Painter's art at its best:

> The whole beauty and grandeur of the Art consists in being able to get above all singular forms, local customs, particulars, and details of every kind.

How different was the attitude of late-medieval artists! Drawing strength and conviction from themes inherently sublime, they created an absolutely concrete imagery, full of homely, authentic, telling detail. The Apostles at the Last Supper were represented in a fifteenth-century dining-hall, tiled and beamed,

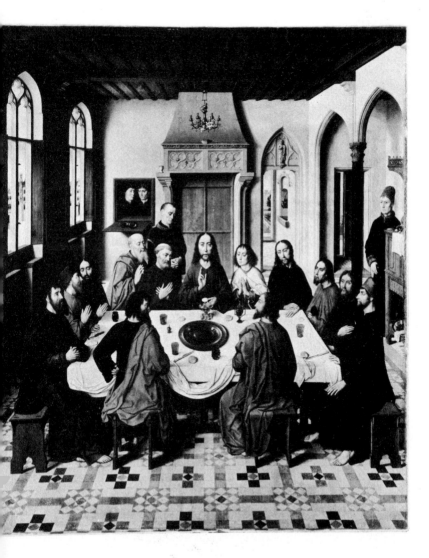

or St Elizabeth shown in a neatly furnished fifteenth-century bedroom, or the holy women at the Tomb set in a landscape of rocks and shrubs, with a carefully observed medieval city in the background [105, 106 and 107]. Ignore the religious motive for all this accurate detail and you have the portrait, the still-life, the genre scene, the landscape, and the city-scape – all those categories of art which Reynolds regarded as fundamentally second-rate. He thought that only by rising above such particulars could art achieve its true end, which was 'to strike the imagination' of the spectator. A vast historical and ideological gulf separates the *Discourses* of Reynolds from the theory and practice of late-medieval artists. These men were originally led to observe and record in scrupulous detail all aspects of their own immediate environment by this same desire, 'to strike the imagination'.

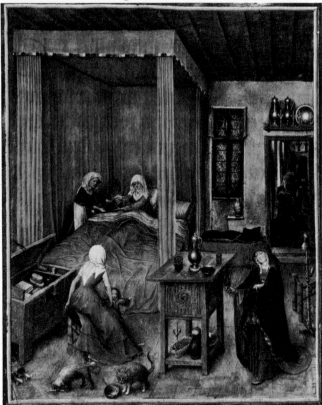

106. *The Birth of St John the Baptist* from *The Hours of Turin*

107. *The Three Maries at the Sepulchre* by Hubert van Eyck

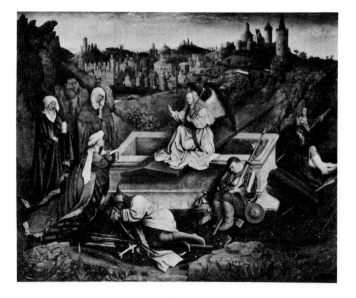

5
Postscript

In the previous chapters of this book I have tried to define the Gothic style, outlining the social and intellectual conditions which shaped it, the formal rules or habits which guided its progress, and the ideas which it was designed to convey. I hope that my interpretation of this complicated subject is not out-of-line with the known or guessable attitudes of the men who worked for four hundred years within the unchallenged framework of the Gothic style. The Gothic age began in the second quarter of the twelfth century and lasted until the second quarter of the sixteenth century. After that time, of course, Gothic did not cease to exist as an aesthetic and intellectual phenomenon. Every successive generation down to our own has offered its own personal interpretation of the style, either in written commentary or practical emulation. A fascinating mass of literature – critical, polemical, scholarly – and a rich array of artistic monuments – some of them of a surprising beauty – bear witness to the vital rôle played by the Gothic style in the cultural development of post-medieval Europe.

The idea of medieval art as being a distinct phase in the history of art and as having certain stylistic features peculiar to itself first appears in the writings of Italian fifteenth- and sixteenth-century theorists and critics. Italy's classical heritage was, as I pointed out in the previous chapter, a vital factor in the development of Italian art, but until the fifteenth century the influence of antiquity was balanced by other influences, and no one thought of being a purist. Filippo Brunelleschi's researches into classical architecture, its techniques and its visual harmonies, heralded a hardening of attitudes. An absolute standard of artistic excellence, consciously based on the authority of Greek and Roman antiquity, was proclaimed in Italy. By this standard all the artistic monuments of the post-classical age, that is, all the works in the 'modern' as opposed to the good antique style, were judged and condemned.

At the very moment when Italian artists and theorists were asserting themselves as the exclusive heirs of Roman culture, it became apparent that the impure 'modern' style must have been forced upon unwilling Italy by invaders, first by the notorious Goths and Lombards, who in the fourth and fifth centuries had squatted on the wreck of Roman civilization, and in later centuries by their successors, the Germans. A *Report* on the antiquities of Rome, addressed by a member of Raphael's circle to Pope Julius ii, contains the notion that the 'modern' or 'German' style of architecture, with its pointed arches and overshading ribbed vaults, had its origin in the forests of northern Europe, where a barbarian people, ignorant even of tree-felling and carpentry, had constructed rude shelters by hauling together the branches of trees. For centuries Italian architecture was corrupted by the crude empirical methods of foreigners. The German manner was regarded by Giorgio Vasari as 'lacking everything that can be called order'. Some improvement in architecture was brought in by Arnolfo and Giotto in the late thirteenth and early fourteenth centuries, but even they, said Vasari, continued to ignore the measurement and proportion 'required by the art' and depended too much on their own undisciplined invention. The crude ugliness of early-medieval art and its subsequent slack fancifulness, as commented upon by Renaissance writers, were of course strictly artistic failings. There was never any intention of criticizing the function of artists in society or the religious ideology which they served. It was their lack of technical skill and formal knowledge which was condemned and which proved their work to be barbarous or 'Gothic'.

By the seventeenth century, Italian ideas about the origins and nature of Gothic art and architecture had passed into common currency north of the Alps, as part of the general spread of Renaissance cultural values. Vasari's theory of 'Gothic' – that it was the invention of the historical Goths and the very essence of disorder in the visual arts – appears in the heroic poem entitled *Alaric, ou Rome Vaincue* by Georges de Scudéry, published in Paris in 1654. In the first Book, a heavenly messenger swoops down on Alaric's palace on the shore of the German Ocean, and summons the valiant King of the Goths to deeds of glory. Alaric's palace is *d'un éternelle Structure*, without rule or art. In it, the classical orders have capitulated to Gothic disorder. But the poet does not share Vasari's absolute contempt for Gothic architecture.

Unlike Vasari he has first-hand knowledge of the great medieval buildings of France, of cathedrals like Reims or Paris, and he is evidently conscious of their power. In his description of Alaric's palace, de Scudéry emphasizes its irregular natural grandeur. Its columns are formed of masses of rock. The palace lifts into the sky 'ambitious towers, vaulted staircases, spacious chambers', from whose roofs vast festoons of flowers hang, so numerous and heavy that one cannot tell by what means they are suspended.

Here we seem to be touching upon the theory of the natural origin of the Gothic style, first proposed in the early sixteenth century by the author of the *Report* on the antiquities of Rome. This theory is fully explicit in the *Dissertation touchant l'architecture antique et l'architecture gothique*, published in 1699 by J. Félibien, secretary to the Académie française. Félibien subdivided Gothic architecture into ancient and modern Gothic, the first – corresponding to our Romanesque – excessively ponderous, and the second – our Gothic – excessively light and fanciful. The ancient type took its character from the caves and grottos in which the northern peoples had lived in primitive times, the modern type from bowers formed in the woods by the spreading intersecting leafy branches.

The 'natural analogy', whereby Gothic architecture is related to raw natural forms, whether mineral or vegetable, continued to find favour in the eighteenth and nineteenth centuries. Perhaps its most famous expression is Goethe's exultant eulogy of Strassburg Cathedral, of 1772.

> It rises [he wrote] like a most sublime wide-arching Tree of God, which with a thousand boughs, a million twigs, tells forth to the neighbourhood the glory of God

Later, the great English philosopher, critic, and poet, S. T. Coleridge, discerned a Gothic quality in St Michael's Cave, a spectacular stalactitic cavern at Gibraltar, which he visited in 1804:

> . . . the long grooves and ribs – the crown upon crown, a tower of crowns, the models of Trees in stone, here a row of tall slender Pine Trees, or whatever else are thin and tall, branching only at the top, with branching Stems . . . all forms of ornament, with niches for Images not there. Excepting that there were no Saints or Angels, it was perfect Gothic Extravaganza . . . [108].

Historically inaccurate and misleading as the 'natural analogy' is, there is about it a sort of poetic justice. The

108. St Michael's Cave, Gibraltar

designer of the Percy Tomb permitted leaves to sprawl along the edge of his high gables. The architect of the Frauenkirche at Ingolstadt wove a pattern of artificial twigs across his chapel vault. In Prague Cathedral the builder of the Ladislas Gallery covered the whole surface with rough hewn branches and fluttering stems all ingeniously carved in stone. Gothic artists, in the late, mature, and ultra-sophisticated phases of the style, had themselves fashioned visible proofs of the natural, primitive, and artless quality of their art.

In northern Europe in the sixteenth century, the rapidly hardening Protestant tradition had brought its own sweeping charges against the art and culture of the Middle Ages. In his *Praise of Folly* and his *Manual of the Christian Knight* Erasmus of Rotterdam condemned sculptured and painted representations of sacred persons as idolatrous.

It was never revealed to the Apostles [he wrote] how divine adoration should be paid at the same time to our blessed Saviour in heaven and to his picture below on a wall, drawn with two fingers held out, a bald crown, and a circle round his head.

Erasmus linked the false gods of antiquity with the modern painted saints. 'The Christians have now their gigantic St George as well as the pagans had their Hercules.' These opinions, published in English early in the sixteenth century at the famous printing press of Wynkyn de Worde, became commonplace in this country as the century progressed. In 1562, in the course of a sharp rebuke to an erring clergyman, we find Queen Elizabeth interpreting idolatry as the 'gross absurdity' even of attempting to portray the Trinity, the saints, or the angels. The visual records of medieval piety were little by little blotted out from English churches. The Tudor government passed a long series of decrees against them, and they fell victim also to the fanaticism of the Puritans during the Civil War. Some of the notes made by the ferocious Dowsing while on his iconoclastic mission through East Anglia in the early 1640s have a fine cosmic ring: 'We gave orders to take down eighteen cherubim.'

Erasmus provided his own and future generations with a forceful vocabulary of hate for yet other aspects of medieval civilization. The ancient and elaborate system of the Religious Orders was represented by him as mere obscurantism and confusion. The various Orders had multiplied 'as if the common name of Christian were too mean and vulgar'. The religious instruction offered to the faithful by monks and friars was 'hard gibberish'. They and their 'needless trash' will meet, at the Judgement, 'a shameful repulse'. Erasmus also condemned the medieval philosophers – the Schoolmen, or Scholastics – who 'trifle away their misspent hours in trash and babble.' With words like 'tough', 'crabbed', 'clamorous', 'obstinate', he helped to veil for centuries the organic and disciplined

systems of medieval theological and philosophical speculation.

109. Vault of Henry VII's Westminster Abbey

In *The Advancement of Learning* (1605), Francis Bacon notes that in the past the medieval philosophers have been regarded as 'barbarous', but he does not regard them as barbarous so much as narrow and over-subtle. He sees in their work 'a kind of quickness and life of spirit', 'an infinite agitation of wit', but 'no soundness of matter or goodness of quality'. They

spin out . . . those laborious webs of learning which are extant in their books . . . cobwebs of learning, admirable for the fineness of thread and work, but of no substance or profit.

In *The Elements of Architecture*, published in 1624, the sturdily Protestant Sir Henry Wotton comments thus on the pointed arch:

These both for the natural imbecility of the sharp angle itself, and likewise for their very uncomeliness, ought to be exiled from judicious eyes, and left to their first inventors, the Goths and Lombards, among other reliques of that barbarous age.

Here is Vasari's aesthetic judgement being retailed to a northern audience likely to receive it with a conviction born of the Protestant creed. We may be sure that these Goths and Lombards had tonsured heads! Similarly the comment of the diarist John Evelyn, that the Goths introduced 'a certain fantastical and licentious manner of building, of the greatest industry . . . sparing neither pains nor cost', is broader in its implications than the Italian original, and conjures up Bacon's picture of the scholastic spiders. So also does Sir Christopher Wren's contemptuous judgement on the great pendant vault of Henry VII's chapel in Westminster Abbey – 'nice embroidered work' [109]. The same idea, sunk down almost into the subconscious, may underlie Nicholas Hawksmoor's practical anxieties about the repair and restoration of the fabric of Westminster Abbey. The vault of Henry VII's chapel 'is so tender', he wrote in 1734, 'that one cannot tell how to brush down the cobwebbs'.

We are not now dealing with the Gothic style as something close to Nature, primitive and artless. It is rather the result of perverted ingenuity, and everything that is *natural* belongs emphatically to the opposite camp, that of the honest and rational antique style. In his *Anecdotes of Painting* (1762) Horace Walpole, dilettante son of the first British Prime Minister, writes that the medieval priests

110. A Gothic stage design by F. da Bibiena

exhausted their knowledge of the passions in composing edifices whose pomp, mechanism, vaults, tombs, painted windows, gloom and perspectives infused such sensations of romantic devotion; and they were happy in finding artists capable of executing such machinery.

Here a medieval building such as Westminster Abbey is interpreted in terms of Baroque illusionism, of the kind commonly found in Catholic countries after the Council of Trent, and which appeared briefly in England in the reign of Charles I, when François Dieussart designed a machine for the Queen's Chapel at Somerset House, to exhibit the Holy Sacrament in a majestic setting of mounting clouds and singing angels.

Walpole was not the first to link Gothic and Baroque. Back in 1715, in the introduction to *Vitruvius Britannicus*, Colen Campbell lamented the repudiation by recent Italian architects of the serene Renaissance-classical style of Palladio, and saw in the free, vehement, and extravagant manner of Borromini (1594–1667) a style verging dangerously on the Gothic. In Italy itself, early in the eighteenth century, Gothic and Baroque were visually amalgamated by the Bolognese artist Ferdinando da Bibiena, significantly enough in the context of the theatre. A number of Bibiena's spirited and original stage designs contain Gothic forms, borrowed from Italian Gothic buildings such as Milan Cathedral [110]. His particular flair was for the grandiloquent architectural vista, and his draughtsmanship is hectic. Consequently his interpretation of Gothic is richly baroque, melodramatic and emotionally overwrought.

Horace Walpole's view of Gothic architecture was conditioned by Deism, the eighteenth century's religion of common sense. Deism rejected crudities such as dogma and revelation, and damned all priests as crafty degenerates, the enemies of liberty and right reason. Matthew Tindal writes:

> Natural religion was easy first and plain –
> Tales made it mystery, offerings made it gain.
> Sacrifices and shews were at length prepar'd,
> The priests ate roast meat, and the people stared.

For the eighteenth century, Gothic architecture was one of the finest of these 'shews'. As the philosopher David Hume remarks ironically:

If that theology went not beyond reason and common sense, her doctrines would appear too easy and familiar. Amazement must of

necessity be raised, mystery affected, darkness and obscurity sought after.

So when Walpole speaks of the 'well-applied obscurity' of Gothic churches he is implying that the Gothic style is the visual counterpart of medieval theology. In this he is doubtless correct, though for the wrong reasons.

At Strawberry Hill, Walpole built himself a rambling Gothic mansion, 'imprinted', as he says, 'with the gloomth of abbeys and cathedrals' [111]. Walpole was drawn to the Gothic style because he saw in it an escape from the humdrum, the

111. The staircase at Strawberry Hill

familiar, the conventional. Like his older contemporary, Hume, he believed that the 'imagination delights in whatever is remote and extraordinary ... in order to avoid the objects which custom has rendered too familiar to it'. According to Hume:

Imagination has liberty to transpose and change ideas, as in poems and romances, where Nature is totally confounded and nothing mentioned but winged horses, fiery dragons, and monstrous giants.

At Strawberry Hill, Walpole wrote *The Castle of Otranto*, a Romance whose chief protagonist is a monstrous giant. Significantly, he calls *Otranto* 'a Gothic story'. In local colour and visual detail it may not strike a modern reader as any more Gothic, in the historical sense, than, say, *Romeo and Juliet*, but Walpole considered it Gothic because the plot allows for supernatural intervention.

In his house and his writings, Walpole was prepared to try anything that tempted 'genius out of the beaten road'. Like all educated men he knew that Gothic ignored the rules by which 'the rational beauties of regular architecture' had been established. But from a reading of Ben Jonson and Dryden it was clear that the god of the English, William Shakespeare, had also violated classical rules, but nonetheless stood high above all rivals. In a fascinating footnote in the *Anecdotes of Painting*, Walpole drifts from Westminster Abbey to *Macbeth*. Both were devised by men possessed of a thorough knowledge of human nature. Commenting on *Macbeth* he says:

Addison's *Cato* is a regular drama, *Macbeth* an extravagant one: yet who thinks the genius of Addison equal to Shakespeare's? The one copies the rules, the other the passions

In consequence, the fact that 'one only wants passions to feel Gothic' was enormously to the credit of the style.

Eighteenth-century assumptions about the emotional content and stage effects of Gothic architecture are founded on false premises and are wholly irrelevant to a serious interpretation of the Gothic Cathedral. Reims and Amiens have nothing to say to our passions, except perhaps to calm them. But the 'Baroque analogy' is useful and has meaning when we turn to the medieval pictorial arts, about which, incidentally, the Age of Enlightenment was largely ignorant. We have seen that emotional response and involvement were deliberately sought

for by the painters and sculptors of the late Middle Ages. The mood and presentation of much late-Gothic pictorial imagery does actually point towards the Baroque, as I suggested in the case of Fouquet's *Pietà*. The theories of eighteenth-century writers about the meaning and purpose of Gothic art are therefore not altogether wide of the mark. And at any rate, the conviction of Walpole and his like, that Gothic artists had investigated an area of experience, an imaginative world, beyond the range of classical art, is still a valid one.

*

In 1699, Florent le Comte in his *Cabinet des singularitéz d'architecture* drew a parallel between the fantastical refinements of 'modern' Gothic (as opposed to ancient Gothic, or Romanesque) and Arabic architecture and ornament. Fourteen years later, Sir Christopher Wren wrote on his *memorial*:

> This we now call the Gothic manner of architecture (so the Italians called what is not after the Roman style). . . I think it should with more reason be called the Saracen style. For these people wanted neither art nor learning, and after we in the West lost both, we borrowed again from them, out of their arabick books.

He goes on to give an imaginative account of the light, part-prefabricated, architecture of the Saracens, the materials of which were carried to building sites on the backs of camels. Of this light architecture, with its small component stones and its pointed arches, 'the Crusado gave us an idea'.

Nowadays it is generally allowed that the broken or pointed arch, as an isolated visual element, may well have entered European building practice from the Near East. Employed occasionally in southern Italy in the second half of the eleventh century, it evidently spread from Italy to Burgundy, thanks perhaps to contacts between the great southern monastery of Monte Cassino and Burgundian Cluny. The pointed arch was used in the late eleventh century and early twelfth century in the abbey of Cluny and its dependent churches. Subsequently it was taken over by the Gothic architects of the Île de France. The Saracens' contribution to the creation of the Gothic style amounts to no more than that they were responsible for promoting, in buildings not otherwise influential, a kind of arch which certain Romanesque architects later found interesting and which, later again, was found to fall logically into place as part of a great, original, essentially Christian mode of

artistic and intellectual expression invented in northern France – namely, the Gothic style.

To call Gothic 'the Saracen style' is certainly a grotesque exaggeration. But this interpretation of Gothic appealed to the eighteenth-century mentality. Regarded as an interesting oriental infection, caught by Europeans in the course of their muddled wars and diplomacy in the Holy Land, Gothic became exotic. Gothic art, like that overriding passion of the eighteenth century, *Chinoiserie*, could stand for all that was strange and far-away. Belief in the eastern origin of Gothic was easy to reconcile with the idea of Gothic as a symptom of medieval intellectual perversity; it was well known that the 'arabick books' of the philosopher Averroes lay behind the dense contortions of Scholasticism.

The Saracenic interpretation of Gothic art and architecture accorded well also with the eighteenth century's conception of social and political conditions in the Middle Ages. This conception, when not merely a matter of 'the dark cloister's mystic rites', was dominated by the idea of Palestine. Every knight's effigy in every country church was that of a returned or intending crusader. Strawberry Hill, for all its ecclesiastical gloomth, would not have been regarded as genuinely medieval without one or two visual reminders of the Crusaders. And so Walpole crammed his armoury with Near- and Middle-Eastern junk, spears and shields of rhinoceros hide, 'all *supposed* to be taken by Sir Terry Robesart in the Holy Wars'.

The climax of the popular fixation with the Crusades is represented by Sir Walter Scott's novel *Ivanhoe*. Scott's picture of English medieval civilization, split between two cultures, Saxon and Saracenic, is often splendidly bizarre. Into the home of the solid stay-at-home Saxon Cedric, whose swineherd swears homely oaths like 'By St Dunstan', comes the sinister cosmopolitan crusader, Knight of the Temple, bringing with him airs from the East. His short battle axe, we are told, was richly inlaid with damascene carving. He flusters the bystanders by conversing in an unknown language with his two Moslem slaves, 'whose dark visages, white turbans, and the oriental form of their garments showed them to be natives of some distant eastern country'. Scott later describes the Jewess Rebecca at the house of a wealthy Israelite in the village of Ashby de la Zouch, sitting on heaped embroidered cushions in an apartment 'richly furnished with decorations of an oriental taste'. This is the early Gothic age as it appeared to

the generations who enjoyed Montesquieu's *Lettres persanes* and Beckford's *Vathek*. In 1804, Scott's elaborate account of Rebecca's domestic ease is thoroughly up-to-date, and charmingly imposes upon twelfth-century Leicestershire the atmosphere of Ingres' *Grande Odalisque*.

Curiously enough Sir Walter Scott, mingling Froissart's *Chronicle* and *The Arabian Nights*, produces a literary picture of the Middle Ages not too remote from that displayed in the authentic poetic Romances. Scott's lush orientalism can be paralleled in Wolfram von Eschenbach's *Parzival*, finished in 1211. Gahmuret, Parzival's father, enters the service of The Baruch, Caliph of Baghdad.

Greener than emerald was his riding gear, splendid with silken *achmardi* [Arabic *azzamradi*, 'emerald-green'] His manly strength won him renown among the heathen in Morocco and Persia. Also elsewhere at Damascus and Aleppo and wherever knightly prowess was shown, in the country of Arabia and before the town of Arabi

He travels to the Kingdom of Zazamanc.

Proudly rode his personal attendants after the squires, twelve young men of noble birth, well-bred and of graceful demeanour, several of them Saracens Forthwith Gahmuret had his best clothes brought, and put them on. They were, as is reported, most costly. Heavy anchors of Arabian gold were embroidered on them

From passages such as these it is clear that the men of the thirteenth century had as powerful day-dreams, and felt the strong allure of the mysterious East as forcibly, as any of their eighteenth- and nineteenth-century descendants.

The theory which traced the Gothic style to the impact of Saracen culture upon the crusaders contained an element of truth in that it recognized the definite strain of exoticism in mature Gothic design. The historical rationalization was inept, but the underlying sensitivity to atmosphere was somewhat acute. Consequently we should not despise the visual or literary reconstructions attempted by Horace Walpole and his admirer Walter Scott. After all, the staircase at Strawberry Hill, leading up to the recesses of the armoury, is no more frail and affected, and Scott's Ashby de la Zouch is no more delectably oriental, than that superb late-Gothic fantasy, the *Presentation of Christ* in *Les Très Riches Heures* [77].

*

I have touched briefly on some of the ways in which the Middle Ages and medieval art were mythologized by various eminent men of letters from the sixteenth century onwards. Mythologized Gothic was, as it were, materialized at Strawberry Hill and the numerous other monuments of the English eighteenth-century 'Gothic Revival'. Gothic 'revived' in eighteenth-century England in as much as the patron class, or at any rate certain influential members of the patron class, ceased to scorn the old style and began instead to identify themselves in some sense with it. The outcome and climax of this revival was of course the rebuilding of Westminster Palace by Barry and Pugin after the destruction of the medieval palace in the lamentable fire of 1834. But although this literary, romantic revival of Gothic was real enough, we must not imagine that Strawberry Hill and its like were the first buildings to be erected in the Gothic style since the close of the Middle Ages.

Up to the period of the English revival, Gothic had quite simply survived. Even in Italy we find cultural and stylistic anomalies such as the great church of San Petronio at Bologna, whose nave is covered by impressive Gothic rib vaults constructed between 1646 and 1658. In northern Europe there are large numbers of convincing-looking Gothic buildings which in fact date, in part or wholly, from the seventeenth century. At the end of the French Wars of Religion (1594), medieval churches which had been sacked by the Huguenots were piously repaired. The work of restoration provided masons with valuable practical experience of the Gothic idiom. Many of the famous monastic churches associated with the reformed Benedictine Congregation of Saint-Maur were repaired, altered, or even completely rebuilt in the seventeenth century. The Maurists' centre of government, Saint-Germain-des-Prés in Paris, received Gothic vaults over nave and transept in 1644–5, and extensive Gothic work was also done at, for example, Saint-Étienne at Caen, Saint-Wandrille-Rancon in Normandy, Saint-Vulfram at Abbeville, Saint-Nicholas at Blois, and at Saint-Maixent-l'École in Poitou. That Benedictine monks should favour the old traditional style in their church architecture is not so surprising as that the new up-to-the-minute Jesuit Order (established 1540) should so frequently have employed Gothic elements in its churches in France, the Low Countries, and Germany. The Jesuits evidently yielded to the religious and cultural conservatism of the local

populace. Particularly in Belgium and the extreme north of France, Jesuit seventeenth-century architecture sank into the medieval townscape. At Arras and Valenciennes, Lille and Tournai, Ghent and Courtrai, and over into Luxembourg, the churches attached to the Jesuit Colleges were planned and built convincingly on late-medieval lines, with tall slender columns, and big windows filled with flowing tracery.

Oddly enough the Fellows of Oxford colleges in the seventeenth century were perfectly in accord with the continental Jesuits concerning the kind of visual environment which they found agreeable. The great Gothic fan-vault over the stair leading to the Hall of Christ Church was erected by one Smith, of London, in 1640, and Lincoln College built its fourteenth-century chapel only in 1631!

When, in the sixteenth century, Catholic and Protestant found themselves bitterly opposed, scholars of both camps turned for the first time to the written records of the past, either to justify rebellion from papal authority by educing historical precedents or to defend traditional beliefs, institutions, and customs. This contentious polemical phase of the new historical scholarship passed rapidly, giving way to a mature desire for truth and a devotion to historical studies for their own sake. A new race of serious high-minded historians made their appearance in Catholic France and Flanders and Protestant England, true children of the Renaissance in their delight in the accumulation and analysis of proven facts and in their grasp of chronology and historical method. They began the scientific examination of charters and chronicles, legal and literary records of all kinds, and also of visual records. A great many things fell within this category of visual records – manuscripts, sculptures, castles, and churches – and in studying these the seventeenth-century scholars laid the foundations of present-day knowledge of medieval art.

In the course of a learned wrangle about the date of a tomb in Westminster Abbey the great English antiquary William Camden (1551–1623) thundered at his opponent: 'Let him go to the tomb, let him look upon it!' It was the strength of the antiquaries that they went and looked, with full historical consciousness. That they looked also with genuine aesthetic appreciation is proved, not only from their words of admiration, but from the beautiful and sensitive engravings prepared for the purpose of illustrating their learned studies of great historical institutions and monuments – for example, the views

112. Hollar's engraving of the chapter house of Old St Paul's

of the monastic buildings of the Congregation of Saint-Maur, compiled by Dom Michel Germain (1645–94), the views of Saint-Ouen de Rouen, prepared for J. F. Pommeraye's *Histoire de l'abbaye royale de S. Ouen* (1622), or the views of Old St Paul's in London in Sir William Dugdale's *History of St Paul's Cathedral in London* (1658) [112]. The survival of Gothic forms in the seventeenth century and on into the eighteenth cannot altogether be attributed to unthinking conservatism. Certain monuments of the Gothic survival reflect the taste and learning of the great antiquaries, their genuine first-hand knowledge of medieval art [113, 114, and 115], just as much as monuments of the eighteenth-century Gothic Revival reflect the whims of the literary mythographers.

The influence of the seventeenth-century antiquaries can be traced in the writings of a few serious and discerning critics of medieval art in the eighteenth century. What Homer was to Keats, Dugdale's *Monasticon* was to Thomas Warton. On a blank leaf of his copy Warton wrote a sonnet which ends with the lines:

> Not rough nor barren are the winding ways
> Of hoar antiquity, but strown with flowers.

Thomas Gray owned a copy of Dugdale's *The Baronage of England*, and he painstakingly filled up the margins with the coats of arms of the families mentioned in the text. In youth,

113. The eighteenth-century west door of Beverley Minster

114. *St Luke* from the Beverley door

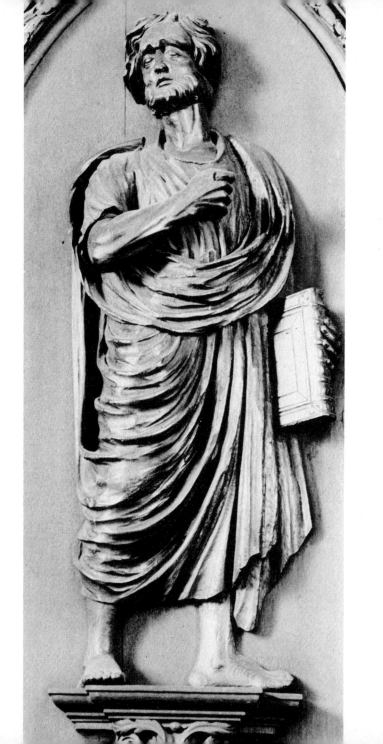

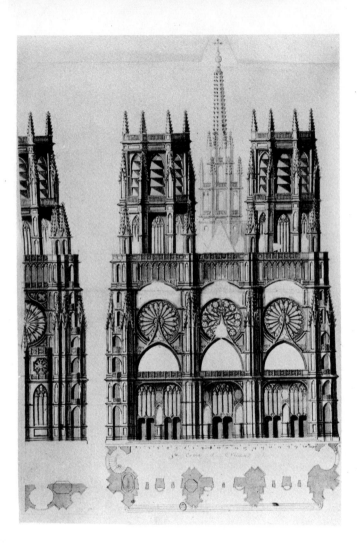

115. Early eighteenth-century design
for the west front of Orléans Cathedral

Gray had lent his support to Horace Walpole's grand literary conceptions of Gothic, but in later life he preferred facts to fancies and turned antiquarian. A note of puzzlement is heard in a letter written to Gray by his friend Mason in 1761:

> Have you made up your mind about Gothic architecture, and consequently given over your genealogical studies, which, it seems, are so intimately connected with that study?

By the time Mason came to write his biography of Gray, however, he too had grasped the principles which Gray had learned from scholars like Camden and Dugdale.

> In his later years he applied himself to those stupendous structures . . . that adorn our own country He endeavoured to trace this mode of building, from the time it commenced through its various changes For this purpose he did not so much depend upon written accounts, as that internal evidence which the buildings themselves give of their respective antiquity, since they constantly furnish to the well-informed eye arms, ornaments, and other indisputable marks, by which their several ages may be ascertained. On this account he applied himself to the study of Heraldry as a preparatory science, more than sufficient to prove him a complete master of it. By these means he arrived at so very extraordinary a pitch of sagacity as to be able to pronounce, at first sight, when every particular part of any of our cathedrals was erected.

By the early nineteenth century, Gray's hard-gained 'pitch of sagacity' had been overshot. A crowd of publicists of Gothic – antiquarians, architects, and others – were hard at work and their books were finding a ready market. Gothic was rapidly rendered accessible, and safe. Thomas Rickman's volume entitled *An Attempt to Discriminate the Styles of English Architecture from the Conquest to the Reformation* is typical of the sober methodical coverage which medieval buildings were now thought to deserve. The familiar categories, Early English, Decorated, Perpendicular, make their appearance, and within these categories we find a systematic description of the design of doors, windows, arches, piers, tablets, niches, ornaments, steeples, battlements, roofs, fronts, and porches. Here is Gothic anatomized, pinned on a board. Since the species was now recognized and recognizable, it befitted nineteenth-century scholars to raise again the question of origins. Where you could find the first flying buttress or the first pointed arch or, best of all, the first rib vault, there you would discover the origin and the secret of the whole style. Of course

the pursuit of Gothic architecture back to its technical basis has been of very great importance. It has clarified and will continue to clarify the resources actually available to medieval masons and the gradual process whereby these resources came to be comprehended in full. But what immediately strikes one is how inevitable it was that the nineteenth century, a period of massive material and technical progress, should have launched the interpretation of the Gothic style as the outcome of technical invention. In this book I have tried to present Gothic as something above and beyond architecture, and therefore above building techniques – as a principle, initially intellectual and subsequently decorative, which was applied equally to all the visual arts and by which they were blended into one Total Art.

Appendix 1
The Wilton Diptych

Richard II came to the throne in 1377 aged ten years. He was deposed in September 1399 and was dead by the following February, at the age of thirty-three. In the diptych he is represented as a beardless youth. The Westminster Abbey portrait of Richard crowned and enthroned[1] and his tomb effigy, ordered 1395, completed 1399,[2] both represent him bearded.

M. V. Clarke[3] shows that the heraldry in the diptych indicates a date after 1395. V. H. Galbraith[4] suggests that the diptych is a memorial picture painted after Richard's death, e.g. in 1413 when the deposed murdered king was rehabilitated by Henry V. F. Wormald[5] argues from style and iconography in favour of a $c.$1413 date. E. Panofsky[6] agrees.

Accepting Miss Clarke's heraldic evidence, and proposing his posthumous theory, Galbraith, *op. cit.*, says: 'No adequate motive has been suggested for depicting the prematurely aged king as a boy at this late date' (i.e. 1395) 'in the reign.' But no adequate motive has been suggested for depicting the dead king as a boy, or at least as a beardless youth. A posthumous portrait would surely be bound to follow the Westminster portrait and the tomb effigy, i.e. the king's official likeness. If the diptych was painted for Henry V, Richard's likeness would presumably agree with Henry's personal, affectionate, recollections formed in 1398–9. If the diptych, as Wormald suggests, shows Richard's reception into the Kingdom of Heaven, we would expect him to be represented not as a beardless youth, but aged about thirty, i.e. in his perfect manhood, the

1. See Rickert, M., *Painting in Britain: The Middle Ages* (London, 1954) plate 162.
2. See Stone, L., *Sculpture in Britain: The Middle Ages* (London, 1955) plate 151.
3. *Burlington Magazine* 1931, pages 283–94.
4. *History* (Historical Association, March 1942) pages 237–8.
5. *Journal of the Warburg and Courtauld Institutes* (1954) pages 191–203.
6. *Early Netherlandish Painting* (Cambridge, Mass.: London, 1953) page 118 and pages 404–5, note 5.

age at which Christ himself suffered and rose again. Legend has it that Richard's birth was analogous with that of Christ. His age at death, so theologically suitable, would not have been tampered with by anyone promoting a posthumous cult.

Miss Clarke speaks of the 'cunning-faced copper effigy' and its 'sly cynicism'. Galbraith also, on the basis of the tomb effigy, speaks of 'the prematurely aged king'. We gain the impression that the effigy is heavily marked by signs of moral or physical debility, such as might reasonably lead to the substitution of an idealized youthful likeness in a posthumous portrait of the king. However, this reading of the tomb effigy is highly subjective. The fastidious Richard himself presumably saw nothing to object to in the tomb effigy. For a juster interpretation of the effigy, see Stone, *op. cit.*, pages 193–4. There is really no reason why contemporaries should have regarded Richard's adult appearance as unrepresentative of him at his best.

Why is he young and beardless, then, in the diptych, painted after 1395 ? It does not seem impossible that such a youthful likeness would appeal to the eight-year-old French princess whom Richard married in 1396. The diptych would not necessarily be listed in the records of her dowry. The young queen might have donated it privately to a church, say to the Dominicans of Langley, who buried her husband's body, or else to a personal attendant.

But another interpretation seems not improbable. In 1397 Richard began his 'second tyranny', a period of personal rule marked by practical assertions of his Divine Right. The Wilton Diptych looks on the face of it like a picture celebrating the boy Richard's accession in 1377. This may be just what it is, but painted in, say, 1397, as an expression of Richard's conviction that twenty years earlier he had received his Kingdom from God, and that, under the protection of the saints and angels, he still so held it as a sacred office, transcending earthly laws.

Some fragments of painting from St Stephen's Chapel, Westminster (*c.*1360), notably the *Feast of the Children of Job* (Rickert, *op. cit.*, plate 151) in which heads and hands very like those of the angels in the diptych appear, suggest that the diptych could as easily be English work of the late fourteenth century as of the early fifteenth century.

Appendix 11
The Beverley Door

In 1714 Nicholas Hawksmoor, the distinguished architect, colleague of Wren and Vanbrugh, began to erect the north quadrangle of All Souls College, Oxford.[1] The narrow double-towered centre-piece at the east side of the quadrangle reflects Hawksmoor's familiarity with the great leaping verticals of the west front of Beverley Minster. In 1716, Hawksmoor, as consultant architect at Beverley Minster, published an appeal for funds for the decaying fabric, illustrated with a fine engraving of the west front. In a letter to the Dean of Westminster dating from 1734 or 35 he boasts: 'I repair'd the Minster at Beverley, a fine old Monastick fabric.' In 1735 Hawksmoor wrote:

> The church at Beverley is fully repair'd and the floor all new paved with marble and other hard stone, in figures, and the inside repair'd and clean'd; so that it is surprisingly beautiful.

And in 1731 in a letter to Lord Carlisle he says:

> I stay'd two days at Beverley to see that beautiful church which surpasses anything of the sort in England it is so well beautify'd and repair'd all which is owing to that incomparable gentleman Mr Moyser.

Moyser had been a Member of Parliament for Beverley and was a prime mover in the restoration.

Did Hawksmoor's enthusiasm stem from seeing his own schemes for the beautification of the minster actually executed? He nowhere states his responsibility for the lavish post-medieval fittings, but the galleries (long since cleared away) supported on Doric pillars with an entablature ornamented by triglyphs sound like Hawksmoor's, and the splendidly festive screen across the entrance to the choir, which survived into the era of photography but which is now unfortunately demolished, looked odd enough to be of his design.[2] The

1. See Downes, K., *Hawksmoor* (London, 1959) pages 132–5
2. See Whiteing, R. H., *Georgian Society for East Yorkshire* (1951) III, i.

surviving oak front-cover could certainly be his, for it recalls in its sumptuously buoyant outline the famous 'eminences' that rise above the roofs of Blenheim Palace, and also the fantastic stone pyramid called 'The Four Faces' in the grounds of Castle Howard. When we turn however to the inner side of the great wooden west door of the minster we seem completely out of Hawksmoor's depth. Here is one of England's truly spectacular displays of Gothicism, executed with tremendous verve and yet with an archaeologist's care for accurate detail.

Did Hawksmoor bring a skilled craftsman from London, or from Oxford – the kind of man, for example, who carved the stalwart little figure terminals on the stalls of Lincoln College Chapel, with their splendidly scooped and pleated draperies?[1] The tautly posturing Evangelists of Beverley remarkably evoke the Middle Ages. They have a touch of Villard, of the Reims statues [cf. 9, 37], even a touch of those tough vivid statuettes by the twelfth-century Mosan metalworkers which formed the ground-work of French and indeed northern English, Yorkshire, sculpture in the early thirteenth century.[2]

Or did John Moyser attract some local talent to the pious work? Certainly local models inspired the designer. The dynamic ogee arches which rise over the heads of each pair of Evangelists and the heart-shaped motif which dominates the top of the door were borrowed from the great west window of York Minster. Then again the flowing tracery patterns, the cusped ogees which support the brackets below the Evangelists and below their symbols, the foliage which sticks up so alertly, the round heads which emerge from the cusps of the tracery, and the angels which sprout out of the uppermost tracery panels, are all taken over from the Percy Tomb at the east end of Beverley Minster [cf. 47]. The designer appears to have had a sound grasp of the stylistic vocabulary of the first half of the fourteenth century. The Percy Tomb dates from about 1340 and the York West Window from about 1330. The ogees which support the brackets roll forward like the 'nodding ogees' in the Lady Chapel of Ely Cathedral of between 1335 and 1350. The dense tracery patterns placed below a central transom are a feature of windows in Bristol Cathedral

1. See *Royal Commission on Historical Monuments* (City of Oxford, 1939) plate 126.
2. See Swarzenski, H., *Monuments of Romanesque Art* (London, 1955) plates 226, 227, and 228 (539), and Marcousé, R., *Figure Sculpture in St Mary's Abbey, York* (1951).

in the first quarter of the fourteenth century, and the round-headed arches transected by strong verticals can be paralleled at Gloucester in the second quarter. Altogether the Beverley Door, as well as being wonderfully handsome, is a most creditable academic performance. The man who carved the west door was also responsible for eighty-eight bust-length figures on the canopies of the stalls in the choir, many of them strikingly lively and imaginative in pose and costume; also for doors and openwork screens throughout the minster, and for stone figures, heads, and foliated capitals in the second and third bays, counting from the west end of the south aisle.

One final query: why in the Beverley Door do the Evangelists stand reversed from the order of their Gospels in the New Testament – John, Luke, Mark, Matthew, instead of Matthew, Mark, Luke, John?

Catalogue of Illustrations

1. JOSEPH OF ARIMATHEA AMONG THE ROCKS OF ALBION. By William Blake. Signed 1773. Engraving. 22·8 × 11·8 cms. (Photograph reproduced by permission of the Trustees of the British Museum.)
 In original state executed in 1773. The plate was later re-worked, the date of the original state inserted, and the inscriptions added.
 Literature: Keynes, G., *Blake Studies* (London, 1949), pp. 45–6, and pl. 14; Blunt, A., *The Art of William Blake* (Columbia University Press, 1959) p. 4.

2. TOMB-SLAB OF HUGUES LIBERGIER. After 1263. *Reims Cathedral.* (Photograph: courtesy Archives Photographiques, Paris.)
 Lit: On Libergier's church, Saint-Nicaise, see Frankl, P., *Gothic Architecture* (Pelican History of Art, Harmondsworth, 1962) pp. 94–6 and 111, fig. 33.

3, 4. KING OFFA OF MERCIA VISITING THE BUILDING-SITE OF ST ALBANS CHURCH. By Matthew Paris. 1230–40. Tinted drawings on vellum. *Life of St Alban, Dublin, Trinity College,* MS. E.i. 40, ff. 59b and 60a. (Reproduced by permission of the Board of Trinity College, Dublin.)
 Lit: Vaughan, R., *Matthew Paris* (Cambridge, 1958).

5. HEAD OF THE EFFIGY OF PHILIP VI, KING OF FRANCE. By André Beauneveu. Shortly after 1364. *Saint-Denis, Abbey Church.* (Photograph: courtesy Pierre Devinoy, Paris.)

6. ST THOMAS. By André Beauneveu. c.1385. Miniature in grisaille on vellum. 25 × 17·5 cms. Psalter of Jean de Berri, *Paris, Bibliothèque Nationale,* MS. Fr. 13091, f. 24a. (Photograph: courtesy Bibliothèque Nationale, Paris.)

7. INTERIOR OF COLOGNE CATHEDRAL. Begun 1248. (Photograph: courtesy Helga Schmidt-Glassner.)

8. EXTERIOR AND INTERIOR ELEVATION OF A BAY OF REIMS CATHEDRAL. By Villard de Honnecourt. c.1235. Pen drawing on vellum. 24 × 16 cms. Handbook, *Paris, Bibliothèque Nationale,* MS. Fr. 19093, f. 31b. (Photograph: courtesy Bibliothèque Nationale, Paris.)
 Lit: Hahnloser, H., *Villard de Honnecourt* (Vienna, 1935). For Villard's visit to Reims, see also Frisch, T., *The Art Bulletin,* XLII (1960) pp. 4–5; Reinhardt, H., *La Cathédrale de Reims* (Paris, 1963) pp. 83–8; Branner, R., *Gazette des Beaux-Arts,* 61 (1963) pp. 129–46.

9. APOSTLE AND PROPHET. By Villard de Honnecourt. c.1235. Pen drawing on vellum. 24 × 16 cms. Handbook, *Paris, Bibliothèque Nationale,* MS. Fr. 19093, f. 28a. (Photograph: courtesy Bibliothèque Nationale, Paris.)

10. THE TEMPTATION OF CHRIST. By Pol de Limbourg and his brothers. Shortly before 1416. Illumination on vellum. 17 × 11·4 cms. *Les Très Riches Heures, Chantilly, Musée Condé.* (Photograph: courtesy Giraudon, Paris.)

The miniature shows the castle of Mehun-sur-Yèvre, erected between 1367 and 1390 on an island in the river Yèvre, ten miles from Bourges.

Lit: Durrieu, P., *Les Très Riches Heures de Jean de France, Duc de Berri* (Paris, 1904).

11. CHARTRES CATHEDRAL, SOUTH TRANSEPT FAÇADE. *c.*1210–*c.*1220; porches added after 1224. (Photograph: courtesy Giraudon, Paris.)

12. PENTECOST. *c.*1220. Illumination on vellum. 21·7 × 15 cms. Psalter of Queen Ingeburg. *Chantilly, Musée Condé*, MS. 1695, f. 32b. (Photograph: courtesy Giraudon, Paris.)

13. THE WILTON DIPTYCH. 1395–9. Tempera on coating of gesso, on oak panels. Each panel 36·8 × 26·7 cms. *London, National Gallery*. (Reproduced by courtesy of the Trustees of the National Gallery.)

Lit: See Appendix I.

14. THE NORMANS IN THEIR BOAT. Shortly before 1100. Illumination on vellum. 29·5 × 20·5 cms. *Life of St Aubin, Paris, Bibliothèque Nationale*, MS. Nouv. acq. Lat. 1390, f. 7a. (Photograph: courtesy Bibliothèque Nationale, Paris.)

A bible and a psalter from Saint-Aubin's monastery at Angers, and wall-paintings at Château-Gontier, a dependency of Saint-Aubin's, are in the same harsh style.

15. APSE OF THE PRIORY CHURCH OF LA CHARITÉ-SUR-LOIRE. Consecrated 1107, but later heightened (?). (Photograph: courtesy Archives Photographiques, Paris.)

La Charité was begun about 1059, evidently with seven parallel apses. Bishop Geoffrey of Auxerre was buried before the high altar in 1076, by which time one would have expected the church to be consecrated. The first recorded consecration took place, however, in 1107. Dr Joan Evans dates the capitals of the columns of the present apse to before 1107 (*Cluniac Art of the Romanesque Period*, Cambridge, 1950, p. 21). Cf. Saint-Réverien, of the early twelfth century, for which see Evans, J., *The Romanesque Architecture of the Order of Cluny* (Cambridge, 1938) figs. 32, 109. But Hilberry, H. (*Speculum*, xxx, 1955, pp. 1–14) argues that the church consecrated in 1107 was of the seven-apse design and that the present choir in its entirety is somewhat post-1107.

16. TREE OF JESSE. 1110–20. Illumination on vellum. 12·5 × 7·5 cms. Legendary from Cîteaux, *Dijon, Bibliothèque Municipale*, MS. 641, f. 40b. (Photograph: courtesy Remy, Dijon.)

Round the Tree of Jesse are Old Testament 'types' of the Virgin Birth cited by Honorius of Autun in his sermon on the Annunciation, Moses and the burning bush, Gideon watching the dew falling on his fleece, Daniel in the lions' den, and the Hebrews in the fiery furnace.

17. BAPTISMAL FONT. By Rainer of Huy. *c.*1110. Bronze. Height 635 cms., diam. 103 cms. *Liège, St Barthélemy*. (Copyright: A.C.L., Brussels.)

Commissioned by Hellinus (1107–18) for Notre-Dame-aux-Fonts.

18. TREE OF JESSE WINDOW. Before 1144. Stained glass. *Saint-Denis, Abbey Church*, Chapel of the Virgin. (Photograph: courtesy Archives Photographiques, Paris.)

The central area of the window alone is genuine twelfth-century glass, i.e. about one third of the whole. The remainder is nineteenth-century restoration.

Lit: Panofsky, E., *Abbot Suger on the Abbey Church of Saint-Denis and its Art Treasures* (Princeton, 1946) pp. 73, 192–8.

19. WEST PORTALS, CHARTRES CATHEDRAL. *c.*1145–50. (Photograph: courtesy Giraudon, Paris.)

20. GOD ENTHRONED IN MAJESTY. *c.*1145–50. *Chartres Cathedral,* west front, central tympanum. (Photograph: courtesy Bildarchiv Foto Marburg.) The sculpture represents the vision of God adored by the four Beasts and by the twenty-four Elders, recorded in The *Book of Revelation,* chapter iv.

21. INTERIOR OF AMBULATORY OF SAINT-DENIS. 1144. (Photograph: courtesy Archives Photographiques, Paris.)

22. EAGLE VASE OF ABBOT SUGER. *c.*1140. Antique porphyry vase, converted into an eagle, with silver gilt mounts. Height 43 cms. *Paris, Louvre.* (Photograph: Musée du Louvre, Paris.)

23. GROUND-PLAN OF CATHEDRAL OF NOTRE-DAME, PARIS. 1163. (After E. Gall, *Die gotische Baukunst in Frankreich und Deutschland.*)

24. WEST FRONT OF SAINT-DENIS, prior to destructive repairs carried out in nineteenth century, including removal of north-west tower. (Engraving after S. McK. Crosby, *The Abbey Church of Saint-Denis.*)

25. WEST FRONT OF LAON CATHEDRAL. Designed *c.*1170. Constructed *c.*1180–90. (Photograph: courtesy Archives Photographiques, Paris.)

26. TOWER OF LAON CATHEDRAL. By Villard de Honnecourt. *c.*1235. Pen drawing on vellum. 24 × 16 cms. Handbook, *Paris, Bibliothèque Nationale,* MS. Fr. 19093, f. 10a. (Photograph: courtesy Bibliothèque Nationale, Paris.) Cf. the bulls projecting from the Brazen Sea (17).

27. WEST FRONT OF STRASSBURG CATHEDRAL. Begun 1277. (Photograph: courtesy Bildarchiv Foto Marburg.) The west front was begun in 1277 to a design by Erwin von Steinbach. Many later architects worked on this grandiose façade, in its upper reaches. The spire, designed by Johannes Hültz, was finished in 1439. At Strassburg one has to admit that the 'Game of Consequences' conception of Gothic does fit with the facts, and with the visual effect!

28. INTERIOR OF LAON CATHEDRAL. Designed *c.*1170. (Photograph: courtesy Courtauld Institute, London.)

29. INTERIOR OF CHARTRES CATHEDRAL. Begun 1194. (Photograph: courtesy Courtauld Institute, London.)

30. INTERIOR OF NAVE OF SAINT-DENIS. Designed by Pierre de Montereau. Begun 1231. (Photograph: courtesy Archives Photographiques, Paris.)

31. NORTH TRANSEPT WINDOWS, CHARTRES CATHEDRAL. *c.*1230. (Photograph: Eric de Maré.)

32. ASSUMPTION OF THE VIRGIN. *c.*1170. Illumination on vellum. 16·5 × 15 cms. *Glasgow, Hunterian Library,* MS. U.3.2, f. 5, 3vo. (Reproduced by courtesy of the University of Glasgow.) Lit: Boase, T. S. R., *The York Psalter* (London, 1962) pp. 8–14.

33. VAULT OF NAVE OF LAON CATHEDRAL. Built *c.*1180. (Photograph: courtesy Bildarchiv Foto Marburg.) The vault is sexpartite, over each double bay.

34. CORONATION OF THE VIRGIN. *c.*1210. *Chartres Cathedral,* north transept, tympanum of central portal. (Photograph: courtesy Professor G. Zarnecki.)

35a. CENTRAL PORTAL, SOUTH TRANSEPT, CHARTRES CATHEDRAL, *c.*1220, porch added after 1224. (Photograph: courtesy Archives Photographiques, Paris.)

b. DETAIL OF 35a. (Photograph: courtesy Courtauld Institute, London.)

36. INTERIOR OF WESTMINSTER ABBEY, LONDON. 1245–69. The choir, looking east. (Photograph: courtesy L. Herbert-Felton.)

37. SS. PAUL, JAMES, AND JOHN. *c*.1225. *Reims Cathedral*, north transept, left door, right embrasure. (Photograph: courtesy Archives Photographiques, Paris.)

38. QUATTRO SANTI CORONATI. By Nanni di Banco. *c*.1415. *Florence, Or San Michele*. (Photograph: courtesy Alinari/Mansell Collection.)
The figures represent four Christian sculptors who refused to execute a commission from the Emperor Diocletian for a statue of Aesculapius, and were consequently killed.

39. SLEEPING APOSTLE, AND MAN MOUNTING HORSE. By Villard de Honne-court. *c*.1235. Pen drawing on vellum. 24 × 16 cms. Handbook, *Paris, Bibliothèque Nationale*, MS. Fr. 19093, f. 23b. (Photograph: courtesy Biblio-thèque Nationale, Paris.)
The Sleeping Apostle belongs to a Gethsemane scene.

40. JOACHIM ASLEEP. By Giotto. 1305–12. Fresco. Detail from *Joachim in the Wilderness. Padua, Arena Chapel*. (Photograph: courtesy Alinari/Mansell Collection.)
Lit: For Giotto generally, see Gnudi, C., *Giotto* (London, 1959); also White, J., *Art and Architecture in Italy, 1250–1400*. (Pelican History of Art, Harmondsworth, 1966.)

41. THE RAISING OF LAZARUS. By Giotto. 1305–12. Fresco. *Padua, Arena Chapel*. (Photograph: courtesy Alinari/Mansell Collection.)

42. THE MARGRAVE ECKHARDT AND HIS WIFE UTA. *c*.1250. *Naumburg Cathe-dral*, interior of western choir. (Photograph: courtesy Bildarchiv Foto Marburg.)

43. HEAD OF PILATE. By Giotto. 1305–12. Fresco. Detail from *Mocking of Christ. Padua, Arena Chapel*. (Photograph: courtesy Alinari/Mansell Collection.)

44. CAPITALS CARVED WITH HAWTHORN, MAPLE, AND BUTTERCUP LEAVES. 1290–95. *Southwell Minster*, Nottinghamshire, entrance to chapter house. (Photograph by the late F. H. Crossley.) Lit: Pevsner, N., *The Leaves of Southwell* (London, 1945).

45. THE ANGEL WITH THE FIFTH VIAL OF WRATH. (*Book of Revelation*, xvi, 10). *c*.1270. Pen drawing on vellum. 11 × 14·4 cms. *The Douce Apocalypse, Oxford, Bodleian Library*, Douce MS. 180, p. 66. (Photograph: reproduced by courtesy of the Bodleian Library, Oxford.)

46. PROPHETS. *c*.1300. *Strassburg Cathedral*, west front, central portal, right embrasure. (Photograph: Bildarchiv Foto Marburg.)

47. PART OF THE CANOPY OF THE PERCY TOMB. *c*.1342–5. *Beverley Minster*, Yorkshire. (Photograph: courtesy Courtauld Institute, London.)
Probably an Easter Sepulchre, i.e. a 'tomb' prepared for the reception of the Host during the Easter ceremonies.

48. THE CLEVER PEASANT GIRL. *c*.1380. Wooden misericord. *Worcester Cathedral*, choir stalls. (Photograph: courtesy Courtauld Institute, London.)

49. VISITATION GROUP. *c*.1225. *Reims Cathedral*, west front, central portal, right embrasure. (Photograph: courtesy Professor G. Zarnecki.)

50. CENTRAL WEST PORTAL OF REIMS CATHEDRAL. *c*.1240.

51. RELIEF WITH SCENES FROM GENESIS. *c*.1285–1305. *Auxerre Cathedral*, west front. (Photograph: courtesy Courtauld Institute, London.)

52. BEAK HEADS. *c*.1140–50. *Oxford, St Peter's-in-the-East*, south doorway. (Photograph: courtesy Professor G. Zarnecki.)

53. FIGURE OF ST PETER FROM THE WESTMINSTER RETABLE. 1260–70. Entire Retable 91·8 × 336·6 cms. Tempera with egg or oil medium on oak panel, glass and gesso ornament, imitating enamels, cameos, and jewels. Architectural framework attached to panel. *London, Westminster Abbey.* (Photograph: Otto Fein, courtesy Warburg Institute, London.)

Lit: Wormald, F., *Proceedings of the British Academy*, XXXV (1949) p. 161.

54. CHRIST CARRYING THE CROSS. Detail from The Steeple Aston Cope. *c.*1310. Cope cut in pieces, used as frontal and dossal of an altar. Silver gilt thread and coloured silks in underside couching, and split stitch, and raised work, on fawn silk twill. Dossal 141 × 158 cms. *London, Victoria and Albert Museum.* (V. & A. Crown copyright.)

Lit: Christie, A. G. L., *English Mediaeval Embroidery* (Oxford, 1938), No. 87.

55. BUTLER-BOWDEN COPE. *c.*1330. Silver and silver-gilt thread and coloured silks in underside and surface couching, split stitch, laid and couched work, raised work, French knots and satin stitch, on red velvet. Many details formerly enriched with pearls. 168 × 345·4 cms. *London, Victoria and Albert Museum.* (V. & A. Crown copyright.)

A cope of this type is recorded in the collection of Jean Duc de Berri in 1403.

Lit: Christie, A. G. L., *English Mediaeval Embroidery* (Oxford, 1938), No. 90.

56. FRONTISPIECE TO GRAY'S ELEGY. By Richard Bentley. 1753. From *Designs by R. Bentley for Six Poems by Thomas Gray* (with the poems, and an explanation of the prints) (London, 1753). 29 × 22 cms. (Photograph: reproduced by permission of the Trustees of the British Museum.)

57. THE CORVINUS GOBLET. 1462. Silver-gilt decorated with drawn enamels. Height 81 cms. *Wiener Neustadt, Town Museum.* (Photograph: courtesy Wiener-Neustadt Museum.)

Engraved with motto of Emperor Frederick III, the imperial eagle, monogram of Matthias Corvinus, King of Hungary, and Corvinus emblem.

58. COFFER (or CASSONE) PANEL. 1400–50. The panel decorated with foliage strands in relief, framing three medallions painted with scenes from the story of Saladin and Torella from the *Decameron*. Originally from Sta Maria Nuova, Florence. *Florence, National Museum.* (Photograph: Alinari/ Mansell Collection.)

Lit: De Nicola, G., *Burlington Magazine*, XXXI (1918) p. 169.

59. RELIEF SCULPTURE, ORVIETO CATHEDRAL. By Lorenzo Maitani and workshop. 1310–30. (Photograph: courtesy Alinari/Mansell Collection.)

Lit: White, J., *Journal of the Warburg and Courtauld Institutes*, 22 (1959) pp. 254–302.

60. INTERIOR OF THE CHOIR OF SÉEZ CATHEDRAL. *c.*1270. (Photograph: courtesy Bildarchiv Foto Marburg.)

61. INTERIOR OF SPIRE OF FREIBURG IM BREISGAU MINSTER. Completed *c.*1340. (Photograph: courtesy Helga Schmidt-Glassner.)

62. EXTERIOR OF THE CHOIR OF PRAGUE CATHEDRAL. Begun 1344. (Photograph: courtesy Bildarchiv Foto Marburg.)

63. NOTRE-DAME AT LOUVIERS. *c.*1510. South façade of nave, with south porch. (Photograph: courtesy Giraudon.)

64. NOTRE-DAME AT ALENÇON. *c.*1500. West front. (Photograph: courtesy Giraudon.)

65. NOTRE-DAME AT ALENÇON. *c.*1500. Exterior from the north. (Photograph: courtesy Giraudon.)

66. PRESENTATION OF CHRIST. By Ambrogio Lorenzetti. Signed 1342. Tempera on panel. 257 × 168 cms. *Florence, Uffizi.* (Photograph: courtesy Alinari/Mansell Collection.)

67. CHAPEL VAULT, FRAUENKIRCHE AT INGOLSTADT. *c.*1520. (Photograph: courtesy Bildarchiv Foto Marburg.)

68. CHURCH OF ST CATHERINE AT OPPENHEIM. Designed 1317. Exterior from the south. (Photograph: courtesy Bildarchiv Foto Marburg.)

69. FIGURE OF A MAN. *c.*1400. Pen drawing on vellum. Whole page 25·1 × 19·8 cms. Pepysian Sketchbook, *Cambridge, Magdalen College, Pepysian Library,* MS. 1916, f. 4b. (Photograph: courtesy Courtauld Institute, London.)
Lettered on back of Pepys's binding, 'Monks Draw: Book'. Printed catalogue, 1697, calls it 'An ancient book of Monkish drawings...'
Lit: James, M. R.: *Walpole Society,* XIII (1924–5).

70. GALLERY OF KING LADISLAS II, CATHEDRAL OF PRAGUE. 1490. (Photograph: courtesy Helga Schmidt-Glassner.)

71. PENDANT FIGURINE. *c.*1500. Wood, polychrome, with deer's antlers. *Munich, Bayerisches Nationalmuseum.* (Photograph: courtesy Bildarchiv Foto Marburg.)

72. INITIAL TO PSALM 109. *c.*1310–25. Illumination on vellum. 38 × 25·5 cms. Ormesby Psalter, *Oxford, Bodleian Library,* Douce MS. 366, f. 147b. (Photograph reproduced by courtesy of Bodleian Library, Oxford.)

73. THE TRINITY, AND OTHER SUBJECTS. *c.*1426. Illumination on vellum. 20·5 × 15 cms. *Les Heures de Marguerite d'Orléans. Paris, Bibliothèque Nationale,* MS. Lat. 1156 B, f. 163a. (Photograph: courtesy Bibliothèque Nationale, Paris.)

74. GITTERN. *c.*1290–1330. Wood. 61 cms. long. *London, British Museum.* (Photograph: courtesy of the Trustees of the British Museum, London.)
A kind of guitar, richly carved with grotesques, foliage, and figures. It belonged at one time to Queen Elizabeth I or to Robert Dudley, Earl of Leicester. Elizabeth's arms and Leicester's badge are carved on the silver cover for the peg box.

75. ADORATION OF THE MAGI. By Giovanni Pisano. 1302–10. Marble. Panel from the pulpit, *Pisa Cathedral.* (Photograph: courtesy Anderson/Mansell Collection.)
Lit: Pope-Hennessy, J.: *Italian Gothic Sculpture* (London, 1955) pp. 8–12, 178–82.

76. THE MAGI ON HORSEBACK, AND THE MAGI SPEAKING TO HEROD. *c.*1270. 30·4× 19 cms. Oscott Psalter, *London, British Museum,* Add. MS. 50000, f. 8a. (Photograph: courtesy Courtauld Institute, London.)

77. PRESENTATION OF CHRIST. By Pol de Limbourg and his brothers. Shortly before 1416. Illumination on vellum. 20·5 × 14·4 cms. *Les Très Riches Heures, Chantilly, Musée Condé.* (Photograph: courtesy Giraudon.)

78. PRESENTATION OF THE VIRGIN. By Taddeo Gaddi. *c.* 1338. Fresco. *Florence, Sta Croce.* (Photograph: courtesy Alinari/Mansell Collection.)

79. FALL OF MAN AND EXPULSION FROM PARADISE. By Pol de Limbourg and his brothers. Shortly before 1416. 24 × 20·9 cms. *Les Très Riches Heures, Chantilly, Musée Condé,* f. 25. (Photograph: courtesy Giraudon.)

80. INITIAL TO PSALM 52. *c.*1150–60. Winchester Bible, *Winchester, Cathedral Library.* (Photograph: courtesy Warburg Institute, London.)
Lit: Oakeshott, W., *The Artists of the Winchester Bible* (London, 1945).

81. TAPESTRY WITH FIGURES OF CHARLES DUC D'ORLÉANS, THE POET, AND HIS WIFE, MARIE DE CLÈVES. Tournai or Brussels. *c.*1460. *Paris, Musée*

des Arts Décoratifs. (Photograph: courtesy of the Musée des Arts Décoratifs, Paris.)

82. IVORY CASKET, *c.*1325–40. *New York, Metropolitan Museum*, gift of J. Pierpont Morgan, 1917. (Photograph: courtesy of Metropolitan Museum, New York.)

The scenes carved are Tristram and Yseult's tryst beneath the tree, and the capture of the unicorn.

83. THE BURGHLEY NEF. By Pierre le Flamand. Paris hall-mark for 1482–3. Nautilus shell mounted in silver, parcel-gilt. 35 × 20·5 cms. *London, Victoria and Albert Museum.* (V. & A. Crown copyright.)

84. THE ROYAL GOLD CUP. *c.*1380. Gold with figure scenes in enamel on the gold, in sunk relief (*basse taille*) technique. The foot has a foliate cresting, enriched with pearls. Height 23·7 cms. *London, British Museum.* (Photograph reproduced by permission of the Trustees of the British Museum, London.)

Cresting like that on the foot has been lost from the cover, which has also been stripped of its knop or finial. The stem has been twice heightened, once in the reign of Henry VIII (cylinder bearing Tudor roses) and in Spain in 1610 (cylinder with Latin inscription). These additions have been removed in my illustration. Made for Jean Duke of Berri, perhaps as a gift for his brother King Charles V; actually presented by Jean de Berri to King Charles VI.

85. ALTAR TABERNACLE, CALLED THE 'GOLDENES RÖSSEL'. 1403. Gold, enamelled and enriched with pearls and gems. *Upper Bavaria, Altötting, Pilgrimage Church.* (Photograph: courtesy Professor Erwin Panofsky.)

Given by Isabel of Bavaria to her husband King Charles VI of France on New Year's Day 1404; left in pawn by Charles VI to his brother-in-law, the Duke of Bavaria. The tabernacle takes its name from the little horse which awaits its rider below the Virgin's throne.

86. GOTHIC ARMOUR FOR HORSEMAN AND HORSE, *c.*1480. Steel plates, fluted and embossed. *London, The Tower of London.* (Crown copyright.)

87. ST JOHN THE EVANGELIST AND ST JOHN THE BAPTIST. By Albrecht Altdorfer. *c.*1511. *Regensburg, Katherinenspitals.* (Photograph: courtesy Bayerische Staatsgemäldesammlungen, Munich.)

88. EPOPUS AND PELICANUS. Shortly before 1200. Pen drawing on vellum. *Bestiary,* or collection of animal lore, *Cambridge, University Library,* MS. ii. 4.26, f. 38a. (Photograph reproduced by permission of Cambridge University Library.)

The pious offspring of Epopus pluck out their parent's old feathers, warm him, and rejuvenate him; the impious offspring of Pelicanus attack their parent, and are attacked by him in self-defence.

Lit: Henderson, G., *The Archaeological Journal,* CXVIII (1961) pp. 175–9.

89. A VISION OF ST HILDEGARDE OF BINGEN, *c.*1220. Illumination on vellum. 28 × 19 cms. *S. Hildegardis Revelationes, Lucca, Biblioteca Governativa,* MS. 1942, f. 136a. (Photograph: Courtesy Biblioteca Governativa di Lucca.)

For text of vision, see Migne, J.-P., *Patrologia Latina,* 197, 'Sanctae Hildegardis Liber Divinorum Operum Simplicis Hominis', Pars III, Visio IX, col. 983–98.

90. ST JOHN LOOKING INTO HEAVEN. *c.*1250. Tinted drawing on vellum. 10·8 × 16·6 cms. Apocalypse MS., Sotheby sale 1.12.50, Lot 58, *ex* Dyson Perrius Coll., f. 4b. (Photograph: courtesy Courtauld Institute, London.)

Lit: James, M. R., *The Apocalypse in Latin, MS. 10 in the Collection of Dyson Perrius* (Oxford, 1927).

91. DETAIL OF THE ADORATION OF THE TRINITY. By Albrecht Dürer. Signed 1511. Oil on Panel. *Vienna, Gemäldegalerie.* (Photograph: courtesy Kunsthistorisches Museum, Vienna.)

92. DREAM VISION. By Albrecht Dürer. Signed 1528. Watercolour. *Vienna, Kunsthistorisches Museum.* (Photograph: courtesy Kunsthistorisches Museum, Vienna.)

93. THE ADORATION OF THE MAGI. By Hieronimus Bosch. Signed, *c.*1500–16. Oil on panel. Central panel of triptych. 138 × 72 cms. *Madrid, Museo del Prado.* (Photograph: courtesy Museo del Prado, Madrid.) Lit: For Bosch generally, see Baldass, L. von, *Hieronymus Bosch*, Vienna, 1943.

94. THE CREATION OF THE WORLD. By Hieronimus Bosch. *c.*1500–16. Oil on panel. Closed wings of The Garden of Delights. 220 × 195 cms. *Madrid, Museo del Prado.* (Photograph: courtesy Museo del Prado, Madrid.) Inscribed at top '*Ipse dixit et facta sunt, ipse mandavit et creata sunt*', Psalm xxxiii, 9. Cf. Pol de Limbourg's *Paradise* [79].

95. THE CARRYING OF THE CROSS. By Hieronimus Bosch. *c.*1500–16. Oil on panel. 74 × 81 cms. *Ghent, Musée des Beaux Arts.* (Photograph: courtesy Musée des Beaux Arts, Ghent.)

96. ABRAHAM ADORING THE TRINITY. *c.*1260. Illumination on vellum. 28 × 18·5 cms. Miniature from series of Bible pictures prefacing a psalter, *Cambridge, St John's College*, MS. K. 26, f. 9a. (Photograph: courtesy Courtauld Institute, London.)

97. THE LAST JUDGEMENT. By the Maître de Rohan. *c.*1420. Illumination on vellum. 29 × 21 cms. *Les Heures de Rohan, Paris. Bibliothèque Nationale*, MS. Lat. 9471, f. 154a. (Photograph: courtesy Bibliothèque Nationale, Paris.) Probably made for Yolande d'Aragon, widow of Louis II, Duke of Anjou. Lit: Porcher, J., *The Rohan Book of Hours* (London, 1959).

98. PIETÀ-ROETTGEN. *c.*1300. Wood. Height with base, 88·5 cms. *Bonn, Rheinisches Landesmuseum* (Photograph: courtesy Bildarchiv Foto Marburg.)

99. CRUCIFIX. 1304. Wood. *Cologne, St Maria im Kapitol.* (Photograph: courtesy Bildarchiv Foto Marburg.)

100. SOUL IN TORMENT. By Lorenzo Maitani and workshop. 1310–30. Last Judgement relief, *Orvieto Cathedral*, west front. (Photograph: courtesy Alinari/Mansell Collection.)

101. DESCENT FROM THE CROSS, called the PIETÀ DE NOUANS. By Jean Fouquet. *c.*1470–5. Oil on panel. 147 × 236 cms. *Nouans* (Indre et Loire), *Parish Church.* (Photograph: courtesy Archives Photographiques, Paris.)

102. VIRGIN AND CHILD. By Mathis Gothart Nithart, called 'Grünewald'. 1513–15. Oil on panel. Detail of Isenheim Altar, *Colmar, Musée d'Unterlinden.* (Photograph: courtesy Musée d'Unterlinden, Colmar.)

103. THE NATIVITY. By the Maître de Flémalle. 1420–25. Oil on panel. 87 × 70 cms. *Dijon, Musée de la Ville.* (Photograph: courtesy Remy, Dijon.) The candle in Joseph's hand is a reference to the account of the Nativity in the *Revelations* of St Bridget of Sweden.

104. THE ADORATION OF THE MAGI. By Pol de Limbourg and his brothers. Shortly before 1416. Illumination on vellum. 21·2 × 14·9 cms. *Les Très Riches Heures, Chantilly, Musée Condé.* (Photograph: courtesy Giraudon.)

105. THE LAST SUPPER. By Dirc Bouts. 1464–7. Oil on panel, central panel of triptych. *Louvain, St Peter's.* (Copyright A.C.L., Brussels.)

106. THE BIRTH OF ST JOHN THE BAPTIST. By Jan van Eyck. 1420–24. Illumination on vellum. 28 × 19 cms. *The Hours of Turin, Turin, Museo Civico.* (Copyright A.C.L., Brussels.)

Lit: For attribution to Jan van Eyck, see Panofsky, E., *Early Netherlandish Painting* (Cambridge, Massachusetts, 1953, pp. 232–46).

107. THE THREE MARIES AT THE SEPULCHRE. By Hubert van Eyck. *c.*1420. Oil on panel. Left wing of triptych, or fragment of frieze-like composition. 71·5 × 89 cms. *Rotterdam, Museum Boymans-van Beuningen.* (Photograph: courtesy of the Museum Boymans-van Beuningen, Rotterdam.)

108. ST MICHAEL'S CAVE, GIBRALTAR. Lithographic plate by T. C. Dibdin after Carter, from *Select Views of the Rock & Fortress of Gibraltar dedicated to the Army & Navy of Great Britain by Captn J. M. Carter,* London, 1845.

109. VAULT OF KING HENRY VII'S CHAPEL, WESTMINSTER ABBEY. *c.*1520. (Photograph: courtesy A. F. Kersting.)

110. A GOTHIC STAGE DESIGN. Shortly after 1700. By Ferdinando da Bibiena. *Munich, Graphische Sammlung,* Bibiena vol. III, p. 47. (Photograph: courtesy Staatliche Graphische Sammlung, Munich.)

111. STAIRCASE AT STRAWBERRY HILL. Engraving by James Newton of drawing by Edward Edwards, from the 1784 edition of the *Description of Strawberry Hill.* (Photograph: reproduced by kind permission of the Trustees of the British Museum.)

112. THE CHAPTER-HOUSE OF OLD ST PAUL'S CATHEDRAL, LONDON. By Wenceslaus Hollar. 1658. Etching. 28·5 × 19·4 cms. From Sir William Dugdale, *The History of St Paul's Cathedral in London,* London, 1658. (Photograph: courtesy John Rylands Library, Manchester.)

William de Ramsey is recorded as Master Mason in charge of building the chapter house in 1332. It was torn down in Wren's rebuilding of St Paul's. Foundations of the chapter house still remain in the angle of the nave and south transept of Wren's church.

Lit: For Hollar and the antiquaries see Martin, M., *Motif,* 4 (March 1960) pp. 68–81.

113. WEST DOOR, BEVERLEY MINSTER. 1700–50. Oak. (Photograph: courtesy Dr Kerry Downes.)

See Appendix II.

114. ST LUKE. 1700–50. *Beverley Minster,* west door. (Photograph: courtesy Dr Kerry Downes.)

115. DESIGN FOR THE WEST FRONT OF THE CATHEDRAL OF ORLÉANS. By Guillaume Hénault and Robert de Cotte. 1708. Pen drawing with colour wash. *Paris, Bibliothèque Nationale,* Cabinet des Estampes, Topographie, Va 91, f. 144. (Photograph: courtesy Bibliothèque Nationale, Paris.)

Lit: Chenesseau, G., *Sainte-Croix d'Orléans* (Paris, 1921) pp. 239–52.

Books for Further Reading

H. Karlinger's *Die Kunst der Gotik* (Berlin, 1927) has a useful short text and provides a splendid pictorial survey of Gothic art. J. Evans's *Art in Medieval France, 987–1498* (Oxford, 1948) contains an immense amount of detailed information about French medieval civilization and has excellent plates. J. White's *Art and Architecture in Italy, 1250–1400*, (Pelican History of Art, Harmondsworth, 1966) deals authoritatively with all aspects of Italian art in the Gothic period. J. Baum's *German Cathedrals* (London, 1956) discusses the sculptural decoration of the cathedrals as well as their architecture, and contains fine photographs by H. Schmidt-Glassner of buildings, stone sculpture, and wood carvings.

On the purpose and meaning of Gothic art, there is much important material in P. Frankl's *The Gothic, Literary Sources and Interpretation during Eight Centuries* (Princeton, 1960) and in Part Two of Frankl's *Gothic Architecture* (Pelican History of Art, Harmondsworth, 1962). E. Panofsky's *Abbot Suger on the Abbey Church of Saint-Denis* (Princeton, 1946) is an edition, with excellent introduction and notes, of Suger's own account of the new work at Saint-Denis. Suger's texts reveal the theological ground-work of his great venture in artistic patronage. E. Panofsky's *Gothic Architecture and Scholasticism* (Latrobe, 1951) brilliantly traces an analogy between the thought-processes of the Scholastics and those of the designers of the cathedrals. N. Pevsner's *The Leaves of Southwell* (Harmondsworth, 1945) is an admirable essay on the development of the appreciation of nature in medieval scientific writings and in medieval art. The quality and complexity of Gothic religious iconography is excellently exhibited in A. Katzenellenbogen's *The Sculptural Programs of Chartres Cathedral* (Baltimore, 1959). É. Mâle's *L'Art religieux du XIIe siècle en France* (1922); *L'Art religieux du XIIIe siècle en France* (1902) and *L'Art religieux en France de la fin du moyen âge* (1908) remain the standard works on medieval pictorial imagery.

The best short survey of Gothic architecture is found in N. Pevsner's *An Outline of European Architecture* (Harmondsworth, 7th edn, 1963). For French architecture, E. Gall's *Die gotische Baukunst in Frankreich und Deutschland,* 1 (Leipzig, 1925) has an authoritative text and useful plates. A detailed survey and a comprehensive set of photographs are provided by Frankl's *Gothic Architecture*. First-rate analyses of specific phases in the evolution of Gothic architecture, and important discussions of the transmission of architectural ideas in the Gothic period, are found in J. Bony's 'The Resistance to Chartres in Early Thirteenth-Century Architecture' (*Journal of the British Archaeological Association,* 1958), in R. Branner's *Burgundian Gothic Architecture* (Zwemmer, London, 1960), and in R. Branner's *St Louis and the Court Style in Gothic Architecture* (London, 1965). J. Fitchen's *The Construction of Gothic Cathedrals* (Oxford, 1961) is a fundamentally important book

217

on Gothic building techniques. V. Mortet's *Recueil de textes relatifs à l'histoire de l'architecture et à la condition des architectes en France au moyen âge* (1911–1929) is an invaluable compilation of written sources for the history of French medieval architecture.

A. Andersson's *English Influence in Norwegian and Swedish Figure Sculpture in Wood, 1220–70* (Stockholm, 1949) is an important detailed study of the major trends in the central period of Gothic sculpture. L. Stone's *Sculpture in Britain: The Middle Ages* (Pelican History of Art, Harmondsworth, 1955) contains a lively and comprehensive account of English Gothic sculpture. M. Aubert's *La Sculpture française au moyen âge* (1946) is the amply illustrated standard survey of French monumental sculpture. R. Koechlin's *Les Ivoires gothiques français* (1924) deals authoritatively with the great array of small-scale works in ivory. J. Pope-Hennessy's *Italian Gothic Sculpture* (London, 1955) provides a convenient survey of the remarkable achievements of Italian sculptors of the period, with excellent text and plates. E. Panofsky's *Die deutsche Plastik des elften bis dreizehnten Jahrhunderts* (Munich, 1924) is the basic book on German sculpture.

J. Dupont's and C. Gnudi's *Gothic Painting* (Skira Books, 1954) provides a rapid account of Gothic manuscripts, murals, and panel paintings up to the early fifteenth century, and has handsome colour plates. C. Gnudi's *Giotto* (London, 1959) is the standard work on the great Florentine painter, for whom see also J. White's *Art and Architecture in Italy, 1250–1400*, which covers the whole history of late-medieval painting in Italy. French illuminated MSS. of the Gothic period are discussed by J. Porcher's *L'Enluminure française* (Paris, 1959) and are usefully listed, with notes, in Porcher's *Les Manuscrit sà peintures en France du XIIIe au XVIe siécle* (Paris, 1955). German painting is best introduced by A. Stange's *Deutsche Malerei der Gotik* (Berlin, 1934) and by the magnificent MSS. discussed and fully illustrated in H. Swarzenski's *Die lateinischen illuminierten Handschriften des XIII. Jahrhunderts am Rhein, Main, und Donau* (Berlin, 1937). P. Brieger's *English Art 1216–1307* (Oxford, 1957) contains a good balanced account of thirteenth-century English painting. The best guide to the court school is F. Wormald's 'Paintings in Westminster Abbey and Contemporary Paintings' (*Proceedings of the British Academy*, XXXV, 1949). On fourteenth-century French illumination, and the subsequent glories of fifteenth-century Flemish panel painting, E. Panofsky's *Early Netherlandish Painting* (Harvard, 1953) is the standard work, and one of the greatest books ever written in the field of art history. G. Ring's *A Century of French Painting, 1400–1500* (London, 1949) provides a useful survey of late-Gothic painting in France.

C. W. Previté-Orton's *A History of Europe from 1198 to 1378* (London, 2nd edn, 1948) is a convenient guide to the political events of the period. Sire Jean de Joinville's *Histoire de saint Louis*, gives a vivid first-hand impression of high secular society in the thirteenth century. W. Ullmann, *The Growth of Papal Government in the Middle Ages* (London, 2nd edn, 1962), though it deals mainly with pre-Gothic Christendom, is relevant here as an introduction to medieval political thinking. D. Knowles's *The Religious Orders in England* (Cambridge, 1956) is an authoritative and uniquely sensitive study of the medieval church in action.

For the mystics, W. Preger's *Geschichte der deutschen Mystik im Mittelalter* (Leipzig, 1874–93) contains a mass of material, including important studies of SS. Mechthild and Hildegarde. For Hildegarde, see also C. Singer's *The Scientific Views and Visions of Saint Hildegarde* (*Studies in the History and Method of Science*, Oxford, 1917). For Julian of Norwich see Fr. P. Molinari's *Julian of Norwich: The Teaching of a Fourteenth Century English Mystic* (London, 1958). *The Book of Margery Kempe* was edited by S. B. Meech and H. E. Allen for the Early English Text Society (London, 1940); a modernized version by W. Butler-Bowdon came out in a World's Classics edition, (Oxford, 1954). D. Knowles's *The English Mystical Tradition* (London, 1964) is an excellent introduction to Julian, Margery Kempe, etc. W. A. Pantin has an important study of the Monk Solitary of Farne (*English Historical Review*, LIX, 1944), and the full text, in English, of the 'Meditations on the Crucified' is published in *The Monk of Farne: The Meditations of a Fourteenth Century Monk* (ed. Dom H. Harmer, London, 1961). A. Poulain's *The Graces of Interior Prayer* (*Des Grâces d'oraison*, first published 1901) is an indispensable guide to mystical theology.

É. Gilson's *La Philosophie au moyen âge* (12th edn, Paris, 1952) is still the standard book on the full range of medieval philosophy. G. de Lagarde's *La Naissance de l'esprit laique au declin du moyen-âge* (Paris, 1934–46) contains an important study of the thirteenth-century philosophical situation, but concentrates on the evolution of philosophical and political thinking after St Thomas Aquinas, tracing the gradual disruption of the medieval order. D. Knowles's *The Evolution of Medieval Thought* (London, 1962) is a valuable short history of medieval philosophy. C. Dawson's *Medieval Religion* (London, 1935) contains attractive and stimulating essays on theology, philosophy, and poetry. Medieval scholarship, its personnel and methods, is presented with sympathy and detailed knowledge in B. Smalley's *The Study of the Bible in the Middle Ages* (2nd edn, Oxford, 1952) and R. Vaughan's *Matthew Paris* (Cambridge, 1958). E. K. Chambers's *The Medieval Stage* (Oxford, 1903) is an essential guide to the history of drama and religious spectacles in the medieval period. The medieval passion for pseudo-history and literary fantasy is discussed by various eminent scholars in R. S. Loomis's (ed.) *Arthurian Literature in the Middle Ages* (Oxford, 1959), which includes studies of major poets like Chrétien and Gottfreid. The links between romantic literature and life are well displayed in J. Huizinga's *The Waning of the Middle Ages* (1924) a brilliant and picturesque account of medieval civilization in transition and decay.

For Gothic survival and revival, see Frankl's *The Gothic*. Important short studies are J. G. Mann's 'Instances of Antiquarian Feeling in Medieval and Renaissance Art' (*Archaeological Journal*, LXXXIX, 1932) and R. D. Middleton's 'The Abbé de Cordemoy and the Graeco-Gothic Ideal' (*Journal of the Courtauld and Warburg Institutes*, 25, 1962; 26, 1963). The English revival is excellently traced in K. Clark's *The Gothic Revival* (new edn, London, 1950).

Index

Another volume in the new 'Style and Civilization' series

Mannerism by John Shearman

The refinement of Benvenuto Cellini's golden salt cellar or the monstrous fantasies of the Boboli Gardens in Florence — both are characteristic of Mannerism, a virtuoso style of life and art that intervened between Renaissance and Baroque in the sixteenth century. Mannerism was perhaps the most self-consciously 'stylish' of all styles — in literature, music and the visual arts alike. In the way that we have once again come to appreciate *art nouveau* so it is again possible for us to understand the spirit and beauty of Mannerist art.

Also available
PRE-CLASSICAL *by* John Boardman